ALBUM
FOR AN AGE

ALBUM FOR AN AGE

*Unconventional Words and Pictures
from the Twentieth Century*

ART SHAY

With a Foreword by Garry Wills

Ivan R. Dee
Chicago 2000

I am deeply in debt to my gifted and patient art director,
Kathryn Tutkus, for ignoring my outraged howls as she winnowed
down a half-century of pictures.

Library of Congress Cataloging-in-Publication Data:
Shay, Arthur.
 Album for an age : unconventional words and pictures from the twentieth century / Art Shay ; with a foreword by Gary Wills.
 p. cm.
 Includes index.
 ISBN 1-56663-327-3 (alk. paper)
 1. Shay, Arthur—Anecdotes. 2. News photographers—United States—Anecdotes.
 3. Photojournalism—United States. I. Title.

 TR140.S48 A3 2000
 070.4'9'092—dc21

 00-055510

For my wife, the renowned rare book dealer,
Florence "Titles" Shay,
the stubbornest, prettiest, smartest, and
most forgiving woman I have ever known.
The only editor of my entire career
tough and honest enough to make my ears burn.

Contents

Foreword .ix

Introduction .xi

Growing Up (Still at It) .3

A Motley Crowd .27

Snapshots .107

War and Remembrance .129

The Photographer's Trade .161

Politicians and Other Rascals .225

No Biz Like It .261

Index .296

Foreword

by Garry Wills

I first met Art Shay in Memphis on the night of April 4, 1968, the date
when Martin Luther King was killed. I was writing for *Esquire* then, and had
jumped onto a plane from Baltimore as soon as I heard of the shooting. Art,
a *Life* photographer at the time, had arrived earlier with a *Life* reporter. The
two men let me ride along with them in their rented car as we monitored
observance of a hastily imposed curfew. There were still signs of minor riot-
ing—some liquor stores had been broken into. Police charged into these
places with drawn guns and Art, with drawn camera, rushed in alongside
them. I thought at the time that no one could pay me to do that. I had not
yet seen many news photographers at work, and did not realize that they
need as much courage as talent.

The three of us ended the night at the funeral home where Dr. King's
body was being prepared for a brief morning wake before it was flown off to
Atlanta. We were the only outsiders and the only whites in the converted
mansion that served as mortuary. We could hear the undertakers as they
worked at their task, since only a thin partition separated their space from
the room where the body would be viewed. More eerily, we could hear Dr.
King's live voice giving speech after speech on the black radio station that
was holding a nightlong memorial show in his honor.

When the casket was rolled out at dawn, the undertakers explained
what had taken them so long. One side of King's jaw had been shot away, and
they had to build up a plaster replacement, then tint and powder it to match

his skin color. There was a thin scrim tacked across the open space on the casket. Art asked them to remove it so he could shoot the result of their labors. They refused at first, saying that demonstrative mourners at this home often touched or kissed a dead person's face, and that would rub the color off the plaster jaw. But Art rarely takes no for an answer, and they finally removed the tacks to let him get his pictures before fixing the scrim in place again. Art took pictures of the mourners as they arrived—not a single white person among them.

We had heard on the radio that Coretta King would be arriving that morning at the airport, so we drove out to see her. There was a wheeled stairway rolled onto the tarmac for her descent from the plane. Art, grabbing another of these contrivances, steered it out near the first one, since he meant to be on the top stair, as close as possible, when Mrs. King stepped out of the plane's doorway. Policemen scrambled to remove this extra stairway, but they had to chase Art around for a while to accomplish this. He was as persistent as he is courageous. I did not know then about his World War II service in the air force, which had made him well acquainted with danger. I was not surprised when I did learn of it.

I did not see Art again until, twenty years ago, I moved to his town, Chicago. Now I see him at various events, his camera always at the ready. Though there are things we do not agree on—John Kennedy, Harry Truman, and Jesse Jackson, to name just three—my initial admiration for his talent and courage have never dimmed. How could they? Just look at the pictures.

Martin Luther King and mourners.

Introduction

Photography wasn't always "in." The first *Atlantic Monthly* color-photo cover in the late 1940s, a small-town Vermont snow scene, was credited: Photo by Kodachrome.

In the 1950s I shot a five-page picture story on Little League baseball for *Collier's*. My captions included a 150-word block of text. I got a byline: Photographs by the Author.

Photography is in today. Some years ago Philippe Halsman got $350 to shoot his famous Einstein *Life* cover—resurrected by *Time* for its millennium issue, when they named the scientist Man of the Century. Presumably Halsman's heirs got a bigger check than he did for the original. Annie Leibovitz shoots the milk mustache pictures for $25,000 each; the museums and galleries are filled with photography. The next big thing, digital photography, will only add to its reputation as the art of the people. But it took a fight. My pictures of Hugh Hefner and Leo Durocher hang in the National Portrait Gallery. To my surprise I've become collectible.

We have come a long way since Susan Sontag suggested—and various movies confirmed—that photography was a sexual experience. The nature of the chase, the configuration of the telephoto lens, etc. My old friend, the novelist Nelson Algren, with whom I often wandered on the wild side of Chicago, quoted Walt Whitman: "I do not doubt the majesty and beauty of the world are latent in any iota of the world. . . . There is far more in trivialities, insects, vulgar persons, slaves, dwarfs, weeds, rejected refuse than I have supposed." He loved to write captions for my street pictures.

We photographers have always been a motley crew. Diane Arbus often slept with her weirdest subjects in order to get close as possible to them. Fashion photographers roam the slums and tribal backwaters seeking locations for their high-priced models and higher-priced clothes. "My technique," boasted Helmut Newton to Charlie Rose, "is like those recreations of crimes on TV. I just set my models down in real-life situations and shoot." Newton is great at juxtaposing semi-nude models with attack dogs; his sado-masochistic images sell clothes. Out-of-focus pictures are in vogue; one thick collection by Nan Goldin contains a blurry, two-page picture of restive, unfocused swimming pool water and a two-pager of the artist's blurry battered self in a mirror, showing a black eye administered by a former friend. Computer-enhanced images stare at us from every newsstand: was the magazine wrong to change a horizontal shot of a horseman into a vertical to make a more feasible cover?

The other midnight another renowned photographer, Richard Avedon, a master of posing models in static situations, said on TV that he liked to be where "things happen." He reminded me of a sudden anomaly during the famous police riot in Chicago at the 1968 Democratic Convention. I was photographing the police teargassing and clubbing hippie demonstrators. The scene was terrible enough—but suddenly a "hippie" swathed in bandages and covered with "blood" threw himself into the fray. A few feet away a commercial movie crew "documented" this outrage. It turned out that this actor and attendant cameras were merely using political reality as a background for a fictional movie! You cross a line and you don't always score a touchdown.

Journalism had—but photography had not—fully arrived during the lifetime of Henry James, so when he wrote a marvelous little book about Honoré Daumier, the French caricaturist, he lauded Daumier's "matutinal crayon" doing its wicked surgery around the courthouses of Paris in the mid-nineteenth century. Daumier's achievement, James pointed out, branched upward from journalism, which he presciently tagged "criticism of the moment *at* the moment," and touched the fine arts, manners, and morals, giving journalism "its inexhaustible life." It feeds, the master averred, on the incongruities of life. Said James: "A society has to age before it becomes crit-

ical enough to take pleasure in the reproduction of its incongruities by an instrument as impertinent as . . ."

As Daumier's sharp diurnal crayon! The hideable Leica as social crayon was way in the future, but the Civil War photographers and many a brave traveler had already begun to use the unwieldy camera and developing process to document Henry James's world.

My greatest influence? Daumier! A nonphotographer! For years I've loved and collected his courtroom drawings. A hundred years later his way with pad and crayon became my own way around Chicago's courtrooms and jails with Leicas hidden in hats, books, under jackets, in briefcases. Luckily the forties and fifties were the age just before metal detectors.

Daumier's capture of our incivility to one another, courthouse clout at work, the madness in the streets—must have been exactly what Gogol, Dostoevsky, and Kuprin saw in the corrupt legal fens and slums of Russia. What cameraless Kafka saw in Prague.

Daumier taught me to aim my predatory camera at the contumely, snobbery, pretensions, cruelty, and machinery of petty power. I was prepared to record it, having worked as a *Life* magazine reporter for nearly three years. A reporter's function on *Life* was to dream up picture stories, make arrangements to cover them, write the captions, and shepherd the stories "into the magazine." I was lucky to have worked with and known Francis Miller—the greatest of *Life*'s unsung photographers—unsung probably because he looked and sounded like W. C. Fields, drank a little too much, and dressed like the rough-hewn Texan he was. As a wartime naval officer he had been wooed by Steichen's renowned photo unit and had killed an Icelandic marine in a Reykjavik street fight. He was transferred to Australia, where he photographed then married a circus acrobat named Yvonne. I also worked with *Life*'s first and second lovers of movie stars, Ralph Crane and Peter Stackpole, and with Andreas Feininger, the great Lyonel's son, Leonard McCombe, Al Fenn, Tom McAvoy, Alfred Eisenstaedt, George Skadding, Wallace Kirkland, Walter Sanders, Lisa Larsen, Philippe Halsman, and many others.

I began shooting pictures at the age of twelve with my father's folding, guess-focus Kodak. I learned developing and printing as a Boy Scout, and with money earned this way, bought an ancient $10 Graflex. By the time I was sixteen, I was moving a half-frame cardboard left and right so I could shoot two pictures on each sheet of film. I did school plays, bar mitzvahs, street candids, babies. Crawling on the floor trying to keep a three-year-old in the viewfinder, I found myself shocked by the mirrored view in my camera: the unpantied hindquarters of my quarry's mother! I wrestled with a moral dilemma: was I a perverted voyeur? I finally decided I was just a lucky teenager.

A year later I had more doubts. The busty Polish woman across the alley, Mrs. L., a friend and contemporary of my thirty-seven-year-old mother, visible from my dark bathroom through the window she kept open at night against the summer heat, used to dance and sway endlessly before her mirror. What an instrument, the camera! I thought, as my ultimate Squadron Commander, Jimmy Stewart, would demonstrate in *Rear Window*. Mrs. L.'s posturing, long before Grace Kelly's, was vanity, I imagined. But one day, shyly offering to pay for a print to send back to her estranged husband in Europe, she confessed that she loved to pose for me. Our secret. "And Arthur," she added unnecessarily, "please don't tell your mama."

I remember the very first time I used the camera as a Daumier–Henry James "crayon." I was sixteen and against a subway bulwark I noticed an Aunt Jemima ad—jolly, chubby Jemima, hand extended toward the viewer with piping hot spoonful of cereal. Sleeping next to the billboard, head lolling, was a black man, his open, snoring mouth exactly juxtaposed to swallow that cereal. I had to pass six station stops to get the ten-second time exposure my picture required, but I got it and it was thrilling.

I would have proudly published it in these pages except for one problem: my mother accidentally threw my old negatives away during World War II. But here are some pictures and captions almost as good that survived the past half-century. My album of our age.

Twenty Seconds
Twenty Men

U. S. airmen die in crash over England

Flight Officer Arthur Shay, of the Bronx, N. Y., just back from a bombing mission, heard the roar of a great bomber formation rendervousing over his base in England for another smash at the enemy, rushed outside with his camera just as two Liberators collided (1). One plane (2), its tail sheared off and flung far to left (visible over left wing of other bomber), bursts into flame; smoke spirals from other. Craft below race clear of doomed ships. Pictures 3, 4 and 5 show both ships plummeting earthward ahead of the lighter tail. One bomber describes an arc, hovers almost directly above other at final plunge. "Twenty seconds, 20 men," gasps a watcher as flames (6) shoot skyward. (Note tail near horizon.) There were no survivors.

END

Look *magazine tearsheet showing sequence of a mid-air collision between two B-24s, then their deadly wakes of smoke until they hit the ground. June 1944. These are my first published pictures. Returning to my base in England from a bombing mission, I aimed my camera at the terrible roar of engines overhead, forty-four Liberators forming around a radio buncher. Suddenly two of the planes hit—I was horrified as I shot-wound film, shot-wound—but equally horrified because a hysterical colonel was pulling and pushing me, screaming, "You can't shoot that—it's restricted." I ducked, dodged, and documented. And eventually answered six lachrymose letters that came from the families of some of the kids who died this way.*

ALBUM
FOR AN AGE

Growing Up
(Still at It)

Kids at camp.

The tall, beautiful editor was thirty-two and her problems were many. Her authors' manuscripts were late. Her company's warehouse had misplaced an entire edition of a hot book. Her married lover had changed his mind about leaving his wife, having discovered religion in the week since the couple returned from the Bahamas all sunburned.

"He's suddenly remembered his three children too," she confided archly. "And what their summer camp is costing him."

A dreamy look crossed her perfect Gallic face, under her tears. "You know what I secretly wish?" she asked.

"That I was a foot taller, twenty years younger, and asked you to run away with me?"

"That my mother would walk through that door this minute and say 'Okay, young lady, let's start packing for camp.'"

She stretched her arms in front of her, clasping her fingers in backward arches just before they got away from her. "The name tags, the shorts, the pre-addressed postcards—I miss all of it. More than miss. God, I lust after those days." She groaned impiously and retrieved her arms. "But those days'll never return. Childhood is a lost manuscript, and memory is a bad carbon of it."

At lunch, to cheer her up, I offered my own camp recollections.

In the beginning there was my Bronx scout troop #257, about to start a drum and bugle corps. I was twelve and wanted to play the drum in the worst possible way, which I probably was meant to do. But standing in line to get a drum, just two kids away from the drum table I saw the assistant scoutmaster doling out not drums but simply drumsticks with small O'Sullivan rubber heels attached. The drums would be delivered in two months. Two steps to my right the bugle line was moving nicely. Each scout would get a shiny Rexcraft bugle wrapped in wax paper, easily worth three bucks.

In a year I became bugle champ of the East Bronx. First prize: a summer job as bugler at a coed camp in Armonk, New York. It was a rich kids' camp, $250 a season. I learned about marriage, divorce, and significant others by observing the nervous truces of sundered relationships and new ones flapping like untied sneaker laces around our campers, who couldn't wait for their nervous visitors to leave.

At 7 a.m. I played "Reveille" and then "To the Colors" as we raised the sacred blue flag of Camp Peter Pan.

At 9 p.m. I played "Taps" mournfully, aiming at a huge boulder on our hill that bounced the sound all the way down to the village, which always paused to listen for a reflective moment. My soothing, brass-throated "Taps" washing over the lucky landowners who would in a few years become instant millionaires by selling their land to IBM, which had blue flags of its own to plant over our long-ago campsite.

My early Boy Scout interest in photography took a giant leap in the camp darkroom the day a beautiful college girl, Betty, the arts counselor,

locked the door and in one hour helped me produce four quick enlargements and three orgasms. An exciting career beckoned.

Having a profession—camp bugler (long before PA systems made me obsolete), I migrated to the Catskills next year. There, tooting at Camp Winston on Sackett Lake, I met my wife-to-be, Florence, a counselor there.

Had I not become a bugler I would have missed participating in Camp Color War, a simulacrum of the real thing waiting in those deadly 1941 wings. Our camp was divided into two armies, Green and White, and we competed in every sport and craft. Camp was a painless forge where we hammered ourselves into shape for the long haul and learned to win and lose gracelessly, as in real life.

The war, which seemed so far away from the Bronx, in less than two years would place me in a Pathfinder B-24, leading eight hundred planes to Berlin on one June day and eleven hundred planes to Hamburg on another. And give me the fearful joy of shooting down a Focke Wulf 190 at sixty yards and bombing hell out of the Nazis who had used the old Zeppelin hangars at Orly Airfield to maintain Goering's fighter planes.

That's a victorious Green team camp ribbon peeping out from behind my Distinguished Flying Cross, Air Medals, and croix de guerre.

Now, if only my mother could come in to help me pack for camp one more time, my Arty Shay name tapes all sewn in, my new $2.50 Thom McAn shoes and one-dollar Keds sneakers ready to go, my sacred Rexcraft bugle shined with Noxon and safe from dents in the black leather drawstring bag my beloved father, the out-of-work tailor, had lovingly made for it . . .

Speaking of parents, the multimillionaire father of a friend of mine was a legend in the tiny worlds of two small sports, an innovator, a gifted speaker, a fierce competitor into his seventies. *Sports Illustrated* had covered him several times. He had also mindlessly let himself be used by big-league gangsters, larcenous and murderous, who had, shortly before he died, bombed his home as a warning: you never ask the mob for your money back

or even progress reports if you're involved with them. He had made the mistake of letting mobster-lawyer Alan Dorfman, later murdered, help handle his finances. Dorfman used him as a dupe for cleansing some dirty Teamsters money.

I knew him, kowtowed to his vanities, and played with him and against him in both his sports a couple of times a week for years. He was tough. He cheated with a smile; he hated the long hair, beards, and mustaches of the sixties. He felt, in the smallness of his soul, that God's intention was to have us all kempt, orderly, and paying whatever bank interest, and voting for whomever the Republican party deemed proper.

Each year as Father's Day approaches, I think of this fatherly man and his relationship with one of his sons, the one who worked for him keeping records of his sport. (Two other sons, unable to abide their dad's authoritarian nature, went into businesses of their own in which they are markedly successful.)

The son I knew was in his fifties, a loving father of three, a bored veteran of his own father's hoary reminiscences beginning "When I was your age . . ." and ending "I just hope your children . . ."

He would wryly joke that his acclaimed father was squeezing his life by paying him a meager salary. Like his father's, his vision was somewhat flawed; like his father, he was likable but not lovable. Like his father, he had a persistent memory. He often recalled his father's coaxing him, at age eight, to jump off the high board at the local pool. "I'll pull you out," he mocked in his father's long-ago voice, promising the nonswimming kid safety. "I jumped in," he said, "and my father turned his back on me and walked away. It was his way, he thought, of training me to be as brave as he had been trained to be by his own tough, Teutonic father. I hated him for that. I'm still scared of the water, of drowning."

When the crusty old man died a few years ago, I called the son to offer him condolences. He said, "A lot of people have been calling up." Pause. "I tell them, 'Thanks, but that's one less SOB in the world.'"

Another pause. "He once screwed these plumbers doing a building project for him. I just found out how they got even: they put some long two-by-fours into the plumbing pipes they were laying in for him on a new project. It took months for the new homeowners to find out why they couldn't get enough pressure when they flushed. Wasn't that neat, how these guys got even with him?"

I was in my twenties when my own father died about fifty years ago. I don't need Father's Day to remind me of him. Not a day goes by without my having some happy thought of him, or some remembrance of riding with him on the New York subway during the depression as he went downtown to look for work. He was barely five feet tall and had been born in Riga, Latvia, in 1882 and grew up in Dvinsk in Russia. Responding to the starvation and pogroms he saw all around him (he had watched Cossacks murder the Uncle Artur I was named after, and then, as my aunt wept, they murdered her nineteen-year-old son), he became a political activist, a socialist. He had been swayed by Lenin's oratory in the streets of St. Petersburg.

As a Jew he couldn't gain entrance to college in Russia, but under a false identity he made it to Heidelberg University in Leipzig, Germany, for a while. Restless, he emigrated to England just before World War I and opened a tailor shop in Trafalgar Square, then finally made it to the land of his dreams, America. When I was a kid he would translate postcards from all over the world into English for me. And when I was three he would play the tinkly and soothing mandolin for me some nights, singing in Russian and stroking my hair between songs until I fell asleep. He was, he thought, distantly related to Tchaikovsky, his name in Russian being "Tchai." It became Shay when he got to England. One of his postcards showed a tethered hot-air balloon lofting in Paris, the Eiffel Tower in the background. There was a close-up of him in his album, showing the tower over his shoulder. When I got to Paris as a liberating officer in 1944, I had my picture taken in the approximate spot he had stood.

An old uncle, Isaac, told me he had seen my atheist father conduct a revolutionary meeting that was raided by the tsar's police on horseback. My father had calmly lifted a prayer book and begun chanting from it to fool the cavalry. My uncle remembered my father clambering up a roof with a mounted Cossack flailing away at his retreating backside with his saber. My existence hung on that near miss.

My enterprising mother kept finding tailor shops for my father in the Bronx so he wouldn't have to ride the subway to Manhattan. When I was nine I remember his handing a rare week's wages, $24 in singles, to my mother. "If you could do this once a month," my mother said, kissing him, "we'd get along."

I loved my father's slight Russian accent. His English, learned from the *New York World,* and the *Times,* was excellent except for the word *sword,* which he pronounced accenting the *w* all his life, unable to understand what the hell it was doing in the word.

He introduced me to his beloved libraries, museums, and the Bronx Zoo. He took me rowing on the Bronx River, and some Sundays he'd take me to Central Park to watch the rich kids play with their sailboats. It never even occurred to me to ask for a boat. I knew we couldn't afford anything like that. Poverty carries its own sense of parameter. You just know that stuff is for other people. He taught me how to make and fly kites.

When my father was sixty and my mother forty, they had twin sons. A father again at sixty! It made him younger. Times were improving. Between us and my mother's frugality, and the constant exercise of her credo of life: "You've got to try, try, try in order to achieve anything," we got the twins through college. (Her philosophy was the positive side of Wayne Gretzky's: I've missed a hundred percent of the shots I didn't take.") The twins became aeronautical engineers. One helped design the communications system for Air Force One and designed improvements for some of the earliest giant computers; the other served as a model for one of the first Astronaut moon suits and today helps run a sophisticated metals company. Our middle broth-

er, who worked at my knee in my first home darkroom, headed a color pro-
cessing division for *Time, Life,* and *Sports Illustrated.*

At weddings and other gatherings we recall our parents' love and
instinctive pathfinding and guidance into the main channels of American
life. We also recall that when I became a Boy Scout, my father wept, because
the uniform, to his generation of Jews, meant oppression and a going away
from the family. When I left my single year of college to enlist in the air force,
my parents wept again. They knew war meant death.

My father was the kindest, gentlest, wisest man I ever knew. I once
defended his atheism to the religious zealot just becoming known as "the
young Schweitzer" for his work in Laos, Dr. Tom Dooley. Dooley was con-
vinced that no one could be good or saved unless he believed in God. We
were on a small chartered plane that almost crashed as we skittered aloft
after sashaying over the icy St. Louis runway. I asked what he was muttering
during the takeoff.

"I was praying to God," he said when we were airborne. "I was saying
goodbye to my father," I said.

"Maybe it's the same thing," said Dooley. "My father didn't influence
my life very much. Mother did. Did yours?"

I thought for a long time, then realized that both my father and I had
loved my mother, and somehow he had survived her subtle Jewish house-
wife tyranny. Looking back I see that in addition to the depression, to being
a tailor in this country instead of a political activist on behalf of the poor,
and in a language not native to him, he had also survived my mother's
rebukes.

"How was the party, Mom?" I'd asked one evening when they'd
returned from one.

"Terrible," she said. "Everyone thought daddy was my father. He's too
short to be a good dancer, and I didn't have a new dress. It was all right."

My father loved me and I loved—love—him. He's part of me every day
of the year, not merely on Father's Day.

Las Vegas mob honcho Moe Dalitz, by purse camera.

In Las Vegas to sneak into a Mafia casino counting room and photograph, if possible, the relationship between tainted hotel owners and gaming officials who looked the other way during the sacred counting and disappearance of cash from the tables, I found myself hanging around a then-new place called Circus, Circus. The gambling and food operations had been fitted under a candy-striped tent as large as a couple of football fields. All to the cacophony of gamblers, the whir of roulette and bingo wheels. (One touter pitches a nice couple: "You don't have to put money down, folks. You from Iowa, is it? Sir, ma'am? Just make a mind bet and find out how much you coulda took back to Des Moines.")

The main feature of Circus, Circus, however, was impossibly skilled and sexy acrobats flying overhead, up and down the length of this weird Big Top as you gambled, ate, and gaped. The falsely cheerful clink of coins and slap of bucks mingled in the air with the smell of kosher delicatessen.

"Marvelous," said my wife Florence nervously. Uneasy because my beautiful square wife was packing a tiny robot camera in her purse, its high speed lens peeping out through a clasp. She also carried a Leica hidden in a hollow book with a peephole for the lens.

Circus elephants perform but work too.

"Not as marvelous as my first circus," 1 reminisced later alongside the Riviera pool.

Bronx River Avenue ran out of pavement just a few yards north of the small four-flat building where I grew up. Tarred road in front, vacant lots behind us, and just beyond them, James Monroe High School—then the largest in the world. Fifteen thousand students, part of the World War I baby boom. High schooler Hank Greenberg used to pepper our lots with over-the-fence homers and practice fly balls.

My native street meandered through deeper vacant lots and petered out along the nondescript shorelines of the struggling Bronx River, which ran past a sometimes gypsy camp, the Hakoah home soccer field, and the Bronx Coliseum. Then it went on to gurgle over a waterfall at the beautiful, nearby

Bronx Zoo, where its water, Bronxified from the snooty Long Island Sound, provided wallows for rhinos and elephants and scenic walkways for lovers.

During the spring rains, the trails near my house became quagmires through which the Ringling Brothers, Barnum & Bailey Circus had to push to get to the Coliseum. One grey, rainy morning, still shimmering in my memory there at poolside in Vegas, I awoke to the sound of the grunting of harnessed elephants pushing and pulling circus wagons past my back windows, headed north for the back doors of the Coliseum.

Because of the high finance involved during those depression days, I didn't get to see that circus. But I never forgot those elephants. They were the kind of free show that lives on pricelessly in the memory of a kid hung up on fairy tales, Horatio Alger, Tom Swift, and the Rover Boys. Poor city kids like me battened on charming fictive lies that somehow eased our way into the real world, the world of strange doors ready to open if only we learned to knock properly.

Years later I did a circus book for children and took my own kids along. A friendly canvas boss, guiding men and elephants in erecting the tent masts, yelled at us, "I need some volunteers—you kids, help pull on this rope." They've never forgotten setting up the Cole Brothers circus in the parking lot of their rich suburb at dawn. No mud, no tight trails beyond their house—but the *elephants* were the same. "C'mon, I'll show you what to do. Put your body into it. We gotta get this tent up by 9 a.m. Do you mind walking a few dogs for the animal act, kids?" This tough Carny guy, called a "flattie" (for the flat cars they used to travel on) wouldn't take a tip. "Kids and circuses," he said. "It's love."

The mists and arbors of memory is what Nabokov called them, and having just coursed the makeshift elephant trail beyond my window, my own

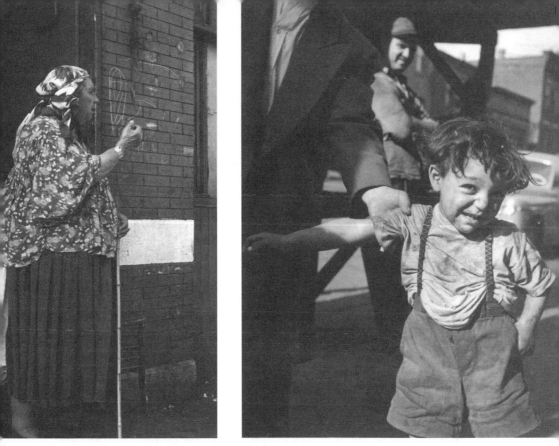

Maxwell Street Chicago gypsies, 1949.

mists and arbors lead me back to the colorful band of Gypsies who used Bronx River Avenue as the staging area during some magic summers of my boyhood. They would push through the brush to a mosquito-heavy camping ground on the western shore of the Bronx River, a mile short of the Coliseum and three miles from the Bronx Zoo.

The appearance of the Gypsies would terrify my Russian-born mother and five or six of her friends in the neighborhood who feared, as their mothers had before them in Odessa, that the Gypsies would steal their children. It seems impossible all these years later that I was once imprisoned by my mother against the possibility of being snatched by marauding Bronx Gypsies.

After they had passed down our street sharpening knives and begging for food and old clothes, and putting on impromptu penny-begging dances in which all of their children seemed to be miniature Gypsies, they settled in at the waterside campgrounds for a couple of weeks. My mother and her friends would then relax their vigilance over us nine- and ten-year-olds who went back to stickball (the sport that prepped Phil Rizzuto and many other New York street kids for the big leagues).

But I had a kookie Uncle Ira. Until World War II he had been the family athlete—a boxer in the military who claimed to have sparred with Barney Ross and Benny Leonard. Enough class for any uncle, but also a war hero. He had big picture books of trench warfare bodies with flies on them, two or three French words, a tatty *Croix de Guerre*, and a japanned boxful of French postcards he'd show to other cigar-smoking males around the early flower-speakered radios that brought in the Dempsey and Sharkey fights. When I was sixteen I heard him call Luis Firpo—who'd knocked Dempsey out of the ring in South America—"The Wild Bull of the Pampered"!

Uncle Ira owned a hardware store in Yorkville, in the hostile heart of New York's Nazidom. He never tired of telling us nephews of his feats as a warrior in the fields of Flanders—until my well-meaning cousin Sheldon, drafted into the adjutant general's office, looked up Uncle Ira's war record. He'd gone overseas all right, but the war ended before his transport could leave the port at Le Havre. He'd never set foot on foreign soil. Furthermore, Uncle Ira's record indicated he'd been acquitted at a court martial for cheating at cards during his month at sea. He could shuffle cards with one hand, taught me card tricks galore, and I loved him. Years later, in 1947, when I became a *Life* staffer, Uncle Ira invited me to his Catskills summer bungalow near Monticello. Borscht belt country. He had organized a big softball game, and I drove him "downtown" to get the ball. In the sports shop I waved two bucks to pay for it. Ira was insulted, thrusting the money back into my pocket. "Don't be a fool, Arty," he said. "You're an important person now. Act like one." He called over the owner, introduced me as the new editor of *Life*

magazine, and said that if he gave us a free ball, I'd do a big story on his store for *Life.* "Maybe a cover? Eh, Arty?" I fled.

You can't choose your uncles. "Don't be so modest," he said later, tossing his free two-dollar ball up and down proudly, ready to pitch. I raced back and forced a fiver on the confused merchant who'd been brushed, he thought, by fame for the price of a $1.33 ball, wholesale.

The peripatetic Gypsies of our long-ago summers fascinated Uncle Ira, and he befriended a few with Garcia Grande nickel cigars. One dusk he asked me if I wanted to go with him to the Gypsy camp. We crossed the 174th Street Bridge, recently dedicated by Major Jimmy Walker, and trampled our way through the briary outskirts of the Starlight Amusement Park, which had a real World War I submarine on cement chocks (I would see a picture of that sub—proud inventor at its snout—years later in *American Heritage).*

We were welcomed by the Gypsies, who were playing the violin and dancing. They gave Uncle Ira some wine to drink from a leather bottle. In a while one of the Gypsies led out a trained bear wearing huge leather gloves on its front paws. My uncle put on some smaller ones and began sparring with the clapping animal, scoring a body blow every now and then. The Gypsies were impressed. Soon Uncle Ira disappeared with a pretty Gypsy girl into her wagon—"to have my fortune told." He emerged after ten minutes, buttoning his fly and carefully folding what remained of his money. As a kid, I didn't connect the two actions until years later, long after my favorite uncle had died with very few of his secrets intact. "Your hand is too small to shuffle a whole deck," he warned me as I entered manhood. "Stay away from gambling, Arty my boy. Especially if you hit Monte Carlo like I did once on leave . . ."

He left a son who worked his way up to being in charge of the repair operation for an industrial furnace company. "I have to decide for businesses whether they should repair, rebuild, or buy new machines. I get a commission on the new ones."

"Doesn't that raise a problem for you?" I asked.

"Of course," he said.

"So you're honest, right?"

"Hey Arty," he said. "I'm just like my old man, God rest his soul. I'm honest but I ain't *honest* honest."

There are several booming apothegms in life. One is love, powerful but often incomprehensible. We sort of understand love between people, even unlikely couples. We understand the bonds between some humans and their animals. We shrug understandably at kids with their security blankets, collectors with their dolls, the very rich and their aquatic toys. In late 1946 I fell in love with a dark grey 1936 Plymouth coupe with a rumble seat.

It was my first car, it had 71,555 miles on it, and I paid three hundred dollars for it, two hundred saved up by my parsimonious wife who loved it almost as much as I did. Like most women of the day, though, she resisted learning the mysteries of its gear shift. "I can take a bus anywhere," she said. "Or you can drive me."

My love affair began in the Bronx, continued in dozens of lovely towns with streets named after trees and veterans like me picking up their lives again, across the unfolding green fields of our republic. And then back east by the northern route, which took us driving through our first foreign country, Canada. By the fourth year of my bonding with the car we had run the odometer up to 124,000 miles, about half of it underwritten by the air force at seven cents a mile. Sleeping in it, making love in it, making our transcontinental moves in it, guiding it to its regular parking spot at the Pentagon for some months, taking home our first baby, Jane, in it, we'd certainly gotten a lot more than our money out of the Plymouth. It was a trusty member of our little postwar family.

Florence and I in the Bronx, beside our 1936 Plymouth coupe, moments before we drove to Los Angeles.

There came a day when my softhearted mother fell prey to a pitch by her shrewder sister for her daughter and new husband. "Why don't you ask Arty to lend his little car to (let's call them) Shirley and Howie for their honeymoon. Ten days in the Catskills. It wouldn't kill him. He uses the subway to go to work from Brooklyn. Ten days." (I was in the last days of my air force service and would shortly begin to work on *Life*.)

Exerting maternal pressure going back to having brought me into her impoverished world, supplied me with mother's milk because who could afford formula in those days, which they didn't have yet anyway, and financed my bar mitzvah during the depression out of food money, Mom supervised my nervous handing over of the Plymouth keys to my cousin Shirley and her dentist husband. "They'll take care of it like a baby," my aunt said. "Howie is a responsible person and knows all about everything. He was a dental officer in the army on Long Island, he's finance chairman on the board of our synagogue, and he's going to be a dental school principal in two years." Jewish logic at work on the family level.

I could not have sent a son off to war with more trepidation than watching my Plymouth coupe recede in the hands of Howie, who had spent ten minutes of his wedding listing his academic credentials and, as he would for years afterward at family gatherings, lecturing me on the advantages of building on my one year of college until I earned some kind of degree, the ticket to a higher income, a better life, and certainly, for a would-be writer, an absolute necessity. He meant well, of course, like a dental drill means well.

I heard through the family grapevine that the newlyweds had arrived in the mountains safely and the honeymoon was going well. A day after it ended I got a collect call from Howie at an upper Manhattan garage just off the George Washington Bridge.

"Arty?" he said. "Your clutch just burned out. I'm in this garage—we just barely made it—and the guy will charge you $36 to have it fixed. I think it's highway robbery, but we can't get it in gear to go anywhere else. Do you want them to fix it? Like I said, it'll cost you $36 and it'll take two days. Or should we call a junkyard? The car has over a hundred thousand miles on it. We felt a few rumbles on the way up, around Fallsburg. You probably should've had a new clutch put in months ago, you wouldn't have had this problem. Too bad. It was a nice little car." His voice echoed with Talmudic doom. "We've only got two suitcases so we're going home by subway."

After I composed myself, I considered matricide followed by cousin and aunticide. I called the garage owner. Tony, Italian accent.

"You lenda him your car for ten days, and now he won'ta pay to fix the clutch, lieutenant?" he says.

"I'll pay," I said. "I'll come up by subway Friday afternoon, okay?" It would be a mere hour and forty minutes on three trains.

"She'lla be ready," he said. "Cash—no checks."

That established, Tony said, "I geeva you some advice, lieutenant, I lenda my wife before I lenda my car."

When the Plymouth reached 150,000 miles, and I had bought a new car, I sold my old friend for the exact sum I had paid for it—$300.

The doctor's only son, a beautiful little boy of six, has just died, taken by influenza just minutes ago, his bright blue eyes paling but still open, his mother weeping at the bedside, his father numb with shock and angry with his helplessness.

Suddenly the doorbell rings. It is an agitated, disliked nobleman. His wife, he blurts out, is dying, and the doctor must come this moment "in my troika outside" and save her life. It's only ten miles away. Hurry! Hurry! Never mind water for the horses . . .

We are in the midst of a Chekhov story, no doubt drawn from the master's own experience as a doctor. In a book discussion group we are arguing the priorities Chekhov has so nimbly posited. Should the grieving doctor leave his distraught wife, put aside his own grief, and rush to save the wife of an influential member of the community? Or should he refuse on personal grounds and presumably let the woman die, along with part of his practice and reputation?

Despite abhorring the nobleman, the doctor goes with him. He finds the "sick" wife gone: she's run off with a lover. Sending her husband for help was a ruse and a cruel retaliation for ongoing abuse.

The doctor, still in shock, berates the cuckold for dragging him on a fool's errand, realizing he is being unfair and catering to his own anger.

Back and forth scurries our discussion, each of our comments, including my own, revealing our own attitudes towards life, death, marriage, infidelity, duty, profession. After a while we agree that death makes us behave strangely and unpredictably, but on not much else. Chekhov had struck a note that still jangles today.

A few days later *Time* sent me to photograph a new electronic device. Arriving at the hotel exhibit, part of an industry convention, I could sense that some tragedy had occurred. Hushed voices, downcast eyes, no enthusiasm, no commerce. The Japanese company's American sales manager, a vital woman in her fifties, the one who had set up the show, had died in her sleep.

With three days of convention remaining, should the exhibit be scrapped?

Opinion was undivided among the Americans. The woman would have wanted the show to go on, right? You would, I would, right? It's not the money, it's the continuity.

But the Japanese management, the bosses, disagreed. The better way to show respect for their talented executive was to tear down the exhibit, pack, and go home. All their Japanese affiliates and, they hoped, the Americans would understand.

Death interposes, like weather. It is the final storm before the calm in our personal weather. A psychiatrist I knew, a father of two in his forties, a happily married man with a full calendar of patients depending on him each week, nosed his car around the warning gates, ignored the clangor of the bells because the north track seemed clear, and was killed instantly when a train from the opposite direction crashed into him.

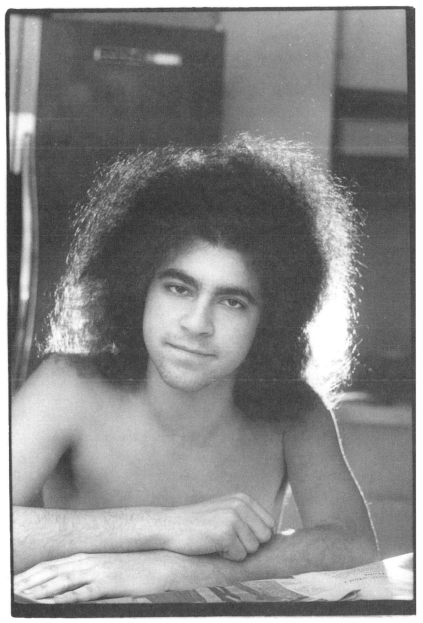

Our late genius hippie son, Harmon, twenty in 1971.

"Suicide," people said, nodding knowingly. I recoiled from the idea of suicide but also from the thought that the doctor's loving family, driving over the tracks in the future, would have death crash at them again and again.

I belong to that terrible fraternity of parents who have lost a child. More terrible, to murder. And more terrible still, to those who never recovered the body to bury.

Years later, when an airliner crashed in the Everglades, burying a hundred passengers in the green, impenetrable ooze that probably covers my son, my wife and I watched the heroic efforts of police, navy, and the airline to bring some of the debris, any of the bodies, to the surface. Without saying a word we looked at each other grimly. We had, unspoken, clung to the weird, wild, irrational hope that those boats and choppers, those flatbed cranes and God knows what else would somehow retrieve the long-dissolved body of our beloved son, and we'd go to Florida to claim the remains and bring them home.

I imagine behind every one of the terrible TV and newspaper stories regarded the violent death and disappearance of loved ones during war or peace are precipitated feelings such as ours.

Do they imagine him or her forever the same age as he or she was ten, fifteen, twenty years ago when saying goodbye? Do they see him getting older, as I've imagined Harmon in the birthday week of my boy murdered at twenty, maturing normally in my mind year after year? Would having perfect SAT scores and winning those four science fairs, creating a viable computer at age sixteen, long before Apple, have turned him into the scientist we expected? Of course. We still miss him not helping us unfathom our computers.

Is it sick to mourn that Harmon never saw a laptop, or for the unborn grandchildren he might have fathered to take their places next to their beautiful cousins? Yes, a little sick. And not much comfort. But avoiding these thoughts that screen up involuntarily is just as bad. And then you meet the parents of kids who committed suicide and grieve with them. Yes, suicide is worse.

As I write, it's Harmon's forty-ninth birthday. Nelson Algren's tragic godson. A character out of an Algren or a Chekhov story. As am I, I suppose. I had always thought, photographer that I am, we'd take out his kiddie snapshots and share his didos with his children. But the snapshots merely map out the boundaries of my loss, and I find it hard to look at them without weeping.

Like the Japanese manufacturers, I prefer to close the book. I suppose the rational thing to do is to emulate Chekhov's doctor—permit yourself to be thrust into mindless activity while still smoldering with the outrage, the impotence, the unfairness of death. And gird yourself for death's never-ending second strike: dealing with the ever-widening hole death stabs in your life and your sleep. And try not to take comfort in greater tragedies suffered by other people. Or invade your own privacy to mourn pathetically for your unborn grandchildren, for their cheery voices proudly passing on the amazing, happy details of their childhood. Their worn sneakers and tossed jackets sloppily filling the hallway.

A Motley Crowd

Jimmy Hoffa campaigns in the election that probably cost him his life.

I had known and liked Jimmy Hoffa a long time. I did the first *Fortune* story on him, and he introduced me to his teamsters from the union podium in Green Bay, Wisconsin, as "Chicago's best camera kid—tell 'em your name, son." *Fortune* used an *agitprop* frame—Hoffa orating in front of a huge blowup of Hoffa orating.

The day he was imprisoned at Lewisburg Penitentiary in Pennsylvania, I was in the small group of press waiting in two feet of snow at the head of the walkway on which he was scheduled to surrender and walk into the holding pen.

Hoffa got out of the car, waved to me and the others, then began walking down the thirty-foot path between the snow banks, heading for captivity. I hung back—and just as the press crowd began to disperse, I ran through the two-foot drifts like a madman, right up to the barred holding pen. Two guards

were fifteen feet behind me. Suddenly Hoffa recognized me through the bars and shifted his topcoat so that it covered his manacled wrists, and thrust them out at me with a silly grin. He didn't want the handcuffs to show. I fired a quick burst as I was grabbed by the guards.

"You can be my cellmate," Hoffa laughed as his guards jostled him into the jail. My guards, of course, demanded my film. I shrugged my shoulders, made a big display of rewinding and emptying my Nikon, and, oozing guilt and defeat, gave them a blank roll from the wrong camera. My picture of Hoffa behind bars was a full page.

When Hoffa got out several years later, ABC-TV hired me to do the still pictures for their special on Hoffa, then reemerging as a force in the Teamsters. Jimmy had the entire crew out to his Plum Grove farm, just north of Detroit. I photographed him rowing his little grandson around his small lake and directing some carpenters who were putting an addition on his house that would overlook the lake. While the TV crew was setting up, Hoffa and I, both handball players, talked about his having perfected his one-wall kill in prison, and he did some weight-lifting sets for my camera.

"You shoulda been around with that camera at the Ford strike," he said. "1936. Walter Reuther saw the press over here and the action over here, and ran away and ripped his shirt and made a little cut in his arm with a penknife. Then he loosened his tie and came running up in front of all the cameras like he had just fought off all of Ford's strikebreakers. . . ."

During a pause, Jimmy stood near his Ford pickup. "You wanna go downtown shopping with me, kid?" he asked. He meant the small neighboring Plum Grove, not Detroit.

"Sure," I said. "Whaddya need."

"Some stuff for the carpenters. Nails, screws . . ."

"Couldn't you send them?" I asked.

"Hell no," he said. "They get nine bucks an hour. They're on my clock, so they'd stop for beers—on my clock! That's why I'm going."

Right: Hoffa at ease.

Digging for Hoffa.

"But Jimmy," I said, "you gave American labor the guts to do that."

"Yeah, kid," he said, "but it's different when you're the one paying the labor cost."

Three months later Jimmy disappeared. The strongest rumors had his enemies grinding him up in restaurant machinery or encasing him in cement beneath the east goal of the Meadowlands Stadium in New Jersey. Like most of his Teamsters, I liked Jimmy a lot. He had at least as much charisma as his longtime pursuer, Bobby Kennedy, who couldn't laugh at himself as Hoffa could. Bobby, like his employee, J. Edgar Hoover, was able, most of his short, busy life, to keep his own sins secret—from everyone but his equally sinful brothers, his confessor, and that relentless bitch goddess, History.

hree Chicago institutions with habitual scowls on their faces: the two lions in front of the Art Institute on Michigan Avenue, and Midwest Mafia capo Tony Accardo. On the day Accardo was to make one of his rare federal court appearances, I leaned on *Life* magazine's connections with the FBI to spend a few idle moments in the office cubicle next to the one in which Accardo's lawyer was briefing Tony on how to "take the Fifth." As soon as Tony appeared, I popped up with my Leica and made the picture of Accardo seeming, as *Life* put it, to emerge from the shadows.

An hour later the renowned crime reporter Sandy Smith and I rode down from the courtroom with Tony in a back elevator. On the street I was trying to get a picture of Smith interviewing our quarry. Accardo said, "Fuck you both." My camera misfired. "Ask him to say it again," I said mindlessly, whipping a second camera to my eye. Accardo laughed and accommodated us. "Fuck you both, again," he laughed, and strode briskly east toward Michigan Avenue. Sandy left to write his story, but I followed Accardo, whipping out my 400 mm telephoto lens with motorized Nikon attached, my trusty *Sports Illustrated* rig for shooting Bears like Walter Payton and Packers like Vince Lombardi and Bart Starr.

I watched the receding Accardo cross Michigan Avenue, then head north. I stalked him from the west side of the street, using the lunchtime crowd as cover. In a few seconds I saw the picture I wanted—and raced ahead to frame the northernmost lion in my finder. I had to wait perhaps five seconds, but there came the scowling Accardo, striding briskly past the scowling lion. I shot a burst of five and liked this one the best.

Which of these two pictures did *Life* use full page? The mysterious capo emerging from the shadows! The visual pun of Big Tuna's scowl and Big Lion's scowl, an editor told me, was too subtle. Several years later, though, I used the lion picture as the theme of a big exhibition of my work. Five people bought the picture, including, a source informed me, two members of the Accardo family.

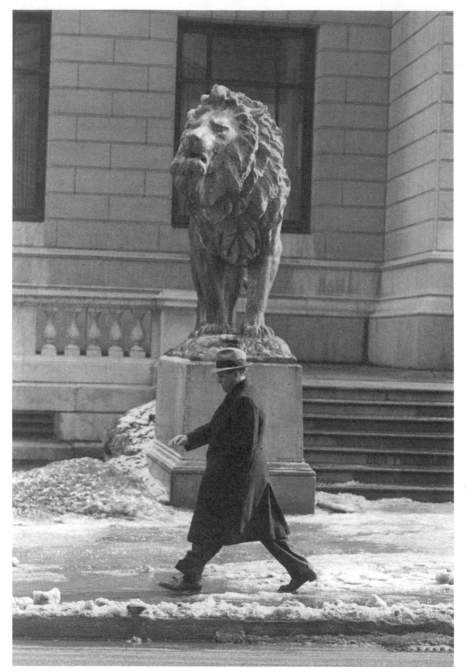

Tony Accardo, reputed head of the Chicago Mafia, known as "Big Tuna," passing big lion in front of Chicago's Art Institute.

In 1951 I was photographing rookie Mickey Mantle for a *Time* cover drawing. In the Yankee locker room I was lucky enough to meet Joe DiMaggio in his last season. I had been warned that DiMaggio didn't like locker-room photos. Seeing me, he said, "Hey kid—you have a darkroom?" I nodded. He then picked up diminutive infielder Phil Rizzuto. "What would you charge to have this enlarged?" he asked

Rizzuto, still in jockstrap, grabbed his crotch. "While you're at it," he said, "I'd like to get this enlarged too."

The only baseball player I really abhorred was the great Cleveland pitcher Bob Feller. I was shooting a Little League story for *Collier's* magazine when Feller walked through the hotel lobby. "These kids are from Canton, Ohio, Mr. Feller," I said from near my tripod. "Would you pose with

them?" The kids were wide-eyed with excitement. Feller was a genuine star, and they were seeing him close-up for the first time.

Feller shook his head and continued walking to the elevator, brushing aside their proffered autograph books. "You want me in a picture," he said, "call my agent." I was somehow cheered years later when I learned that Feller was appearing at baseball card shows and charging three dollars for his autograph. I hoped he needed the money. I knew none of those Canton Little Leagers would buy his signature.

One of baseball's moments.

Sherman Wu, a bright, affable Northwestern University freshman in the late fifties, was the son of the mayor of Shanghai. He was also the pledge of a fraternity whose escutcheon was two hands clasped in friendship. The frat charged the standard $125 a month for rent and meals.

One day several Southern members of the fraternity realized they had a voting majority and decided they wanted to be an all-white frat. They gave Sherman Wu an eviction notice and told him why he was undesirable. If Wu wasn't ousted, the benighted cabal threatened to move eight Southern students out, causing financial distress to the frat.

A campus friend told me of the situation, I suggested the story to *Life,* and the editors assigned me.

Before starting to shoot, I saw an assistant dean, a shoulder-shrugging woman who claimed her hands were tied. This was America—freedom of association, I had to understand.

Stepping out of my role as a photojournalist and back into my anti-fascist, anti-communist wartime stance as a combat navigator bombing the Nazis who were making soap out of people like me, I said to the dean: "Look, all you have to do is tell the fraternity they're way out of line. We fought a whole war recently—and the Civil War long ago—to end this kind of discrimination. . . ."

"It's a matter of money," she said. "The fraternity is pressed. They've got a lot of Southern votes. They just don't like outsiders. It's their decision."

"I'm sure you can work out the money with some kind of fund," I said. "The picture will appear all over Asia, Russia, and Africa," I said. "Northwestern will look terrible. Worse because the kid is the son of the mayor of Shanghai. You'll be sending a message all over the world: if the mayor's son is kicked out, think of what *your* social status would be on an American campus, you peasants who aspire to democracy. . . ."

Right: Wu walks reflectively past his former home.

Sherman Wu leaves the fraternity that ousted him. Below: An ironic no-handshake farewell despite the escutcheon.

Result? The pictures you see. Full page of Sherman Wu sadly walking by his ex-digs, his ex-friends gathered on the porch under the fraternity insignia: hands clasped in friendship.

By not exerting a little leadership and solving a minor financial problem—to say nothing of a social one—Northwestern's name was besmirched in myriad foreign publications. Posters of my pirated picture, that could have been tempered by a benighted university management, were hung on walls all over the benighted world.

As he aged gracelessly a few years ago, King Hussein of Jordan, peacemaker, jet pilot, world-class wiver, and master wheedler of U.S. military aid, ended up in political bed with Saddam Hussein during the Gulf War, embarrassing the Bush administration no end. But modern kings expect people and governments to look the other way, and for some reason, possibly biblical precedent, they are usually accommodated.

In the kingdom of Oakbrook, Illinois, long ago in the fifties, when the fledgling *Sports Illustrated* had a brief fling with athletic society and royalty (to help woo big advertisers), I was assigned by *SI* to cover the twenty-three-year-old King Hussein hunting tame pheasant and being otherwise entertained on the vast Paul Butler Sr. game preserve. Confusing ribands of Chicago's suburban tollway system had just begun to ring the estate with on and off ramps, so the lead limo, transporting His Majesty and the navigating host Butlers got lost for an hour. (Paul Jr. would eventually produce *Hair* and become a great social activist amongst starlets. Paul Sr. would one day in his nineties be run over fatally while hunting to hounds at the nearby club.)

The king, a short, slight 130-pounder in a brown A-2 Air Force leather jacket, safely broke his shotgun as we walked the Butler fields. His reflexes

were admirable. He'd whip the heavy shotgun up at the faintest whir of wings and bring down a bird. Even though I was still in my thirties, I had trouble coordinating my camera moves to his gun speed. A great shooter.

Perhaps a hundred very well connected social types filled the Oakbrook Country Club clubhouse for cocktails and dinner with His Majesty. A likable, short Jordanian colonel, with more international ribbons than Eisenhower, asked me not to photograph the king with glass in hand, so I didn't.

The colonel kept scanning the crowd, I imagined for security. But no, as I moved in his wake, scrounging half as many hors d'oeuvres, I learned that the Colonel was really an advance man for the recently divorced monarch. Carefully staking out attractive, unattached women, he would sidle up and ask, "Would you enjoy to spend a night with His Majesty?" Most of the half-dozen or so women thus importuned glared at the colonel in polite surprise before softly demurring. Who knows the etiquette of turning down an intimate idyll with an unmarried king? By the time I said thanks and

Dead-shot, leather-jacketed King Hussein of Jordan, led by host Paul Butler, Jr., hunt pheasant. His Majesty nailed four birds, possibly five.

goodbye to Colonel Factotum, he was smiling, mission apparently accomplished—if not oversubscribed—and wondering how to buy some of zee snapshots from *Sports Illustrated,* presumably for the royal album.

Dapper little Mickey Cohen had worked as a hit man for Bugsy Siegel in Vegas, and as an enforcer for other West Coast gangsters. His strong-arm henchman was Johnny Stompanato, who was movie-star handsome, very big

L.A. gangsters Mickey Cohen and Johnny Stompanato, cuffed together in Chicago, arrested as undesirables.

with movie ladies, and strong as a pugilist. The enforcer's enforcer, mostly around Los Angeles.

One day in 1951 the pair appeared in Chicago, and in no time the order came down from City Hall: "Leave town or else. We don't want your kind scumming up our pure Chicago." The aldermanic-police fix hadn't been put in for their visit.

The pair was collared downtown and taken to the Maxwell Street station for processing. Celebrity Mickey waved at a couple of admirers and photographers.

They went back to LA, and in a few weeks Stompanato was back in the news. He had been living in actress Lana Turner's house, and, so went the story, had made a nocturnal pass at Turner's fourteen-year-old daughter Cheryl, who grabbed a kitchen knife and thrust it into Stompanato's gut. He bled to death.

The tabloids periodically, and *Vanity Fair* a couple of years ago, resurrected the story, playing riffs on the possibility that a smart Hollywood lawyer had written a hasty script for the ladies to perform for the police, perhaps based on the belief that a jury would be more understanding of a kid than her impassioned mama.

Some years later, while doing *Life*'s famous story on a man they called the country's toughest prisoner, I sneaked into the U.S. prison hospital in Kansas City with four hidden cameras. I hoped to get into the well-guarded library where my quarry worked on his appeal every afternoon. My ploy was to apply for a guard's job, which, a guard informant assured us, would give me a tour of the facility. Heart thumping in fright, I was walking between two huge guards, keeping slightly removed by affecting a cold and misdirecting a red snotrag while shooting through a hole in my jacket. Suddenly, shuffling toward me down the corridor, was the somewhat older Mickey Cohen. One guard said: "Celebrity—Mickey Cohen—little kike bastard. The SOB got the shit beat out of him in a California jail. Brain damage is why he shuffles."

I averted my head in case poor Mickey remembered me from our day in Chicago. I nailed my murderer in the library, working on his brief. Unbelievably, given the laws of chance, on our way out I saw another Mafia operative I had previously photographed—Carlos Marcello, head of the New Orleans waterfront, whose name surfaced in the Warren Report after JFK's assassination.

The manuscript of *Some Came Running* was over a foot thick. I photographed James Jones, then, like me and my *Life* writer Roy Rowan, in his mid-thirties. Jones proudly hefted the ultimate flop of a movie in the workroom of his farmhouse in southern Illinois. I preferred the shot of his lunging at me with one of his twenty-seven hunting knives.

"I got $750,000 for it," he said over and over again. "Much more than for *From Here to Eternity*—including movie rights. Later he told Rowan and me, "You know, I had sex with all the women in *Eternity* except Deborah Kerr—and most of the men." That would have included Montgomery Clift. Not the kind of information a family publication like *Life* would have used in those days.

Jones's mentor, Lowney Handy, stood at his side proudly nodding. She was in her early fifties, busty, sly, and so fond of Jimmy. Basking in the tolerant smile and shrug of her rich and loving husband, Lowney ran a nearby writer's colony for young postwar novelists. Jimmy was her prize, but she made no bones about loving the world of young writers. "Every Friday night I send Jimmy into Terre Haute across the river to play sandwich with two cute whores," Lowney told us. "He gets drunk there, rolls around with the girls, then comes back here ready to write another week." One of the pictures *Life* ran showed Jones drunk, hanging on a lamppost outside the Terre Haute brothel.

Lowney Handy hinted that occasionally she was extremely close to her boarders. "I like to mother the boys," she said. "It's what writers need."

That night Jones hosted a party for some of the colony members. "Lowney's reading manuscript back at the colony," Jones said. "I got these teachers coming in. You gonna see some real action."

Rowan and I socialized with the young ladies but were more interested in Jones's behavior, specifically in watching how the stud qualities he continually broached would work out as *Life* picture coverage. We watched Jones like two of the night owls coursing the prairie outside. He went to the john twice, made a flat-out proposition to one of the teachers, was playfully rebuffed, danced a few times, and played some of his beloved Django Reinhardt guitar records. His sex score: zip!

When the other guests had gone, Jones dragged us to the kitchen table.

"I screwed the small one three times," he said, shaking his head in awe of his own performance. He leaned toward Rowan and me. "This is what I like best about parties, getting together with some buddies afterward to talk about what happened. That's why I'm never getting married. Here we are, three men of the world in our mid-thirties—let me ask you guys something. Did either one of you ever try it dog-fashion?"

Rowan and I exchanged fleeting glances speaking reams in both directions. Here was a guy obsessed with sex, who had made a fortune putting Deborah Kerr and Burt Lancaster on that famous beach making love with the tide coming in. . . . This guy who had what we judged to be a lusty writing coach. . . . And here he was asking us a kindergarten question about sex!

"What're you gonna do next?" I asked Jones before we left.

"Either go hiking along the Great Divide," he said. "Or learn skin diving in the Bahamas."

Right: James Jones hefts his manuscript of **Some Came Running** *(a $750,000 flop) for his loving mentor, Lowney Handy.*

"Could I go as photographer?" I pitched.

"Sure," said Jones.

"Would you mind if I got an assignment for us from *Sports Illustrated*?" I asked. "With an advance?"

"Better and better," he said.

I called *Sports Illustrated*'s managing editor Dick Johnston, an old friend, and put Jones on. After a few minutes Jones hung up and put his hand out. "They've already got something on the Great Divide. We're goin' to skin-diving school, buddy. Let's get some scuba stuff and charge *Sports Illustrated*."

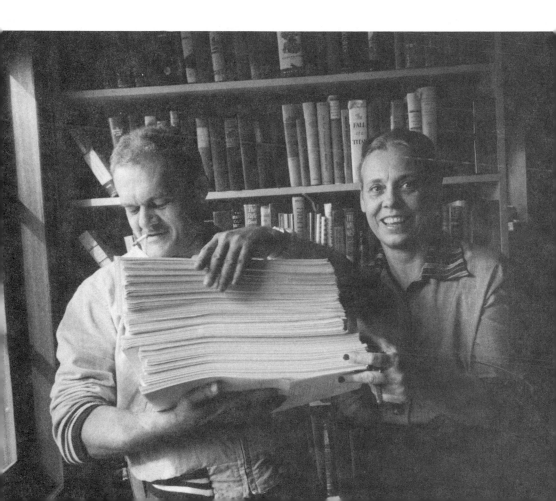

The Jones story had a strange codicil for me. Some months later Jones phoned me to say, "Hey, I met Marilyn Monroe's stand-in down in the Bahamas—Gloria Mosselino—and we got married. Now we're getting ready to move to Europe." He invited me and my wife to his farewell party on New York City's upper west side. Florence and I went to the party, which was held around an open steamer trunk that dominated the living room. Periodically Jones or Gloria would stuff something into the trunk. Adolph Green and Betty Comden sat with their little chihuahua who doggedly and (to me) disgustingly kissed both of them on their lips, begging for food morsels. The show people sang and cracked wise. Jimmy took my picture with his Polaroid and warned me if I ever got sick, to starve myself ("like Upton Sinclair taught me") until I got better, and if I got to Paris with my friends Nelson Algren and Simone de Beauvoir, to call him for a party. We could bring Sartre and Camus. Lots of alcohol flowed.

"You look like Scott and Zelda," I said as we parted.

"Yes, yes," Jones yelled. "That's who we are. Scott and Zelda." They left in the morning to live and breed in Paris. He sent me a couple of picture postcards, a manual on starving yourself into health—and I never saw them again.

Blue Cross wanted to show how their service worked in rural areas. My Blue Cross editor was a horse nut. He located a tribe of Indians living deep in the bottom of the Grand Canyon, Havasupai territory, and rented a posse of horses for himself, a U.S. Public Health Service physician, and me.

"We'll have a wonderful day riding in, a day of shooting, and another day in the saddle riding out. Great, right?" He was in horse heaven.

Right: Lunge time for Jones.

Blue Cross was paying me a thousand dollars a day, I pointed out, and it wouldn't be fair if I charged for horsing around. We compromised. The editor and the doctor mounted up for a few hours, and then my rented chopper picked us all up at the lip of a mountain and fluttered us down to the Havasupai.

Below: Nearly scraping the walls of the Grand Canyon, we helicoptered out. Right: An Indian gold-star mother proudly displays the sad memorabilia of her son, killed in action in Vietnam.

I photographed the doctor and some of his colorful patients, then, in one of the shacks, noticed this sad Indian woman. She proudly displayed the flag that had been sent back to her from her son's burial in Vietnam. She kept a JFK illustration next to it. She pointed to the backyard just out her window. "He used to swing on that swing for hours. 'I want to swing up to heaven,' he'd say. I know he's up there now. He died because he was an American, not because he was an Indian. I died inside when he died. He was my hope for my old age."

Our helicopter proved providential. We were able to take an ailing baby out for urgent surgery, our rotors practically scraping the sides of the canyon. The operation saved the baby's life.

Jack Muller was the toughest Chicago cop ever. So tough was this guy on a three-wheeler that he gleefully did what no cop dared do before: he ticketed cars belonging to aldermen, their wives, girlfriends, and well-connected businessmen on quick trips into City Hall with envelopes of cash for such worthy projects as influencing votes on zoning committees, calling off electrical and sewer inspectors in the precincts, fixing traffic tickets. Even the mayor was furious and flabbergasted. The Machine's system had broken down because of one faulty cog in the greasy wheel.

Resembling another toughie of his age, Green Bay Packer coach Vince Lombardi, Muller's unpopularity and renown grew at the same pace. Even newspapers loathe to criticize either Muller or the illegally parked aldermanic minions did reluctantly admiring features about him. Reporters and

Right: Chicago's toughest cop, Jack Muller, at work.

editors weren't the city's most circumspect parkers either, and got their
share of tickets.

Thus it was that Muller found himself transferred from his car-filled
Loop to a precinct awash in racial tension, far far south, and it fell to me to
follow him for *Life*. Looking back, Chicago's reputation for being run by Fat
Cats accustomed to municipal backscratching was suddenly at stake: a

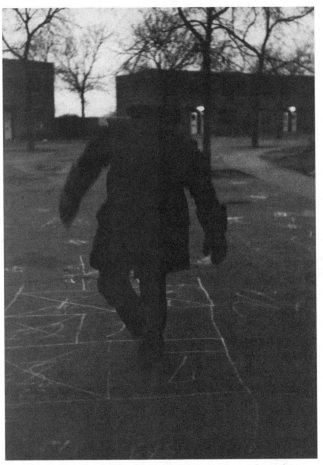

*For daring to fight City Hall, Muller was transferred to
the boonies.*

national magazine thought it was big news to find an honest cop in Chicago.

"I must be part pig," Muller once told me. "I love the squealing around City Hall."

In real life Muller had the quiet mien of a pussycat, joined kids in games on his new antipodal beat, and even enjoyed hopscotch at dawn. "It's a game with rules," he said. "So is Chicago. I obey the rules, you obey the rules. Aren't we all equal?"

In the city at that time, the answer was "No." Muller's replacements had been vetted in the system, and carefully chosen. The aldermen continued to park their limos illegally until, at the ongoing rate of one-a-year, they went to jail. But never for illegal parking.

In the 1980s the police press pass most of us were issued for our windshields replaced the fives, tens, and twenties commonly used as parking fees. These bribes made it easier to cover a fast-moving story. The favorite press parking space of Chicago journalists used to be an area outside North Central Airline's gate complex at O'Hare. It was possible to park there free for nine days! On the tenth day you'd get towed to an outlying lot—where you could do another week free, then reclaim your car with a ten-spot. I knew a *Tribune* team that did a story in Europe while parked at North Central for three weeks.

I once took my wife and two kids along on a trip down the Mississippi on the *Delta Queen*. I was shooting the story for TWA's magazine, the *Ambassador*. We drove to St. Louis and parked in the ball stadium lot across from the arch. We boarded the *Queen* at a nearby dock. Reclaiming the car after two weeks, I gave my ticket to the attendant who said, "Two dollars."

"Sorry," I said, always honest in front of my kids. "We've been here two weeks. I think I owe—"

"You telling me how to do my job? You want to talk to my supervisor? You come in Friday, you go out Saturday. Two bucks."

"Why didn't you talk to the supervisor?" said my ten-year-old son.

"Shut up," I explained.

Above: This is my favorite picture. Simone de Beauvoir liked its ambiguity and hung an autographed print. Nelson Algren and Jean-Paul Sartre each owned one. Right: Nelson Algren and de Beauvoir.

Simone de Beauvoir twice had her hair done here in Magdalena's on Ashland Avenue, a few blocks south of Algren's ten-buck-a-month bathless pad on Wabansia Street. I regret not being around at Simone's beauty sessions (where she had her hair upswirled), but I always loved, as she did, the mannequins in the window that I kept slightly soft while focusing my Leica sharply on the lady under the beat-up dryer. The mannequins are what we want to look like, the lady is who we are. Thus when anyone asks me which of my pictures defines my work, I point to this one. Well after suppertime on a cold winter night, Nelson Algren and I were driving south on Ashland Avenue when we saw this cheerily lit beauty shop. "Look at the man-

nequins," Algren said. "Simone loved the mannequins." As I raised my Leica—I still remember the setting, F:2 at 1/30, the threshold of exposure—I noticed through the fakey heads of the big-haired mannequins the wonderful Ashland Avenue face of the sixtyish neighborhood lady. Her hair wasn't visible because it was covered by a space helmet of a dryer. But there she sat, Chicago's quintessential mother, aunt, grandma, patiently being beautified in a field of la-dee-dah plastic reality. Her time against our time.

My small camera with fast lens and film, even as Daumier's "matutinal crayon" 150 years before, was born to monitor casually this area between illusion and reality.

Touring Chicago's Art Institute with Marcel Marceau, he laughed so hard he was thrown out by the guards. What was he laughing at? Some Lake Forest society ladies enjoying a 1912 Marcel Duchamp painting—long before the ascent of elephant dung—which sported a recent artist's toilet brush.

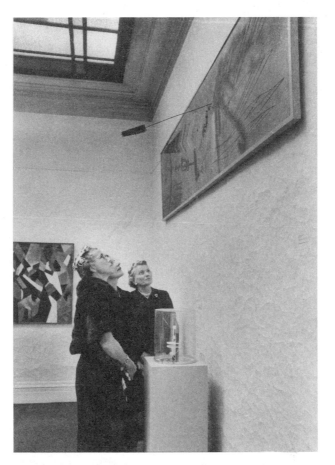

At Chicago's Art Institute, some Marcel Duchamp admirers from Lake Forest discuss the significance of the toilet brush the artist stuck into his canvas, circa 1912.
Left: The guards threw us both out for sacrilege.

You ever have woman trouble?" Mahalia Jackson asked me before her eyes teared up and she began singing.

"No," I lied.

"I got the terriblest man trouble you ever did hear—about money. That's okay. Women gets used to it. My mama did. Singing makes me feel good. You mind if I sing a spell? Money! I never expected to have enough to worry about some man stealing from me."

At home, Mahalia Jackson thrillingly sang for the Saturday Evening Post. *Left: Marceau, miming for* Life *before Seurat's famous* Sunday in the Park.

Why should I pose for *Time?*" Saul Bellow asked on the phone. "They always savage my books, don't understand my writing at all. So give me one good reason I should pose."

"*I* think your books are great," I said, "and *Time* is paying me three hundred bucks to shoot your picture."

"That's a good reason," he said. "What time?" During the shoot he bounded up and waved to a person down the hall. (His office was at the University of Chicago's Committee on Social Thought.)

"Hannah Arendt," he said. "A great lady. You should be shooting her, not me. Jewish—but she once was involved with that Nazi genius Martin Heidegger." I was so intent on the natural-light exposure that I was too distracted to draw him out. Bellow's casual remark boomeranged on me the other day, after a quarter-century or so, when I read a *New York Review of Books* piece on the weird love affair and tortured letters that passed between Arendt and Heidigger.

The Socratic notion that a school should ideally be a log, with a teacher at one end and a student at the other, becomes more impossible each semester. Yet, strolling the oak- and chestnut-graced campus of Shimer College in Mount Carroll, Illinois, with my pre-college daughter Jane I sensed the Grecian vision in the autumn-chill air of 1962, the week of the Cuban Missile crisis.

I was to spend part of the day with one of my idols Aldous Huxley, and had kept my sixteen-year-old daughter home from high school so that she could listen to one of the world's great intellects.

In President Francis J. Mullin's house the faculty was filling a half-circle of twenty chairs, the teaching staff gathering for coffee and Huxley before he addressed the student body.

"There he is!" Jane exclaimed. Huxley was tall and spare, looking precisely his sixty-eight years—the academic world's rarest adornment, a one-man institution of learning, teaching, criticism, art, philosophy, linguistics, and literature.

After winning the Nobel Prize for Literature in 1976, Saul Bellow's nominal employer, the University of Chicago, honored him with a formal dinner. His beautiful fourth wife, the Romanian mathematician Alexandra Ionesco Tuleca, stood next to him in the reception line. My Leica noticed a certain estrangement in the couple's body language. Looking at life at different angles had apparently become habitual, and shortly afterward they divorced. Of his latest book, *Ravelstein*, critics have suggested that Bellow probably modeled the bitchy character of a Hungarian scientist on Professor Tuleca.
Right: A younger Bellow at work.

So few authors are capable of describing their own creative processes, but here was a man of letters quietly answering questions about *Brave New World*'s embryos of the future bred in bottles, and his famous "savage" character found in New Mexico.

"It's a great book," Jane whispered. "This outsider has educated himself by reading Shakespeare and believes in spirituality and morality. When the big shots import him and try to use him, he goes nuts and kills himself."

"What did you have in mind writing *Brave New World*?" someone asks.

With a shy smile and his right palm covering his cataracted right eye, Huxley explained that a book had come out that year "that everyone seemed to be taking seriously but seemed preposterous to me." He'd written *Brave New World* as a rejoinder.

Before he could continue, someone interrupted with a question about Huxley's friend Ludwig Wittgenstein, and his suicide. "Suicide isn't the worst thing that can happen to a man," said Huxley.

It was then time for Huxley to address Shimer's 280 students. He spoke of his satiric vision of utopia in *Brave New World,* of people decanted from bottles, freed from the bonds of loving parents "forcing their tuition checks on institutions like this on your behalf." That got a big laugh.

Huxley made clear that he felt children receive too much analytical and rational learning that blunts their perceptions. These freeze "the amorphous iceberg of residual brain power." He recommended more serious study of the primitives and open minds toward new systems of education. He delightedly noted that the ancients had excellent ways of dealing with neuroses. Dionysian revels, wild Corybantic dances, maenadism, and other orgies, he averred, helped the Greeks dissemble their frustrations, repressions, and aggressions. A young couple irrepressibly got up and danced a few Lindy steps in the aisle.

"That's it," enthused Huxley, drawing laughter. He noted that the Makumba dancers of Brazil emerge from their squalid hovels and without "the spur of alcohol, dance wildly for hours."

Huxley's enthusiasm for drugs such as mescalin drew enthusiasm from the sometimes stoned students but stone-faces from the faculty. He spoke of concepts, symbols, and linguistics, of bringing them increasingly to campus. He spoke of distorting time for mathematicians by hypnosis or drugs so they could solve two-hour calculus problems in twenty minutes. He said he was currently taking drugs but also studying extra-sensory perception.

"He's much more open than you to new stuff," Jane said on the way out. "He doesn't throw up his hands at stupidity the way you do."

Back in the sitting room of President Mullin's home, President Kennedy's image flashed on the TV screen. Huxley watched with his good eye, his hand shielding the bad one. The events of the missile crisis would conspire to keep my picture of Huxley off the *Time* cover that week.

When the TV blab was off, Huxley walked out on the faculty who were predicting nuclear war. He stood there imperturbably watching perhaps his 25,000th evening coming on. That hardly seemed enough time to accomplish all he had done. After supper, Huxley sat in the president's recalcitrant car as it retched and retched and refused to start.

"Why don't we give him a lift to Chicago?" Jane said. I popped out of my car to offer mechanical aid to the man who in 1932 had sketched out the perils of a machine-centered society. Alas, the university car finally started. Huxley thanked me, shrugged, and splayed his palms outward, accepting momentary salvation from the hated enemy.

It fell to me one week in early 1957 to don a green surgical gown, spray my camera and lenses free of germs, and work on a *Time* cover story at the Cleveland Clinic. My subject was one of the two or three best heart surgeons in the world doing some of the first bypass surgery.

Like worshipers before a shrine from another planet, the six doctors, ten nurses, and three technicians making up the heart surgery team studied the X-ray on the wall lightbox.

"This is what we have to fix," said the surgeon.

"A tough one," the head nurse sighed. The team grimly prepared the anesthetized patient, hooking him up to myriad tubes and wires under the huge surgical lights.

The patient was thirty-one, married, father of two, and unable to work because of the impending failure of his heart. The odds were fifty-fifty that he would survive this operation and live a normal life. Without surgery the chances were he'd die within the year.

Next to me in the viewer's balcony, a beautiful nurse looking through a Zeiss binocular camera began making notes. Despite her breathing mask, her regal lines and magnificent profile and the few words she said marked her as a Scandinavian. I fell in love instantly.

"I have been to India and France for five years before coming here," she said. "There is nothing like this in the world except here. The French merely talk equipment. You have it." She touched my Nikon. "I'm surprised the Japanese beat America to this camera," she said. "You have everything here."

Would she marry a married man a head shorter than she, at least for a while? All photographers are fantasts.

She told me she was a surgical nurse for a Norwegian Lutheran Mission in northern India and had come to Cleveland for three months to study.

"Then I go back to India," she said, "to teach heart surgery. We will be doing this surgery in India within twenty years. We have wonderful engineering minds there, with little for them to do until India catches up. My lovers are both geniuses. They are building a computer. Like IBM's Enniac."

I returned to my picture taking, intensely jealous of two Indian geniuses working on a computer with an eighth the capacity of my eventual Apple

portable! We tried to make sense of the dazzling hardware, the indescribably complex and interconnected tubes, wires, and shunts, the electronics recording every aspect of the body's condition during its invasion.

A Rube Goldbergian pump, by function an artificial heart, dominated the operating room. It was monitored by the young doctor who'd invented it. It worked well on lesser laboratory mammals. This would be its first human test.

My cover subject was tall, handsome, intent, his spectacles flashing as he adjusted the overhead spots to narrow beams. He climbed up on a six-inch platform and planted his feet as carefully as a boxer plants his in the resin box. For the same reason: a slip at the wrong time could prove fatal. For several minutes, gloved hands crossed across his chest, he gazed down at the square of bare chest in front of him, his operating field. His assistants and nurses all nodded their readiness.

Thirty years after my Time *cover subject told me that surgery inside the heart would never be feasible, I photographed the first stages of my own aortic valve replacement—a pig's valve, thirteen years old as I write and, I hope, holding.*

A stainless auto collision tool held ribs and breastbone apart after a bone-cracking hour. Now the excavated lungs could be seen, rising, falling; purple water wings processing uncertain breaths. Between the lungs the heart lurched valiantly as if working to escape.

Soon the drone of technicians' voices calling out pressures, temperatures, numbers, changed from an intermittent chant to a kind of mantra backing up the surgeon who was talking into a microphone.

Two hours after the operation began, he alerted the pump gang. "On the count of three," he said tersely, "we'll stop the heart and start the pump." When the heart was stopped an air of conspiracy drifted through the room, an air of death being cheated.

"Opening the heart now," the surgeon said. As planned, I moved down to the floor of the operating room and mounted the sanitized aluminum ladder readied for me. From my new vantage point I could see the fist-sized purple-red heart still jumping reflexively in spasms. An inch with each beat. The heart is, after all, a muscle. Suddenly the surgeon gently cureted his way inside the heart, his gloved fingers palpating gingerly. An assistant held a sucking tube in position to dispossess surprised arterial blood. The surgeon speedily sewed the faulty ventricle with a C-shaped needle, pulling each stitch through with thin-lipped pliers. I remembered the surgeon's creed muttered to some students while I was shooting the legendary Minnesota surgery teacher Owen Wangenstein: "Get in fast, get out faster. The opposite of sex." Now the surgeon quickly rerouted three of the heart's surface arteries, disconnecting the heart tube by tube and reconnecting it to the patient's body. Then he administered a jolt of electricity from two flat black plates. "Don't stow the machine," he said. "We'll need it in a hurry if the heart doesn't start." He began to massage the broken heart. "It doesn't want to restart," he muttered. "It's not fighting. It wants to die." Another shock. The body lurched.

Several times the heart almost stuttered into cadence. "Like a car with too many miles," an assistant said. "Worn out." Shock. Massage, beat, beat, then nothing. Repeat.

"Put him back on the machine," the surgeon said finally. He had been on his little platform for six hours.

The electric shocks began again, the patient's body recoiling from each jolt. The anesthesiologist momentarily rested his head on the instrument table cushion, tired of holding the emergency breathing apparatus in position. The patient's hair was red, I noticed for the first time. A tough Irishman, except for his heart.

The inventor-operator of the pump called out a suggestion. "We already tried that," the surgeon said.

"How about . . . ?"

He shook his head.

For another hour the weary heart team, all nineteen of them, performed the sad last act of their surgical ballet. No one had eaten in eight hours, or could, I imagined. My own mouth was dry, and there were tears in my eyes. Hope, which had hung in the room at the start of the operation, now drooped, our own hearts sinking.

For a long time the surgeon gazed at his enemy, the human heart, wondering how it had betrayed him. Or how he'd betrayed it. He ripped off his mask and threw it away. "I have to tell his wife he's not coming off the table alive.

"Disconnect," he said.

Having delivered the death sentence he had so desperately tried to forestall, he left the operating room to find the patient's wife and two red-headed children and deliver God's verdict while they were still kneeling in the chapel praying.

Two days later I photographed the surgeon performing the same operation on a golden-haired girl of three. Everything worked. When the surgeon left the operating room he was able to tell her mother she'd be okay from now on. At lunch my reporter asked the famous doctor if surgeons would ever be able to work deep inside the heart, replacing worn-out parts instead of merely rerouting the blood flow.

"Absolutely not," he said. "There are too many nerves we'd have to cut. Unless there's an unforeseen breakthrough."

Almost thirty years from that day I lay on a surgical table myself, about to have my aortic valve replaced by one wrenched from a pig. My surgeon, Dr. Larry Michaelis, let me take pictures, as you can see above, until I was ready for the anesthetic. "Why not?" he said. "It's just routine open-heart surgery."

My long-ago state-of-the-art surgeon, *Time* cover and all, had, to my ultimate good fortune, been wrong in 1957. My breakthrough pig's valve, the only nonkosher part of my body, was twelve years old and counting this past October. This very moment it is pumping blood through my brain, imparting to you some of the observations and feelings I had that long week at the Cleveland Clinic. My valve will probably need replacement before I die, perhaps with the next new thing.

I never married the Scandinavian nurse or followed her to India. My wife is very strict. She permits me to fall in love, but that's it.

I first met Rich Bailey in a Morton Grove, Illinois, racquetball club I played at regularly with the Fruit Juices, a group of A players I formed in 1979. Bailey was a born B player and could not get into our group of fifty. We played with him once a week or so, usually to warm up, and I became his friend. He was a sweet-talking, handsome Missourian, a very young sixty with hair dyed deep black, and completely obsessed with horses and women. We thought he was talking about young women, but gradually we came to understand he was talking about older, wealthier women. He had once boasted that he'd rent a Rolls Royce, park it in the farthest reaches of the parking lot at a fine restaurant, then leave the lights on.

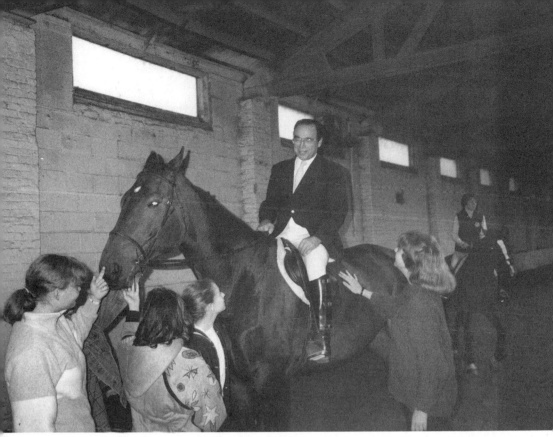

Riding high and surrounded by admirers in the 1980s, my likable racquetball friend, conman Rich Bailey, is now in prison.

When he was paged, this "owner" of the Roll Royce with its lights on would take the long walk through the restaurant, trolling for rich widows. It rarely failed.

He boasted of advertising for female company to ride in his Mercedes convertible to California, and would occasionally show snapshots—such as a tableside one of himself and actress Morgan Fairchild—telling us wild stories of their relationship that none of us believed.

He owned or rented one stable after another, conducting riding classes for kids and women, and I did a story on him for a local magazine. He didn't seem happy about my taking this picture. *Vanity Fair* did a couple of years ago when they used the picture to illustrate an extensive article accusing

Bailey of a charge we'd all heard and ignored: that years ago he had murdered his then girlfriend and horse-buying client, Helen Brach, the candy heiress who'd suddenly disappeared. The magazine implied that Bailey had murdered horses for money and had murdered Mrs. Brach when she discovered he'd overcharged her by some $80,000 for a $10,000 horse and threatened to go to the police.

An aggressive U.S. attorney got on the case, and though Mrs. Brach's body was never recovered, Bailey was convicted conspiring to commit and soliciting for murder. He is currently serving a 30 year sentence in Florida and calls me once in a while to remind me to watch a TV special about him. At least one investigative book, *Hot Mail,* and the *Vanity Fair* piece are on various Hollywood burners as movie scripts.

A few months before Eugene Thompson was to go to trial for hiring someone to kill his wife, I was sent to St. Paul, Minnesota, by the *Saturday Evening Post* to try to photograph him. Thompson was thirty-something, a short, squirrelly-looking young married lawyer, father of three, who had fallen in love, it would develop, with a bimbo. So smitten was he, that he shopped around St. Paul's small but dirty underbelly for someone to kill his wife, asking about rates and techniques. He found a would-be professional drowner and phoned him to drop over and do his thing during his wife's bath time.

All this would emerge in the trial. Thompson, out on bail, professed indignation and agreed to meet me near an outdoor phone booth in his neighborhood. Heart racing merrily, I made the meet—as we in crime said in those days, the early sixties. Gene and I, both family men, hit it off very well. I photographed him innocently golfing, innocently playing with his three kids, innocently boating with them, innocently mourning his wife at his home-

Eugene Thompson, convicted of hiring an amateur hit-man to drown his wife (mantel picture) in her bathtub.

office desk. It was hard not to like Eugene Thompson. Nabokov noted that
murderers generally have a fine writing style. I would add that this man,
accused of murder, had a life style the *Reader's Digest* might have admired
in print. Good infield thrower to his kids, too.

Weeks went by. Just before the *Saturday Evening Post* was to appear,
I suggested to *Life* that whether he was innocent or guilty, I had a pretty good
entree with Thompson and could do a story on what a guy does when he's on
trial for murder. I got the assignment, and the reporter, Paul Welch, and I
headed for St. Paul.

By then the Thompson trial was becoming big news in St. Paul, and
each time Welch and I took Gene to a good restaurant we got the celebrity
glares. It was like being in a movie. Some residents gave Gene the clenched
raised fist—keep on fighting, Gene boy. A few residents turned away mutter-
ing to their companions.

On the second day of the trial, Gene asked how our story was coming,
and how he could help us. I had been casing the trial room from the main post
office across the street. The postmaster was impressed with my *Life* press
pass and with my plan—to use my 1008 mm aerial lens, attached to a motor-
ized Nikon, to shoot from his building into the trial room. There was one
problem: the sixth-floor windows in the courtroom building were greyed out.

When I explained the problem to Gene, he said, "It's awful hot in there,
Art. I could open the window about a foot, I think. Or else—if you want I can
take your hidden briefcase camera into court with me, and kind of do a few
frames of the jury. It'd be fun."

I said, "Gene, I appreciate the offer, but I wouldn't want you to get in
trouble. Just open the window about fifteen minutes after things start."

"You're very considerate, Art," he said. "Of course I'll do the window."

So there I was in a post office storeroom, aiming at the crucial trial win-
dow across the street, when sure enough the man on trial for murder opened
the window and I got a sequence of pictures through the window—the jury
mostly.

Shot into courtroom from across the street.

This story had a trebly unhappy ending. It was scheduled for four pages in *Life,* and I was at the R.R. Donnelley printing plant in Chicago to watch it roll off the presses when all hell broke loose. JFK had just been assassinated, and the whole planned issue went down the drain. Thompson's bad luck got him sentenced to seventeen years.

It was the time of *pacheco* violence at various air bases, the first stirrings of *latino* displeasure for being treated as second-class soldiers because of their accents and dark skin. *Time* sent me to Danville, Illinois, in the late fifties to infiltrate Chanute Field, and incidentally to cover the

whorehouse influx around the populous air base. The mayor, a small, eely man, was wonderfully named G. Napoleon Hicks. I asked Napoleon why he hadn't sent his officers around to shut down the cathouses and protect the airmen from VD.

"You look like a clean-cut war veteran, son," he pontificated. "That's what all my police officers are. I just refuse to send my boys into dirty, immoral neighborhoods like where them whorehouses are and expose them to God knows what kind of filth." I captured his righteous smile on film. "Their wives would never forgive me if they got hurt or came down with the clap. Would your wife forgive you?" Napoleon refused to answer whether he'd ever taken a payoff from the local pimping fraternity. I talked him into posing with his hand in his jacket, like his itchy namesake. He guilelessly led me to a few nice houses with good lawns that bore warning signs for the soldiery, police, and camp followers looking to move up from trailers. The signs said. WARNING—THIS IS A PRIVATE RESIDENCE.

Over Dayton, Ohio, I flew with the Astronauts in training. They would run our DC-6 transports (with gym-mat insulation) up to twenty thousand feet, then nose down. We'd pull out at five thousand feet, in a body-racking arc, but then had twelve seconds of weightless flight in which the Astronauts trained and I, equally weightless, shot pictures.

It was uneventful until one of the wings started to creak at the shoulder joint, and down we came in an emergency landing.

These were not my first Astronauts. I had spent a few days with John Glenn and his wife when he was running for senator in Ohio.

He picked me up at my motel in his Chevy and said, "Running late. Gotta drop something off at my mom's." We tore off. Knowing his home-

town territory, Glenn cut through a New Concord alley to enter the main drag—and we narrowly missed getting clobbered by a pickup truck whose driver flicked his cigarette back at Glenn with an oath for being such a lousy driver.

"I'm still shaking," Glenn said a few minutes later. "Think of the headlines." "Yeah," I said, "Famous *Saturday Evening Post* Photographer Killed in Astronaut's Car. John Glenn OK."

Years later I used the same line when Illinois governor Jim Thompson and I were almost creamed by a train as we sped over a big track yard in his limo toward the State House. I was winding up the shoot when I reminded him he'd met my daughter at the DePaul Law School, and I proudly told him of her historic appearance in the U.S. Supreme Court. "Hell of a lawyer your daughter's gonna make. Already costing the state money. But she's right of course." Jane's winning plea involved the transfer of welfare funds to foster parents related by blood to the foster kids. The old law had excluded them from this support.

Astronaut floating weightlessly, as did I, in training dive and pull-out.

Non-manipulated street picture telling the life story of women.

Momentarily two glaziers rested a glass window across the narrow street where they intended to install it in a store. I had time for but one picture—the pregnant Hispanic woman walking past the brides. As she passed I shot—and only then noticed the reflection of the old woman. She was a gift. Marcel Marceau, who bought this picture to hang with his favorite French street pictures, says it reminds him of his own tableau: youth, maturity, and old age. My title: "The Three, Possibly Four Ages of Woman."

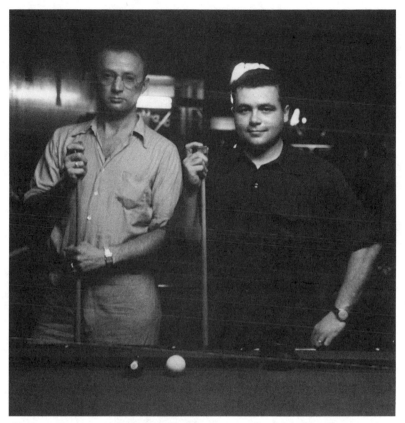

Nelson Algren and I in a pool hall—shutter tripped for me by my pal Marcel Marceau. Possibly to avoid a lawsuit, the New York Review of Books *acknowledged that their artist, David Levine, had copied my little joke—putting Nelson behind the eight ball, and his pool cue pose—and had also pirated my frontispiece portrait for a drawing. "We thought you'd be dead by now," a young editor confided.*

 I had introduced Marceau, the renowned French mime, to Algren, and they hit it off. Whenever Marcel came to Chicago we'd take him wandering with us—Maxwell Street, the Art Institute, a pool hall. There Marceau honed

his tableau "The Pool Shark" and shot the picture of Algren and me for the jacket of my picture book on Nelson.

We went to an old German restaurant, Schulien's, where they had a trunk of actors' gear. Marceau, one of the most lovable hams alive, enlisted an embarrassed Algren's aid.

I had asked Marcel how he chose his characters. He said he kept a mental notebook. *Life* gave me the go-ahead on this ill-fated story, and I followed Marceau everywhere, with him sidling up to unsuspecting prospects and mimicking them. Suddenly this wonderful Frenchman saw Seurat's *À La Grande Jatte* and began mimicking some of those immortal Sunday-in-my-park people. This garnered a few good frames and some scowls, but also got Marceau thrown out of the Art Institute.

Algren dueling with Marceau.

You have five minutes, young man," Colonel McCormick said when I finally entered his suite atop the *Chicago Tribune*. I put camera to eye.

"Wait," said the colonel, shuffling some papers. "I should be holding my new book."

"Of course," I said. It's why *Holiday* had sent me—to photograph him holding his Civil War book, *War Without Grant*.

The tall, white-haired man rose from his chair. "Did you ever hear of General George Catlett Marshall?"

"Yes," I said. "Interviewed him for *Life* in 1948. Great hero."

"I tried to name Midway Airport after him," he said.

"Tried?"

"Yes," he sighed. "Then one of my editors pointed out the damn place where I hangared my *Flying Fortress* would be known as *Marshall Field*! Wouldn't *that* traduce the people of Chicago?"

"Yes," I toadied. I shot a few not very good frames.

The colonel switched to giving me a tour of his office. "Those panels are from a palace in Holland," he said. "Over there—sixteenth-century oak." He looked at his watch. "Your five minutes are up. Be sure you look at the Nathan Hale statue downstairs in our courtyard. Great hero. Goodbye."

"Sir," I said. "My five minutes aren't up—yours are. I enjoyed examining your panels and hearing about General Marshall, but I still need you to pose with your book for five minutes."

He considered me for a moment, then laughed. "Okay," he said. "How do you want me?"

There was no time to set up a needed light, so I juxtaposed him near one of his Gothic windows, using the foldout Civil War map in his book to reflect light into his face. "Is my hair all right?" he asked. "This little barber comes up here the minute I call. He fought in my war—I forget which side."

"Your hair is fine," I lied. I loved the irrepressible tuft that thrust from his head. It was as good a metaphor for his wild streak as *Time*'s cover on

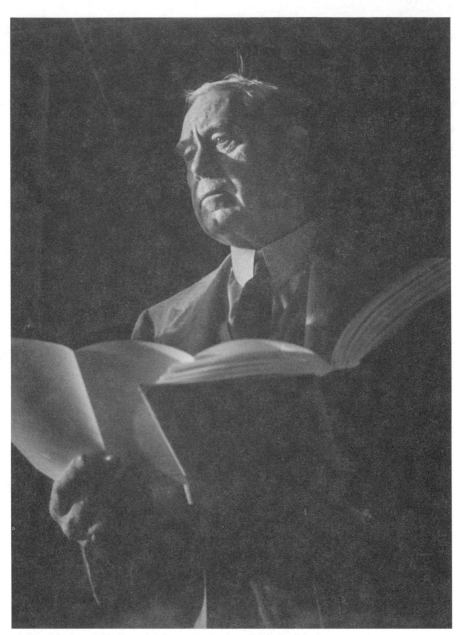

I liked Colonel McCormick's metaphoric wild tuft of hair.

him, which adorned him with a kiddy hat made of *Chicago Tribunes*. They unsubtly augmented their contempt by drawing him with a Napoleonic arm thrust into his jacket.

Downstairs there was Nathan Hale, our greatest spy, bound in British thongs hand and foot, brave eyes peering west from Michigan Avenue. It was Christmastime, and as it happened the colonel's electrical myrmidons added to Nathan Hale's indignity by hanging wires to and from him, making him look as if the *Trib* was hanging him yet again.

The morning after he died, *Life* sent me to the colonel's estate, Cantigny, to try to photograph his widow, Maryland, a veteran newshen who'd been a beauty. Before I got to the front door, the colonel's pet mastiff angrily charged me. In fright I shot one frame but dropped my camera as I retreated. From the door Maryland McCormick whooped the dog away, chuckling. "That's my first laugh as a widow," she said, inviting me in for coffee.

"Thanks. We'll pay for the camera. We're insured." No need. That World War II Rolleiflex proved as durable as the likable old newspaper baron. That one shot of his feisty dog became *Life*'s metaphoric opening page for the often-barking colonel's obit.

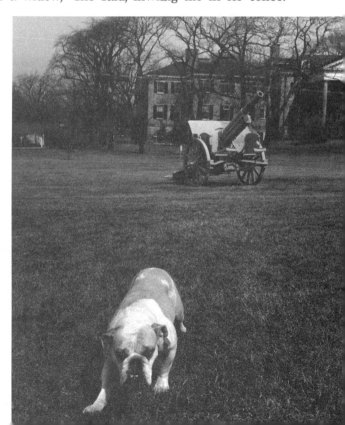

Colonel McCormick's dog charging at me at Cantigny. Life *used this as a full page, feeling that it summed up the Colonel's feisty spirit.*

It was 1965 and I was shooting Ray Kroc for *Time* in front of his very first MacDonald's in Des Plaines, Illinois. I had asked him to autograph my hamburger before I ate it, and he did, saying, "First hamburger I ever auto-

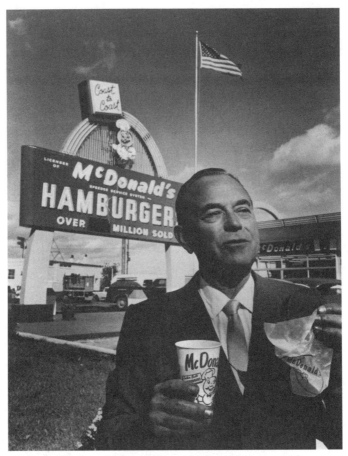

McDonald's founder Ray Kroc enjoying a burger at his very first franchise. I made photographs for McDonald's 1966 annual report, along with some artist named Norman Rockwell. Kroc, half-joking, offered me a Deerfield, Illinois, franchise for $150,000. The eventual investor paid it off in eleven months.

graphed." He laughed and snapped his fingers. "That's what we need—
imagination. Let's hire this kid for the annual report," he told his PR man.
"He's got imagination. I hope the ink isn't poisonous." "Tastes great," I
assured him.

During the 1966 hunt for Richard Speck, who'd murdered nine
Filipino nurses, there was great competition amongst the press for any pic-
tures having to do with the slayings. I had shot the carnage in the nurses'
apartment, the bloodstained nurses' hats, even a wide-angle view from
under the bed where the one survivor hid in terror.

I accompanied a detective team to the dismal Lake Calumet shores.
A rumor placed Speck there, being hidden by some homosexuals who had
a little camp to which they lured foreign seamen, sneaking off their just-
arrived tankers.

A young informant ran up. "He's coming up from the waterfront!" he
yelled, waving the police ID picture every bar in the area had.

Guns drawn, my detectives raced from the car down the waterfront
sand. Suddenly, there he was! Tall, thin, matted hair—Speck! Hands up.

There he was! Until, confusedly, he began to speak: "Vas gebt neues?"

He was a German sailor trying to find the gay group he'd met on his
last trip, the ones who gave him some American money in exchange for a
one-hour gay shoreline orgy.

"Go back to Germany, you creep!" screamed one of our detectives,
holstering his .38 Magnum.

My next stop was the coroner's office. A vain little man I talked into
"posing" in front of his morgue. I did several frames of him, then shot past
him at the bodies on the table. *Life* didn't use this picture, of course, but

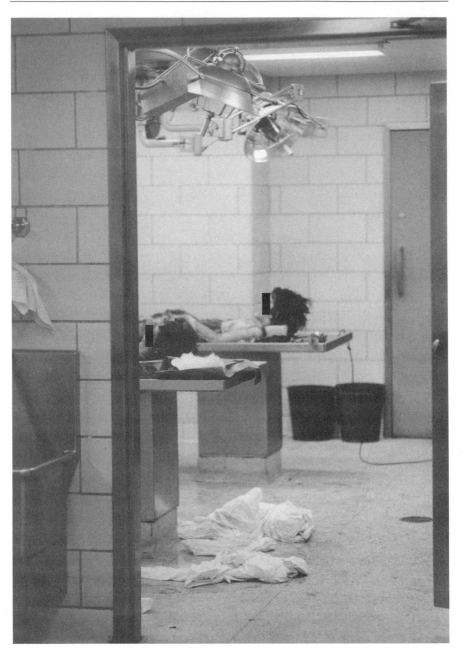

Morgue with dead nurses waiting for autopsies.

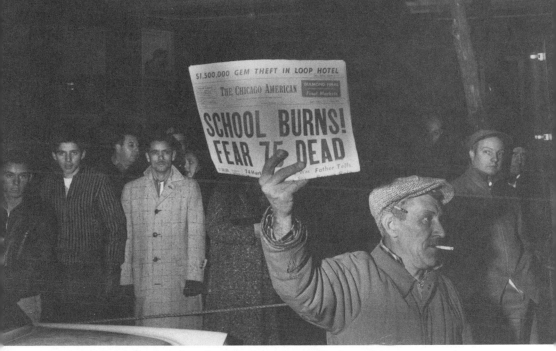

Our Lady of the Angels school fire was the saddest event I ever covered.

chose as their cover a picture I did on the fly, of the nurses' fatal door as it was being carried to the evidence lab.

For several issues this cover outsold any *Life* issue in history. Until the madman shooting from the University of Texas tower killed more than a dozen people at random. The picture of the tower shot through the bullet hole in a phone booth outsold my cover and most others until the Beatles era.

Stunned, I photographed the young parents of eight- to ten-year-olds as the equally young priest told them, "God wanted your son Michael to stand by His throne today. You will see him in all his glory when you go to

heaven." Their feisty little Mike who had raced out of their house that morning, almost forgetting his lunch.

But in their grief these parents nodded with *understanding,* with belief.

When I was a young, handsome air cadet in San Antonio, I went with the beautiful daughter of a wealthy Texas family. I was an overnight guest at their mansion, and at breakfast next morning, in what looked like a mead hall, the imperious grandmother asked:

"Mary Ann, is your young man going to church with us this morning?"

"I don't think so, Grandmama," said Mary Anne. "Mr. Shay is a Jeeeuw."

Grandmama dropped her fork. Horror crossed the mother's face. Suddenly the father rose at the head of the table and raised both his arms.

"That's all right, my boy," he pontificated, saving grace in sincere forgiveness, "our Lord was a Jeeeuw."

Mary Ann's father raised his hands, as in benediction, and forgave me for being a Jeeeuw.

I felt like Oscar Wilde's hero who'd begun life being left at Paddington Station in a handbag and thus had no family to introduce to his wealthy girl friend's clan. The mother could understand losing one parent, but *two* was unforgivable.

"I could bring the handbag," Earnest offers bleakly.

I had no handbag. My ordinary parental and religious credentials were just not commonly recognized in Texas.

Sanctimony is the backbone supporting all our prejudices. There must be a great deal of comfort in *knowing* you are right, that this knowledge will somehow survive, nay, prevail, after your death.

When our son Harmon was murdered in Florida two weeks before his twenty-first birthday, I thought back to the terrible Our Lady of the Angels school fire and I envied the distraught young Catholic couples who really believed they would be reunited with their dead little boys in heaven. My wife Florence, who had been a member of a local synagogue, resigned after our tragedy because, though she believes in God and I do not, she found no consolation in religion. Harmon lives in me all these years later. This very moment I sit in the room, in the small space in which at sixteen in 1966 he invented a computer that wrote two hundred random words of poetry, an electronic roller skate that rolled at a beam of light he shone on it, both objects winning science fairs. When the life of a loved one stops, death starts, then continues and continues and continues. In yourself.

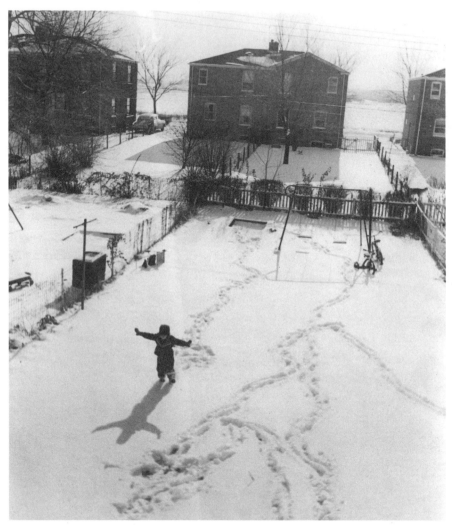

Harmon, age four, showing early signs of creativity.

A quarter of his life already over, my creative son Harmon made a design of his snowtracks and marveled at his shadow in our backyard.

Zurito rode by, a bulky equestrian statue," Hemingway wrote: "He wheeled his horse and faced him toward the toril on the far side of the ring where the bull would come out. It was strange under the arc light. He pic-ed in the hot afternoon sun for big money. He didn't like this arc-light business. He wished they would get started."

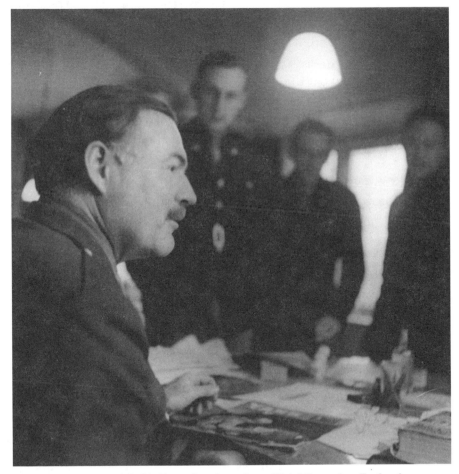

Hemingway at our 8th Air Force headquarters, High Wycombe, England.

We are in the library classroom of a great teacher, Paul Kaplan, resurrecting for us literature we may have missed, in this case "The Undefeated."

The praise my old friend Nelson Algren lavished on Chekhov, Cheever, and Hemingway sprang to mind: "The sonovabitch really puts you in the room."

Manuel, a bullfighter now past his prime, has never killed in the majors. He has been able to get this paltry booking from the crooked manager and has enlisted an old friend, Zurito, a big league picador, to help him make a showing.

Kaplan's audience includes intellectuals of seven different nationalities, all of whom have read and loved Hemingway. One Spanish lady said her sister was not Pilar, but while she briefly served as his translator, she slept with Hemingway outdoors in Spain.

Aging Manuel, most of the group agrees, is much like Arthur Miller's Willie Loman. Each great writer has chosen to make a hero of a man most of us would regard as a loser. Loman, riven by age and the diminution of his "territory," has made his living "riding on a smile and a shoeshine." A dirt stain on his hat becomes a tragedy, a scowl from a receptionist a loss of income, the inhospitality of a company Willie knew as a kid, squeezes his gut and addles his mind.

As they hoot and throw cushions and worse at Manuel, the crowd's bestiality makes an easy leap over the years, over oceans. "They" is the oppressive government to those oppressed, "they" is men to the women oppressed by them.

The codes, the rules, the forms by which Hemingway characters live are the same as our everyday lives of diurnal desperation. The straw people that lesser artists set up in lesser books and on our movie screens are patently disposable. Great writers generally model their people on humans they have known, and their creations are sinewed and veined in their own hearts. Their tears bring our tears and make them flow.

I tell you elsewhere in this album how I met Hemingway, but I didn't

mention the keen light that darted from the curious brown eyes that had established dominance over all his codes, written and lived out. When the code let him down, one guesses, or perhaps when he could no longer live it truly, like his father before him, he killed himself.

And generously remembered all of us in the bounty of his writing.

We eloped," the tall, beautiful woman said, "so I've always wanted a picture of myself in a wedding gown." Would I take it sometime?

The time came. I needed a wedding-gown model. Susanna was perfect.

She told me some of her troubles. She and her husband were of different faiths, and they'd had two of their four daughters before either set of rich grandparents could get past their indignation and visit their grandkids.

Her husband was inordinately obese and given to chasing other women. Susanna didn't mind until he became unreasonably suspicious of her, even tapping her own phone and hiring a detective to follow her. Susanna was an equestrienne, and though she was perfectly blameless—confirmed for me by her best girlfriend—her husband feared she was seeing a riding instructor.

The best friend laughed. "So this perfectly innocent wife is riding at the stable, and she sees this young, good-looking detective in a convertible peering at her.

'Why are you watching me?' she asked."

They ended up in a motel.

By the next year Susanna had become depressed with her husband's antics and his overeating. She began to overeat too. "Why should he live with a beautiful person?" she asked her girlfriend. "I'm not living with one."

When she reached 250 pounds, Susanna committed suicide.

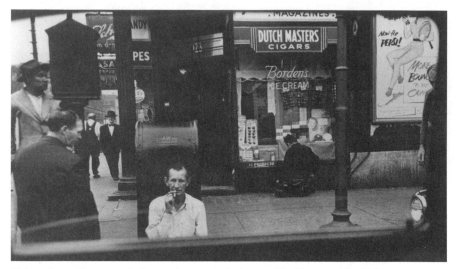

Taken from the car window on my wanderings with Algren, this Chicago street scene is among my favorite pictures.

Algren and I were back on the monotonous highway again at 6 a.m. the second day of our trip to New York. The Pennsylvania Dutch country scrolled darkly past, immaculate red and white farm stands reflected in the sunlight that was trying to break through.

Nelson said, "Like Gatsby's dark fields of the republic rolling on and on. For a country boy, Fitzgerald learned the city pretty well, the poor bastard."

In Manhattan, we stopped at the Rexall Drug store in Grand Central. Nelson rummaged on a table of remaindered books and found a dozen copies of *Chicago: City on the Make* on sale for nineteen cents.

"Let's stock up, kid," he said bitterly. "They should be worth twice as much in a year."

Algren phoned his pal Budd Schulberg from the drugstore. He gave me a triumphant aside. "I already sold one book for fifty cents," he said. "Hey Budd," he added, "they're all out of *What Makes Sammy Run?* What time'll you pick me up?

I left Nelson there, browsing, and went off to my in-laws' house in Brooklyn.

"This town keeps goin' all the time," he reported to me next day. "Great party. Joe Heller says my review of *Catch-22* made a lot of dough for him. All I called it was the best novel to come out of this or any war. . . . No lie, give or take *War and Peace.* Norman Mailer is in trouble for slapping a woman. Says all lawyers are creeps.

"Maybe I'll come east, buy a fighter, and get my own crowd of hangers-on. Everybody here wants to be a writer. Very few bother to write. They look at the blank sheet of paper in the typewriter and realize they're expected to put something down that shows how brilliant they are. We know we ain't brilliant, but—back to Fitzgerald again—we beat on, boats against the current. Something like that. Met a nice broad said she was on the brink of becoming a writer. I told her to step back. I'm seeing her tomorrow. I met this producer wants to do a musical on the [*Man with the Golden*] *Arm.* He advanced me twenty bucks in earnest money."

"One of your better deals," I said, knowing, as Nelson did, not much would come of it.

Algren fell asleep after an hour of *Long Day's Journey into Night,* and when I nudged him he whispered, "Anything happen I should know about? I been here so long I feel like a member of the family."

All the identical Howard Johnsons we passed gave Nelson an idea for a story. "A guy hits the turnpike in his Hudson Jet. At each stop, after a hundred or so miles of driving, he enters another Howard Johnson's. Buildings are the same, the same food. The same soldier trying to make time with the same waitress in every restaurant. Same kids with same lollypops. Guy keeps driving."

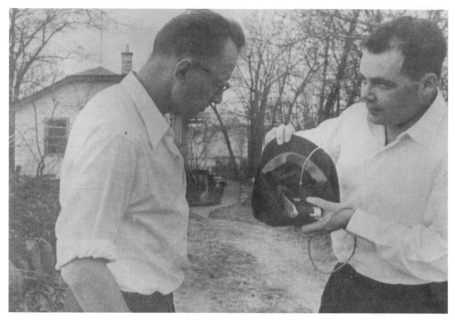

Shay demonstrating one of his hidden cameras to Algren.

Nelson, whom Hemingway blurbed was one of the two or three of our best novelists, sat there with a silly grin, maybe writing in his head.

"What's so funny?" I asked.

"When we come to the next Howard Johnson's, why don't you call Florence? Maybe we were dead before we hit the road and our ghosts—like the Flying Dutchman's on the ocean—are doomed to drive the turnpike forever."

In the acerbic colloquy between Scott Fitzgerald and Ernest Hemingway, the rich are famously characterized as different from you and me because they have more money. It's not the only difference.

If you drove the tollway east out of Chicago and looked to your right, or south, the rolling farmland near La Porte, Indiana (you remember La Porte from the last line of Charlie MacArthur's *The Front Page,* right?), turned into a small, well-groomed gentleman's farm with pleasantly vulgar giant baseball bats crossed A-frame style over a large red "A's" sign. The gentlemen farmer owning this spread (as well as the Oakland then Kansas City Athletics) was Charlie Finley, *luftmensch,* womanizer, family man, and, probably because he well remembered his early poverty, cheapskate.

While recovering from TB in a Gary hospital, insurance man Finley asked a few doctors about their own health insurance. Their vague and vapid answers gave him the idea to insure doctors against their own illness. The morning I began shooting him for the *Saturday Evening Post,* he invited me to watch the money roll in at his Chicago office. He'd added foot-high sidewalls to a Ping-Pong table, which supported the bushels of checks and cash from grateful doctors. Charlie liked to see and feel this haul before his accountants and girlfriends processed it.

While I loaded cameras, Finley fielded a call from pitcher Moe Drabowsky. Drabowsky had apparently asked for a raise. Finley started squeezing him by reading off a list of Drabowsky's walks and the crucial homers he had given up the season before. He kept winking at me as he made poor Moe sweat. "Not a penny more," he said, winking. "These guys get paid on what they did last year, not what they promise to do next year." Charlie lived to one-up the world, and so far—this was 1961—he had succeeded.

Charlie's limo waited downstairs to take us and his daughter, specially flown in from Texas, to be photographed at the Indiana spread with the rest of his brood. Charlie, his PR man, a secretary or two, our writer, and I boarded the stretch Caddie to whisk us westward. "I hope you didn't eat," he said. "Our lunch is coming from the best hot dog place in the country—this back-alley place in Gary run by this Polack or Jew, I can never tell." He took our orders—double franks, French fries, cokes.

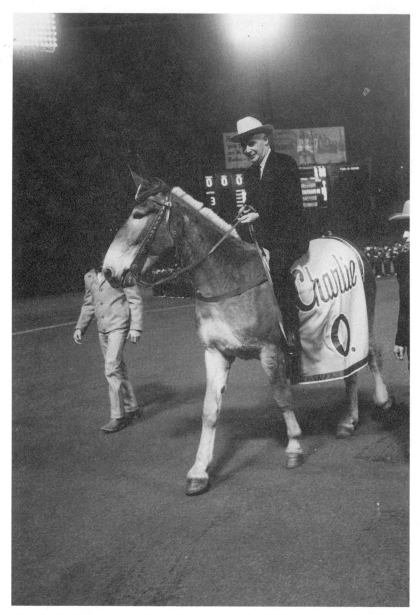

Baseball club owner and frugal maverick Charlie Finley, up on Kansas City mascot Charlie O.

As we approached downtown Gary, Charlie took over the navigation from his black chauffeur. "Two blocks to the alley. Good. Now right. Okay, just go halfway down and park." He handed the chauffeur his neatly written order. "You wanted three dogs, right?" he said. "Yes, sir," said the big man. "Now take off your jacket and put on the sweater you keep in the trunk." The driver obeyed, and Charlie handed him three twenties. "I want change this time," he said. "Don't let me forget, Arty," he said to me. "Okay, Andy," Charlie said, "Go. Don't tell the sonovabitch who all it's for."

When the driver slunk back with a brimming box, Charlie took it, began parceling out our dogs and trimmings, and said, "U-turn your way out, Andy. I don't want him to see us."

"Why not?" asked the confused writer.

Finley, family, and championship trophy.

Charlie made the kind of moue an anthropomorphic ferret might. Shrewd, secretive. "You drive up in a big car," Charlie said, "you're a mark. He'll double the charge of everything and give you yesterday's leftovers. Guy just walks in like he's from some factory around here, the owner treats him like royalty. Aren't these dogs great?"

Later the chauffeur whispered, "He knew it was from Mr. Finley, 'cause he recognized me and knew there was no tip waitin' for him. He don't mind cause Finley sends a lot of ball players here on their way back to Chicago from his parties if they complain they're still hungry."

Next morning Finley and I were standing at the American Airlines ticket counter at O'Hare buying tickets to Florida. I was going to shoot him at his training camp. He moved me ahead of him in the line, and when I put my credit card down, he said to the clerk: Put my fare on his card too—the *Saturday Evening Post* asked for this picture, right?"

I bridled. "C'mon Charlie, the *Post* is having a hard time, so I can't put you on my expense account. I'm not asking you to buy my ticket, just your own. $175 round trip. One of those doctor checks on your Ping-Pong table."

He laughed. "Okay, you win. And don't tell the writer I'm cheap—I'm frugal. I grew up poor, like you. To show I don't have any hard feelings, I'll pay for your breakfast on the plane—you can get dinner in Sarasota."

Years later, shooting for *Sports Illustrated*, I was covering a Finley project at the Kansas City Stadium—a zoo for kids, behind the stands. One of his proudest displays was the eponymous mule "Charlie," who was permitted to cavort in the outfield before the game, led by Charlie Finley in white sombrero. I couldn't resist angling around to make a picture of Finley orating just over the mule's hindquarters. I gave it to him for Christmas and he hung it in his office, scrawling a title under it: "Two of a Kind."

Nobelist Gunter Grass's book *My Century* saw the first postwar year, 1945, through the eyes of a woman working to clear the rubble. Such a woman, I think, was our first live-in maid. I'll call her Sylvia. She was a can-do national resource whom Guatemala carelessly let emigrate. I don't know what was wrong with male-dominated Guatemala, but Sylvia could have fixed it.

A quarter of a century ago, this bouncy, attractive lady with a year or so of high school fell in love with the small Kaypro computer I'd installed as a slight improvement over my IBM Selectric typewriter. On her own time Sylvia learned to type English on the Selectric, and the moment the Kaypro seemed obsolete to me, she insisted on giving me $25 for it. She mastered it in a month, the way she learned to drive on my 130,000-mile Subaru, which she promptly bought.

Today Sylvia drives a new Lexus and employs five computer teachers in her school for ambitious immigrants. Movies have been made about lesser women.

The day Sylvia read about the Valdez, Alaska, oil spill, she asked me how to call the White House. "I told a public affairs lady there I understood the problem—a man drinks a little and something spills. The best way to clean up oil stains," she told her, "is with clean rags or good-quality newspaper."

Billionaire Henry Crown and I hit it off very well when I was shooting him for *Fortune*. He was proud of his Material Services Corporation's fleet of red and yellow cement trucks. He suggested I pose him in front of one of his company's projects along the Chicago River. "So you can get the Loop in the background. I love this town. New York's okay, but this is my city."

My son Dick, along on the shoot as my helper, said, "If *I* owned the Empire State Building, I'd love New York."

Crown laughed and made a note to send him a free pass to the roof.

A few days later Crown and I were crossing La Salle Street en route to the First National Bank office of the redoubtable Edward Eagle Brown.

"He looks like Wallace Beery," Crown said, "but don't let that throw you off. He's much tougher. Wait'll you see his Gay Nineties spittoon! Be gentle with him, I owe him twenty million bucks."

Not only did I see the spittoon, but while moving around with my Leica trying to include it in my picture of the men, I kicked it. The three of us froze as the brown effluvium of expensive Cuban cigars rocked back and forth, within a quarter-inch of spilling. Thankfully it subsided.

"I got a deeper one at home," Brown said. "My record is hitting it from eight feet."

It had taken Crown and his minions a long time—five months—to approve *Fortune*'s request that I follow him with my camera. He really didn't want his finances combed out in a business magazine. Stealth was part of his genius, and so was low-profile modesty. Unspoken, I knew, was the fear that all billionaires have for the safety of their children and grandchildren. For this reason he would not pose with his grandchildren. At that time he was developing General Dynamics into a profitable defense powerhouse, and he also owned 20 percent of the Hilton chain via a handshake deal with his old pal, Conrad Hilton.

When the *Fortune* story appeared, Henry Crown saw that perhaps a quarter of it was unflattering, that the writer had dug a little too deeply and unfairly into the political sand on which Crown's fortune had flourished. So he fired the PR outfit that had falsely claimed it had persuaded *Fortune* to cover him. I think the PR firm also lost the Hilton account in an echo of solidarity by Connie Hilton with his dear friend Henry. They both lived to be

Right: Billionaire Henry Crown owned about a quarter of the Hilton Hotel chain—one Chicago link behind him.

nearly a hundred—alert, family-loving, generous, and feisty to the end.

Crown and Nathan Cummings, the founder-president of Consolidated Foods (and a world-class art collector), used to play gin rummy for nickels and dimes every Sunday in a Drake Hotel room. How do I know this? I had shot Consolidated for *Fortune* and had been tapped by Consolidated's PR people to do their annual report. This took me to all of their divisions, mostly food subsidiaries, but in Wisconsin I photographed the Kirsch Venetian Blind Company. I asked the Kirsch president how his company ended up as a Consolidated Foods unit. "Funny," he said. "I had an appointment to pitch this company to Mr. Crown. He called to change it from Tuesday to Sunday and said, 'Okay, come up to room so-and-so in the Drake. I'll be playing gin, but you can talk to me there for a few minutes.' There was Mr. Crown and Nathan Cummings of Consolidated, who I think was winning lots of nickels judging from his stack. I was in awe, but I rattled off business plans—numbers, production figures, earnings, etc. Mr. Crown listened while he played on, and said, 'How much?' I said, 'Eighteen million.' Crown thought for a minute, then said, 'I pass. Sorry.'"

So Mr. Cummings, still fanning out his cards and very impatient to get on with his game, looks up at me and puts out his hand. "Okay, son," he says, "I'll take it." To Crown he says, "You got any points for me in that hand, Henry?"

Crown on job site with Material Service execs. He also owned the Empire State Building and General Dynamics. Once he agreed to pose for Fortune, *he was an unpretentious subject.*

Fade in: A summer twilight in 1961.

A thoroughly rebuilt and detailed white 1951 Henry J is wheeling through Mitchell, South Dakota. It's gliding down the main drag, past the Corn Palace—its yellow architectural husks gleaming—and heading for the twin-screened Lakeview Drive-In. A tall, hunky high school kid, Randy Herr, Mitchell High's acknowledged car nut of nuts, is behind the wheel of the car, one of the forty thousand or so Henry Js built by shipbuilder Henry J. Kaiser just after World War II. In his scrapbook, Randy has collected ads from *Life* magazine featuring George Burns and Gracie Allen driving their Henry J through Beverly Hills—"Car of the Stars."

Next to Randy is his girlfriend Kate, who lovingly holds the top of his hand as he teaches her the H shift moves....

Randy Herr is fifty now, and still a car fanatic. So is his wife Betty. He has long been a Glenview, Illinois, postman but likes to think back to his high school days. He eagerly shows visitors a snapshot of himself at sixteen, behind the wheel, and recalls that first drive-in trip in his rebuilt Henry J. "One screen had *The Hustler* with Paul Newman and Jackie Gleason," he says. "And the other showed *Judgment at Nuremberg* with Spencer Tracy, Burt Lancaster, Montgomery Clift, and even Judy Garland." But Randy— and several hundred other hot-rodders parked in other movie pews—has few solid memories of the famous pool match between Newman and Gleason, or the surprisingly electric performance of Garland.

"We were all too busy making out," he says. "You know, in the minor kiss-kiss country style of those days. Also, when it began to rain a little, I was busy checking for leaks. There were none! I was so proud!"...

Fade in, 1963.

Randy Herr is sadly driving his Henry J from his father's service station to Ronnie Bollock's new auto salvage yard at the edge of Mitchell. "It was one of Ronnie's first five cars," Randy recalls. "But the only Henry J, of course." Shrewd Bollock circles the perfectly conditioned car with only fif-

teen thousand country miles on it. He then offers Randy a ten and fifteen singles—$25. This at a time when gasoline was thirty cents a gallon and Sears was selling the Henry J in its catalog at $900.

"If that's all it's worth, I guess I'll have to take it," the kid says to the junkman. Ronnie drives Randy home in an old Chevy, sensing that a farewell ride in the Henry J would be too emotional for someone going off to Vietnam, leaving behind his family as well as his car. Besides, Ronnie was planning to save the car for his own kid, then in kindergarten....

The calendar pages fly. Randy returns from the war. He marries a woman named Betty, comes to Glenview, and dons a Glenview postman's uniform.

In 1989 Randy and Betty look up from the twelve-car garage they own in another suburb. It's where they restore cars, mostly 1957 Chevys. One day they pack their new pickup with provender and clothes and head north and west, bound for Ronnie's boyhood home, 620 miles away. "He spoke so much about Mitchell," says Betty, a concrete contractor. "I just had to see it."

The pickup arrives in Mitchell. It drives past the corny Corn Palace. "Let's head out to Ronnie's Salvage," Randy says. "He's got over a thousand cars in his field now. I'll show you where I sold him my Henry J."

"I don't have any kids," Betty says, "but Randy has two from a previous marriage, so I think I know how he feels about that old car. It's family, don't you know."

Randy heads the pickup down one of the rows of the car carcasses rustily arrayed in Ronnie's Salvage yard. "We were really looking for a '57 Chevy, as we always do," says Betty, the family detailer, finger rubber, and spot-paint toothbrush wielder. "Good God!" Randy exclaims. "It's my high school car!"

Ronnie arrives at the scene, and he and Randy start haggling. "Ronnie wants $500 for the surprisingly unrusted corpse," says Randy. "Only the floorboards are rusted out, minor rust on the body. The radiator, heater, and horn button have been cannibalized." A deal is struck, sort of. "When I show

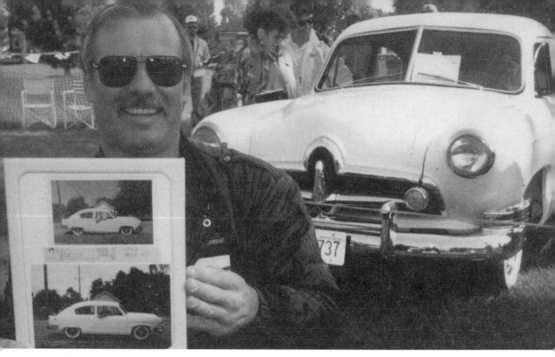

Randy and Henry J.

up for it with a tow truck," Randy says, "Ronnie raises the price to $800. I back off—just poker playing, of course—and he caves in."

Back home, the Herrs begin a three year labor of love and money. The car's body frame is completely honed down and chemically dipped by a rechroming company in Minnesota. Brakes and carburetors are rebuilt in Evanston, Illinois. There's a paint job at a restoration nexus in Wisconsin. A regenerated motor—one of the rare six-cylinder flatheads, most of the Henry Js having been born with fours—is found at Napa in Glenview. Randy and Betty are making out checks—$18,257 total.

"Not too bad," Randy says. "I've seen one or two not this well detailed go at auction for $15,000."

"I really got into it with the detailing," Betty says. "Those fuzzy dice are vintage, but I cleaned 'em like new. You know, cars have personalities, like people."

The Herrs give all of their restored cars ghostly names: Casper, Spooky, Wendy the Wicked Witch. Their newest restoration, a turquoise 1949 Chevy truck, is called Boo! They have yet to provide a name for their Henry J.

Snapshots

My hero and slight acquaintance Ernest Hemingway quoted his lamentably executed friend Garcia Lorca (shot in the ass for being gay by murderous homophobic police) for the theme of *Death in the Afternoon,* Hemingway's paean to bullfighting: "The only beast in the arena is the crowd."

An old Greco-Roman tradition. Thumbs up, thumbs down, life or death at the beast's whim. Or not always so fateful.

When the ancient Egyptian lawmakers had a serious problem to consider, they deployed themselves at a long table and sat a mummy at the head of it. The mummy had two functions.

1. He represented the people.

2. He reminded the lawmakers that they were human and would themselves die some day.

When the citizens complained of harsh laws, of hunger, oppression, and rule by whim, they were advised to shut up or tell it to the Sphinx. After all, they were represented by counsel at the meeting, and he had voiced no objection. The mummy had stayed mum.

But in real life people speak with their feet. As JFK once boasted to Khrushchev, "We've never had to build a wall to keep our people from leaving."

Once in a Vegas gambling hall, the hotel PR lady announced: We have a *Saturday Evening Post* photographer up on that ladder to shoot a nice picture of our casino. If anyone doesn't want to be in the picture for any reason, please walk away from your table and go over there. There was near pandemonium as fully half the gamblers and their girl friends left in a hurry.

But another horde moved in from other areas to squeeze into the picture. When I took down my big strobes and tripod, the crowds reformed in

the original pattern—mostly gamblers and tourists married to other people, here for monkey business with their special friends.

Sam Starr, the cigar-chomping Chicago lawyer who founded Divorcees Anonymous, looked like a Jewish Lyndon Johnson. He couldn't have been happier that Francis Miller, *Life* photographer, and I, his fledgling luncheon reporter, were about to blow his organization's cover.

"These women want to remain private," he said, "so you can't take their pictures. You can come to our monthly luncheon, but no pictures. The discussion subject will be 'Getting a New Husband.'"

My original story suggestion had emphasized the solidarity of perhaps a hundred divorcees and how they helped still-married women who were having marital problems. "The calls come through my office," Sam said. "A woman finds out her husband has been sleeping with his secretary during lunch hour, or with her best friend while she's out shopping. What should they do? Get a divorce? Get a lawyer? Retaliate? What?"

A beatific smile beamed across the Johnsonian pan. "I give them the name of a client of mine with a similar problem—who did get a divorce—and the one calls the other and the other usually tries to counsel her out of a divorce."

"And if she can't?"

"Well, frankly, she becomes another client. It's great for my divorce business. Don't put that in the story, Art. People would get the wrong idea. I could not in good conscience recommend such a troubled woman to another lawyer when I'm the best in the city, could I? That's what I'm here for. To help."

Our much-divorced editors in New York loved the story. To them Chicago was merely New York cut out of *Reader's Digest* patterns, pieced

together by Norman Rockwell. Still, the thirty women who would be at the luncheon meeting didn't want their pictures in *Life*.

I had an idea, the ladies and Sam agreed to it, and Miller got a full-page picture of Sam standing amidst tables filled with well-dressed anonymous divorcees—still anonymous because we posed them holding napkins in front of their faces.

I wrote down their tales of middle-of-the-night phone calls from weeping wives, threats of suicide mollified, strategies to find out just how much dough the bastard was hiding—and membership boomed.

"What's the best thing you learned from all this besides getting so many new clients, Sam?" A young reporter's question.

"My boy," he said. "Most of these anonymous divorcees have the same big problem, which is why they try to talk other women with lousy marriages out of getting divorced."

Pen poised over pad, I persisted: "And you learned?"

He leaned close to my ear. "People should think more carefully—with their heads—before getting married. Especially the second time. You know any single guys? They all want to remarry. Wait a minute, you'll see."

Four or five of the women unmasked themselves and handed us their place cards with scrawled names and phone numbers. Too bad we couldn't buy stock in Sam's law business, which boomed until the anonymity and male prejudice in the courts largely dropped out of divorce a few years later.

Parents and grandparents send kids to school these days with unspoken fears and secret goodbyes largely unknown three decades ago. There were always fears, of course. Some of these have become today's horrors.

Dakota schoolhouse.

In the now forgotten era of Orwell's *1984,* but long before that year—1957 in fact—the teenaged daughter of a Hitler refugee family, friends of mine, came home shaken, her dream of America in sudden tatters because a teacher in her beloved new country had violated her right to a secret ballot. Her mother, a German psychiatrist of some fame then practicing in Chicago, called me for advice. I investigated and wrote about it for a local paper:

An important lesson in citizenship was taught in Des Plaines last week.

A fourteen-year-old candidate for president of the Student Council of Thacker Junior High School—I'll call him Jim—thought he had a campaign gimmick—a slice of gum mounted on a "Stick with Jim" card.

Jim's teacher, an older, autocratic woman—I'll call her Mrs. Emily Hopps—disagreed.

She charged Jim with breaking the school's anti-gum law and being tardy with math assignments, and promptly embarked on a lightning cam-

In my kids' Deerfield school.

paign to cost him votes among the electorate of 360 teenagers who passed through her room each day.

My friend's daughter came home in tears. "Isn't school supposed to be a democracy too?" she asked her mother. "Isn't there a law here that says you can vote for anyone you want?"

"Of course," calmed the mother. "What happened?"

"We have this election coming up Friday," she sniffed. "A lot of us want to vote for Jim—but Mrs. Hopps said if she found out that any of us voted for him she'd lower our grades and put us on her blacklist. Then she rapped her ruler on the desk to show she meant business. We were frightened."

"She did? Really?" said the surprised mom.

"Yes," the girl said. "Mrs. Hopps says Jim isn't worthy of office and if elected she'll get him kicked out. She has a better candidate she wants us to vote for."

That's when the mother called me. It took some twenty phone calls to check the facts. From several sources I affirmed that:

Mrs. Hopps made several warnings to different classes, then asked ominously, "Now that you know the truth, how many of you are still going to vote for Jim? Raise your hands."

In one class which had given every indication of swinging to Jim, only one pupil raised his hand. "You especially shouldn't be voting for Jim," Mrs. Hopps said. "Your math grades are no better than his." (A C average— Jim's—is mandatory for candidacy).

"The rest of us chickened out," one girl told me. "We were scared. Good grades are important to us. We all want to go on to high school and college."

Answering Mrs. Hopps's poll of another class, ten students bravely raised their hands.

"I'm disgusted with you," said their teacher, taking names.

Hearing of Mrs. Hopps's campaign against him, Jim returned from lunch last Tuesday with a pile of handbills made for him by his mother. They said: Vote against Hopps, Vote for the Tops—Jim."

That evening Jim received a call from Principal Phillip Jacobson. "You can't campaign against a teacher, Jim."

"But she's campaigning against me, sir."

"That's different."

I reached the principal on the phone. I told him I was planning to cover the story for *Life* magazine. I had leaked this intelligence to a sympathetic teacher, who had apparently told the principal. "How's the election shaping up?" I asked.

"It's all over," he said triumphantly. "I moved it up to this morning to

prevent a popularity contest between a student and a teacher." Could Winston Churchill or Solomon have done better?

Election returns showed that Jim had been beaten 153–117 by Mrs. Hopps's candidate, an exemplary young woman. A third candidate received 49 votes.

Said one voter: "Lots of us were scared to vote for Jim because of Mrs. Hopps's threats. We want to hit high school with clean records in math."

Another voter disagreed. "I think Jim got more votes than he would've got ordinarily. Lots of kids voted against Mrs. Hopps, not for Jim. I think he would've got beat by more votes if she hadn't interfered."

Still another commented: "I don't know why everyone is so excited by this. Mrs. Hopps always says things like 'This classroom is not a democracy. It's a dictatorship. And I'm the dictator.'"

Moving swiftly, hoping to keep *Life* from coming in, the principal insisted that Mrs. Hopps apologize to Jim and his mother, to her fellow teachers, and to the school superintendent. He circulated a bulletin advising teachers to stay out of student politics. (No other Thacker teacher had ever needed such a reminder.)

Assistant Superintendent Gilbert Rudiger said, "We always felt school elections were a wonderful way to teach how the American election process works. If they vote for a candidate who turns out bad, they're stuck with him or her and next time will know better."

Learning that Mrs. Hopps was preparing under pressure to apologize to Jim and his mother, one student told her mother, "That's nothing. Last year Mrs. Hopps apologized to the two candidates she helped lick. Apologies don't mean anything without action, do they?"

"The important thing," her mother says, "is this year she learned her lesson."

I was the still-picture photographer for the ABC network covering the Montreal Olympics in 1976, and after the murders at the 1972 Munich Olympiad, worldwide security was tense. Unmounted, the Royal Canadian Police are kind of futile. I saw one keep a high school girl in her proper ticket lane brandishing his machine gun. Another armed crew, guarding Queen Elizabeth, walked her past fifty of us photogs under the grandstands where we kept the big black cases for our telephoto lenses, and then escorted her back after she applauded a few events. *Then* they returned without HRH, and inspected each one of our cases for bombs! (The same RCMP that had recently arrested a uniformed American for cruelty to animals when his batting practice liner killed a seagull!) I suppose a comic novelist like Evelyn Waugh might have done the entire Canadian experience to a turn, in the style of his wonderful comedy of errors, *Scoop.*

Almost a year before the swimming meets, posh pools all over the country were conducting Olympic tryouts with ABC covering some of them. I was assigned to the outdoor high-diving championships at Park Ridge, Illinois.

Problem: to get your press credentials you had to go up a long stairway in the fieldhouse to the Olympic office. Two guards stood at the foot of the stairway.

"No one goes upstairs until the event is over," said one, patting his .38. "Them is my orders."

Orders that had to be countermanded by two international phone calls.

Three weeks before the Olympics, ABC flew their entire team into Montreal for acclimatization. Howard Cosell, O. J. Simpson, Mark Spitz, me.

At a Sunday morning breakfast for the press, each of us was assigned a table, to bond with various members of the press. Swimmer Mark Spitz, two East Coast sportswriters, and I were at the same little table.

Sportswriter: "What's new in California, Mark?"

Spitz: "They've just lowered the speed limit. It's awful."

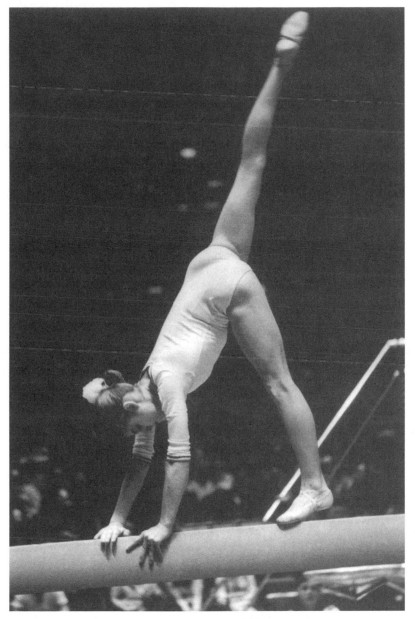

On the beam at the Montreal Olympics, 1976.

Sportswriter: "What's awful?"

Looking earnestly at these sharpies who had their notebooks poised for this super-gold medalist of the previous Olympics, Spitz said: "With this new law, a lot of the old people who would've been killed driving fast now go on living. And there's already too many older people in California."

As the boys scribbled, I broke in: "Oh, that's Mark Spitz for you, always putting the press on. . . . C'mon Mark, let these guys enjoy their breakfast. Tell 'em about your comeback . . ." To the reporters I said, "Mark tried to work this gag yesterday, and this guy from Chicago almost printed it. . . ."

Mark looked a little confused but laughed nervously. My boss on the project, Rick Giacalone, also responsible for PR, thanked me profusely, saying, "He's gotta be one of the dumbest Jewish athletes I ever met."

A few days later we were all standing in the lobby of the St. Bonaventure, checking out. Spitz went up and down the line, asking O.J., Cosell, and two or three others: "If I keep this Canadian money—I've got about twenty bucks worth—and take it back to the States, then come back here in three weeks, will I have to pay duty or anything?" Even O.J. shook his head.

You might think that illustrating psychiatrist David Reuben's bestseller, *Everything You Always Wanted to Know About Sex* (*But Were Afraid to Ask)* was a lot of fun. It wasn't. The book had but one picture—my jacket portrait of Dave. It answered people at cocktail parties who asked, "What kind of pictures do you take?"

Harder to fool was Hugh Hefner, who tried to steal a name or two from my little black book.

What he wanted to know was some behind-the-scenes dirt about the sex experts Masters and Johnson, whom I had shot for a *Time* cover.

"It was like this, Hugh . . ." I told Hef, who's had this thing about sex for years. . . .

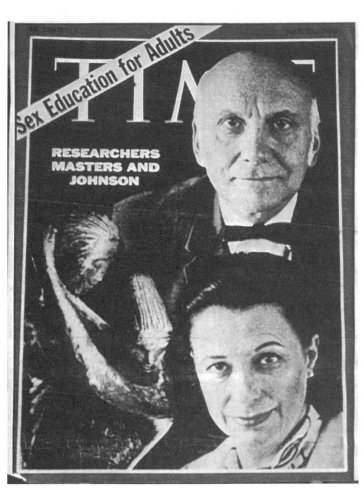

Time *cover: Masters and Johnson.*

Above: Hefner demonstrating a vibrator to bunnies. Right: Hefner looking over my shoulder at my address book.

Bill Masters picked me up at the airport in his white clunker. He's a toughly built little guy in his mid-fifties—and I was in my mid-thirties at the time. He grilled me on the timing of his and Ms. Johnson's cover—then his questions turned to sex.

How often did I? Number of partners? Their sex? Group sex? Suburban mores?

"Am I going to be in your next book?" I asked. "No," he said. "I just happen to be interested in people's sex lives. It's my field."

At their clinic I photographed the famous couple walking through their clinic's garden, hand in hand. "We're in love," Masters said. They planned to marry as soon as his divorce came through. Next day, working through glass and promising not to show faces, I photographed one of the team's woman

Hefner at his bedroom desk in 1964. To my great surprise, the National Portrait Gallery curator loved this picture, and it now hangs in Washington—near one I did of Leo Durocher, and a Time cover from my picture of Vince Lombardi.

sex therapists at work on a male patient. Pictures a family magazine could not use, of course.

I did learn that the white female's body turns a lovely shade pinker during orgasm. Then it fades. "White skin, red skin, not much of a picture," my editor said.

Masters took me back to the airport, Johnson waved goodbye. The cover was well received. Somewhere I have a souvenir snapshot of me "lecturing" to the couple on sex. I heard that Masters and Johnson later married. I'm sure they did everything right.

Time had an inordinate interest in psychiatry, possibly because so many of the editors were on the couch trying to resolve the dilemma of settling for big, safe corporate bucks instead of writing the great American novel.

I took my seat in the front row—Leica in hand, no flash necessary with the new fast Tri-X film—in a room full of a hundred young business executives who had come to hear William Menninger, of Topeka's famed Menninger Clinic, tell them how to advance their corporate careers. The key was to delegate authority to assistants and not permit minor distractions to distract their attention to details.

About ten minutes into the lecture, operating as gently as a master dentist, I made three discreet exposures. (The Leica shutter and film wind are among the quietest in the world.)

Suddenly Menninger pounded both his heavy hands on the lectern, then pointed to me and shouted: "MUST YOU KEEP *DOING* THAT?"

I shook my head and did a Groucho stride out the door. The audience gasped. As I hunkered down behind the last row, I could hear the great psychologist say, "That is what I mean. You must get rid of minor disturbances."

Nothing without great labor," was the motto of Brooklyn College, which I attended for a year before becoming a World War II flyboy. I thought of the motto while watching a dozen Kikuyu work for our safari for $6 a month in 1956. They sent most of their money back to their families near Nairobi.

After two weeks in the bush, our entire safari company, led by Chicago zoo man Marlin Perkins, our kindly, white-haired "fearless leader"

The greatest animal catcher in East Africa, Willie de Beer (wearing hat), and his crew capture a young bull giraffe for an Ohio zoo on the plains of what was then Tanganyika.

known to millions of kids through his weekly "Zoo Parade" program (we were in Africa to shoot nine shows), emerged at Arusha, a small supply and waystation for safaris. It had a fine inn run by a daughter-in-law of Ernest Hemingway.

It had started to rain as eight or ten of us followed Perkins into the inn for Pimms Cup, two sundowners, a bath, and a fine dinner. Our Kikuyu could not enter the hotel, of course. They sat down quietly at the bottom of the stone steps, their backs to the wall being warmed by the sun's heat stored up during the stifling day. Hands around knees, they smoked, spoke quietly, and began going to sleep. The rain grew more insistent. I asked the chief Kikuyu how much it would cost for his boys to find a place to sleep "under tin," as the expression went.

"One shilling each man, sahib," he said.

I started reaching in my wallet for several pound notes. A strong hand reached for my wrist and stopped it. It was Marlin Perkins.

"Why do you liberals always want to change the system?" he said. "The British have run this place a hundred years without your help, and nobody has complained. Put your money away."

"What if they were animals at the Lincoln Park Zoo?" I asked Marlin angrily. "You'd give them shelter, wouldn't you?"

"This is different," he hissed. "These people came out of their tribes to work for the white man."

"For six bucks a month?"

"It's what they're worth on the market here. No Jew liberal is going to change it overnight!"

The young writer on the show, Dorothy Ruddell, pulled me away. "Calm down," she advised. "We've got seven more movies to make."

I came back at midnight and gave the bearers—who had carried my camera equipment for two weeks—three pounds, and they hastened off to sleep under tin.

In the morning Perkins said, "I'm sorry I lost my temper last night."

"Me too," I lied.

It wouldn't be so bad if people would order them in normal proportions," says master baker Bill Hoffman ruefully, shaking his floured head. "What these rich Yuppies really want," he continues in a yeasty whisper that keeps his words secret from the nine other customers at the French Pastry Shop in Chicago, "are giant penises and tremendous breasts. Distortions of the human condition."

Morality and psychology aside, these playful predilections raise tremendous baking problems when you're knocking out sixteen-inch cakes famous for being tasty. "This Women's Lib thing," says Bill (we're now in 1974) "is hitting the cake business too. About half the orders we get now are from executive women who want outsized male nudity. One nervous wreck, a lady shrink from a psychoanalytic institute, says, 'Women are just getting even for the sick male interest in big tits and nipples. Like mother used to have, probably.'"

He waves a baker's oar impotently at a failed thirteen-inch butter-cream penis, disjointed at the glans, and does some hasty surgery.

For forty years this French Pastry Shop was the Chicago Gold Coast's classiest straight bakery. In 1971 it started providing porncakes on special order. Biggest client? The *Playboy* magazine staff nearby. Hugh Hefner, proprietor and steady patron.

"Bill is really an artist," says Bill's jolly wife and partner Karen, who looks as if she just emerged from a Breughel bakery, paddle and all. "He's the Picasso of porncakes. It's about time women got some treats too."

The inscriptions on these cakes catch the spirit: "May your cups runneth over"—for a Bali Bra executive's boob cake. A vasectomy party cake recently delivered was inscribed, "Come, Come, Donald Gerson, You Can't Kid Me Any More." A hopeful divorcee's decree-celebration cake, three-testicled for some reason, said, "Have a ball on me, Stu." A rabbi's gift to his retiring *mohl* (circumciser) friend: "You Can Still Cut It with *Our* Board of Directors, Peter."

In true modesty, Hoffman says, "There's really nothing on canvas or in sculpture at the Art Institute that I couldn't do in cake—given the time, and of course the art patron. If they wanted bigger I could do it in sections. Details. Mr. Hefner stopped by a month ago and said my stuff had a lot more to do with real life than half the sculptures in the Art Institute."

I tell him the story of Jean Vieve, the master chef-baker at a Paris restaurant a hundred years ago, who honored the hungry Alexandre

Dumases, *père* and *fils,* and a party of Left Bank artists with a gorgeous meat and vegetable omelette. It was so beautiful the famished guests refused to eat it, applauding their fellow artist and framing his steaming production as the work of art it was. The restaurateur gave it a place of honor on the wall, alongside the creations of other early Impressionists, until it moldered a year later.

"Happens to me about once a month," Hoffman says. "Clients tell me about setting my work out, the guests admiring it—then suggesting they freeze it for the future and go with Sara Lee for their party. My shrink says Sara Lee is art for the masses. The chocolate makes 'em feel good. Could be subconscious fears of cannibalism, he says, if they eat my work. Or sex hangups about individual areas of the human body? I couldn't care less. It's their money."

Porncake Picasso.

War and Remembrance

On my combat crew's 29th mission, over Kassel, we were bounced by 100 Focke-Wulf 190s and half that number of Messerschmitts. We shot down 25 of the fighters, including one I got from the nose turret at 60 yards. We were one of only four crews that made it home to base. We lost 25 of our 35 Liberators, and 117 kids like us were killed. Military Heritage's February 2000 issue pictures our crew and tells the story of what's become known as the worst disaster suffered by the 8th Air Force. Our fighter support missed their protective rendezvous, not believing the winds of 100 knots that they calculated.

Out the rear window of our Bronx apartment, across the cattails and jimsonweed—the kind that miraculously bursts through the concrete on tollways, the patron weed of us sidewalk kids—stood James Monroe High School. A great school, but one that failed me by making stenography and typing a woman's track—what kind of sissy are you to take typing? So I lack

the two skills that would have made my entire career as a journalist easier. (I've actually delayed American history by this failing, having said to Presidents Hoover, Truman, and Ford variations of "Would you mind repeating that, Mr. President? I missed a couple of words."

When I was fourteen, in 1936, my father encouraged me to submit long-hand articles and columns to the school paper. With Russian reverence for writing, he proudly showed off my bylines, then for my birthday he lovingly walked four miles with me to the typewriter store, put down $2 in somehow amassed dimes, and signed a time-payment agreement. He would pay 25 cents a week until the entire $39 for my new Royal portable was paid off. A three-year commitment. I walked home on a cloud, gaining the strength to beat the world from my left hand in his right hand, and the new machine's case handle hefted in my right. Each Friday night we walked west with our weekly quarter. (My first 25-cent photo-developing earnings—a vacation roll for the Fegarskys—went into this!)

Yes, I should have forced myself to type with all my fingers, but I didn't, getting up to thirty or so words a minute with just two. Then something wonderful happened. In the Ward Theater to see a Paul Muni movie, I won $110 at Bingo.

The next Friday my father exulted next to me in the proudest walk of my life—paying off the thirty bucks we still owed.

Next scene: I'm twenty-two, a flying school grad, navigator, part of a B-24 Liberator crew, loading all our gear—including my trusty Royal—in the bomb bay of *Sweet Sue,* about to ferry her from Davis-Monthan Field in Tucson, north to Vermont and thence to Goose Bay, Labrador, refueling there, and at 150 miles an hour crossing the turbulent North Atlantic on our way to war. Eight droning hours to the greenest green in Ireland, Derry-Na-Cross. We waggle our wings at farmers in muddy puttees, calming their cows and sheep as we drone east to our base in East Anglia, our arc a little north of Lindbergh's.

We landed at our home to be, Tibenham, and opened our bomb bay doors to unload. As I grasped the handle of my beloved Royal, the catch gave way and my typewriter bounced to the tarmac, breaking its black cast-iron shoulder, bending the frame, pieing the letters uncorrectably. Like dropping a baby: horror, guilt, thoughts of repair. War organizes your perspective. The first day off the base I carried the typewriter to a repair shop in Norwich, a big castled city nine miles north.

Another montage: training, formation flying, bombing the two big black dirigible hangars at Orly, not far from the Eiffel Tower, hangars in which reconnaissance photos later proved we'd destroyed some of Goering's fighter planes in for servicing. Hamburg, Karlsruhe, Frankfurt, Berlin. Cologne. Flak and fighter attacks.

Suddenly we were veteran aviators and in training to be a lead crew. One morning we loaded up with practice sand bombs, one hundred pounds each, and were briefed to bomb nearby range targets. As we were about to take off, the tower called. Would Lieutenant Shay leave the plane and come to the tower. Okay for the practice mission to proceed without him. A death in the family? What? Then I saw the little Morris Car at the tower. The type-writer repair man had brought back my Royal! Completely new top, everything else straightened out. "Two pounds, Yank. Glad to help." Eight bucks! I lovingly stashed it on my bunk.

He gave me a ride to Norwich, where a young tea shop lady I knew invited me to a dawnce at the Samson & Hercules. It was there that several buddies came up to stare. Why wasn't I in the hospital with the rest of my crew?

All four engines of *Sweet Sue* had quit. Electrical failure over Tom Paine's farm in Thetford. Bombardier Chuck Bunting was so badly hurt that he was out of the war. He had been crawling forward just beyond where I usually stretched out during practice runs, and the front end of the plane had burrowed into the ground. I would have been killed. Had it not been for my Royal portable.

Hemingway and Shay.

The picture is of me at twenty-three, a much shot-at veteran of thirty combat missions, proudly sporting my Pathfinder wing logo, my DFC and five air medals, full head of curly hair, in the blackout-curtained PR office of 8th Air Force headquarters. I am apparently pointing to a manuscript that Ernest Hemingway—*Ernest Hemingway?*—is reading intently. The manuscript, I hasten to say, is not mine. If it were I would rather have died than impose it on Hemingway! It belonged to a PR corporal of limited grammatical, to say nothing of literary, gifts, who had thrust the pages on a polite

Hemingway as he entered our office. I had just put a scrambler (coded) phone call through for the great man to his girlfriend, Mary Welch of *Time*. Fastest method. I then gave my Rolleiflex to my commanding major, Farley Manning, who clicked me into proud eternity with a half-phony picture. Papa had looked up momentarily, understood what I was up to, and winked.

At lunch Hemingway showed me a manuscript copy about an inch thick. It was entitled "Land, Sea and Air" and began with the verse: "Onward Christian soldiers, marching to a whore." A table-hopping colonel from Key West wanted to talk about fishing in Florida, but Hemingway said, "Let's win

This Masai warrior in Kenya taught me how to throw. After I, an old quarterback, threw a bull's-eye at forty yards, he introduced me as "B'wana m'kuba," the man with the strong arm. I spare you the picture of my throw.

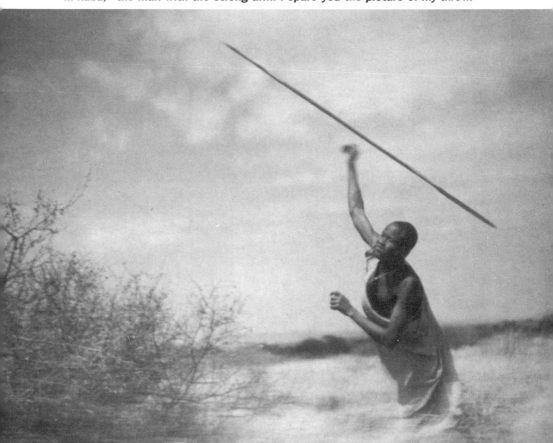

the war first. You can come to the dock, if you like, but bring a couple of female alley cats for me with some Johnny Walker." So much for our literary lunch. I wanted to ask him if he knew the real Pilar and if she made the ground move for him in the Spanish mountains.

Ten years from that day in England I would be on safari on Tanganyika, looking up at the 19,340-foot snowpeak of Hemingway's beloved Kilimanjaro, and like Hemingway, I would wonder what the dried and frozen carcass of the leopard had been seeking up there when still alive. Forty-five years from that moment, a few days before the millennium madness struck, idly shopping for shoes in a local mall, I saw a rugged outdoorsy pair made by Clark in England in my wide size . . . labeled "The Hemingway." I bought two pairs, hoping papa's heirs and heiresses would receive a soupçon of the price for the pleasure, brief company, and literary guidance he had given me. And for his wink that showed there was a real man, a fatalistic and humorous one, under the real men he wrote about.

One morning as I played Ping-Pong at 8th Air Force headquarters, the colonel I was slamming against stopped the game. "Why are you so damn angry, lieutenant?" he asked. "Because you just finished your combat tour, right? And you miss the war?"

"I guess." I had never analyzed my unresolved feelings of ongoing hostility.

The colonel, whom I had met while we'd both shepherded Ernest Hemingway around our operation, was in charge of special projects, and he had two jobs for skilled navigators. He had read a short, impenetrable air force pamphlet I had rewritten, simplifying celestial navigation.

My choices were navigating transport planes from England to Casablanca or Fortaleza, thence from Africa across the South Atlantic to Belem; or joining an eight-plane band of American fliers hauling unarmed planes from Metfield, England, to neutral Sweden. It was the Swedish run hands down. Something called the Sonnie Project, originated by the legendary polar explorer Colonel Bernt Balchen. We would be flying as mock civilians taking in Red Cross supplies and ferrying out reluctant airmen who'd been shot down over northern Germany and somehow made it to Scandinavia to be interned by the Swedes. Many of these fliers had girlfriends, wives, and jobs in Sweden, and preferred sitting out the war there. But many wanted to go home, and we flew them in C-87s, creaky Liberators disarmed and converted to transport duty.

I was outfitted in civilian clothes at Austin Reed's on Regent Street, London, and given a fake passport. I learned in my briefing that the Nazis were doing similar business with the Swedes from the shrinking parameter of Berlin. In a few weeks we would bump into some of the Germans at Bromma Airfield, throw Chesterfields on the floor, and watch them jump for them. We wore civilian clothes, but toward the end of the war began proudly sporting our A-2 leather jackets—eight bucks at the PX, now $300 and up at Brooks Brothers. They had bombs painted on the back, each with the name of a city we had helped destroy: Cologne, Berlin, Essen, Frankfurt, Karlsruhe, etc. One German I ran into refused to believe that the U.S. Air Force allowed Jews to become officers. He did not believe Germany, the land of Goethe and Beethoven, would countenance concentration camps. It was Jew propaganda.

Our route took us north from Metfield, over the North Sea, over all the oil that would be found there eventually, to 63 degrees north latitude. There we would head east over Norway, passing Trondheim. Then we'd find a ten-mile corridor the Swedes had granted us (a matching one had been granted to the Nazis coming in from Berlin) and head for Bromma Airfield in Stockholm. There we would clear customs like any other civilians and be

issued little green ration books—which made us popular with Swedish women. Meat, butter, *tabak,* etc.

As we dipped low over medieval Stockholm en route to Bromma, we buzzed the roof of a coed dormitory. We waggled our wings in approval of the young women sunbathing, who jumped up to wave at us from their roof. On our third trip over them a few weeks later, the young women had drawn their six-digit phone number on four-foot placards.

Which is how the unmarried members of our crew began going with Tura, Tyra, Ella, and Anna-Maria who lived at Ostyategarten 25.

Looking back at the amateur photography I did in Sweden gave me material for a lecture I sometimes give to would-be photojournalists. There I was, Leica in one hand, Rolleiflex in the other, fully conversant with the slow films of the day. I had an eye for good pictures, I thought, and used it fecklessly.

I brought back more than a thousand negatives. People riding bikes to work in shoals of street traffic, legs of the pretty girls flashing. Policemen carrying swords. Drivers feeding charcoal into the round washing-machine sized charcoal burners on their front bumpers, powering their ancient Volvos and Opels. Shop windows with the word "Lax," meaning Lox—a sure sale, I thought, to New York picture editors. (Wrong.) Bucolic landscapes and aerial views of the bridges. Pictures of the stacks of wood lined up outside the Grand Hotel, ferried in by bellmen to feed their furnaces. Pictures of monuments and statues. I raced up to *Life* to offer them an exclusive of a neutral country in wartime. They rejected me, and so did *Look.* I couldn't understand why. *Architectural Forum* bought one frame of a Swedish super-modern apartment building going up on ancient scaffolding.

Only later, after working for *Life,* would I realize where I had goofed. I would realize why my pictures hadn't sold to the magazines. Instead of snap-

Left: Three fake civilians in Stockholm: pilot Sobol, navigator Shay, and co-pilot Whipkey.

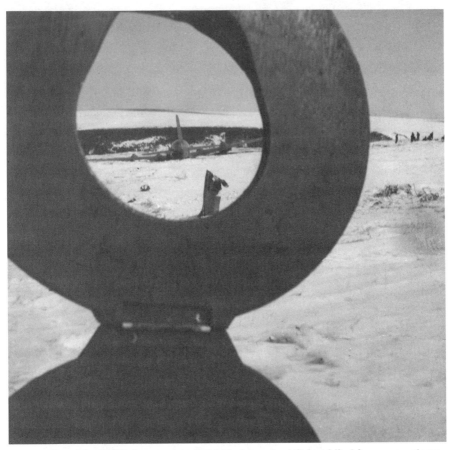

September 23, 1947, I was on a C-54 that crashed flying blind in a snowstorm over Newfoundland. We hit the only snowbank within eighty miles and slid down to the edge of a fifteen-hundred-foot straight-down drop.

shooting like a tourist, I should have done *stories* on: The beautiful gymnasts of Stockholm, the underground factories, Swedish neutrality. How the Swedes make coffee from wood, dresses from wood, etc. Is America ready for charcoal-burning cars to replace gasoline? Shopping bargains in Sweden— bikes for ten prewar dollars, gym shoes for a buck, harmonicas (fifty bucks in

the States, still six dollars on Hamngartan). Pretty German spies in Stockholm. How the Nazi bigwigs hid their money in Swedish banks and shipped stolen Jewish artwork from Norway and northern Germany to Göteborg, Sweden.

For those of us who made it back—and nine thousand didn't from our 2nd Division—World War II was a good war. We started combat flying *knowing* we were going to die, so everything good that fell our way was lagniappe.

One 3 a.m. over the fjord country of Norway, we illicitly dropped a gorgeous Norwegian refugee in parachute from our nosewheel door. I still remember her scent, her pressing, rising, body heat as we rubbed off against each other, and her questions about the position of Orion when she landed. She stood next to me on my little ladder, both our heads in the astrodome dreamily looking at the northern stars. The Nazis had murdered her father, and she was dropping in to join a Norwegian commando unit to murder Nazi occupiers of her native town. I would gladly have jumped with her. Or anything. Whenever I smell Chanel Cinq I think of Anna Maria Hagelin! Some nights when the war memories tap on the windowpane of my sleep, or the Illinois sky is bright with northern constellations, there she is pressed against me, heading east at the latitude of Trondheim, learning the perimeter stars of Orion—Bellatrix, Betelgeuse, and Rigel just before stepping out into the Nazi-occupied night from four thousand feet. You may be a great-grandmother now, Anna Maria, or long dead, but I will love you forever—and my wife knows about us and understands, which is why I love her too.

Other airplane memories: Four days after the Pacific war ended I was navigating the first nonstop transport plane—a DC-4—from Guam to Tokyo. We were carrying some fifty very high brass to Atsugi Airfield to set up the American Occupation. I came out of the nose compartment to announce that in three minutes we would be crossing the International Dateline. Somewhere I have a picture of all fifty officers craning their necks to look out the little windows to catch a glimpse of that International Dateline.

It was a few days before D-day. My bomber, *Sweet Sue*, had just landed at our base in East Anglia. We had bombed Cologne. I was about to be debriefed with the other navigators when I heard the thunder of fifty Liberators overhead gathering around a buncher radio beacon for another mission. I had eight frames left on my Leica roll. As I pointed my camera at the lane-filled sky and shot the first frame, two of the B-24s collided and began to go down. I tried to shoot, wind film, shoot, wind—tracking the horrible twin smoke trails. A colonel standing nearby began screaming hysterically at me and trying to grab my Leica. "That's restricted—don't take any pictures . . ." I dodged and kept shooting.

For some reason 8th Air Force PR sent my negatives to *Look,* which was supposed to return them to me after publishing the photos. I've tried in vain for years to retrieve them. I learned that all *Look* negatives are now with the Library of Congress. The Library says, "They may be in a warehouse we haven't yet computerized." I'll give them another fifty years.

After the crash pictures appeared, I wept over one of the letters I received from the parents of the twenty-one-year-old, who was one of the twenty kids who died in this tragedy.

I saw another such crash. Two hotshot pilots were playing "slap the wing." You know the game: you put your hand on the table, someone tries to slap it before you pull it away. The bottom wing didn't pull away in time. Really. Twenty more men dead because of that good old American hot-rod syndrome.

Once a Liberator off our wing was hit over Kassel, bursting into immediate flame. I watched one flier leap from the bay holding his chest pack in his fists, thinking he'd rather try to attach it to his harness in the air than risk doing it before bailing out and blowing up with the plane. As he hit the slipstream, the wind wrenched the chest chute from his hands. The last I saw of him he was dropping feet first, his empty arms clutching at the air, just two or three feet under the tumbling chest pack.

Combat formation of B-24 Liberators.

Seeing this one death-in-progress closeup affected me more than watching forty kids like me die in the two crashes I've described.

February 13, 1995, was the fiftieth anniversary of the firebombing of beautiful Dresden. Not much of a military target, it was a repository of classical suits of armor and rare paintings, many surreptitiously "liberat-

ed" in 1944 by German, then Russian, military thieves with a sense of economics. Dresden was also a cigarette manufactory, a minor supply depot, and, most famously, the epicenter of German kitsch-art production: those artful blue-white works of porcelain showing carefree German lads and lasses cavorting in good German fun at good German picnics. They had all come from here, not far from the basement where porcelain had been invented in 1707.

In an exercise called Operation Thunderclap, the much-bombed British sent up seven hundred Lancaster bombers to which my own 8th Air Force, under Generals Carl Spaatz and Jimmy Doolittle, added a few American B-17s. Together they bombed the hell out of Dresden. One story holds that Thunderclap was launched to help the Russian advance along the Vistula, a show of solidarity with Stalin. Our terror bombing, a single page in the textbook of terror bombing written by the Germans, destroyed half a million buildings and took the lives of perhaps fifty thousand Dresdeners.

But not the life of the sixty-year-old German woman who gave National Public Radio's Susan Stamberg a touching interview. The survivor said, "I was nine years old—a little girl—when the Allied bombs began to fall. I hid in the Dresden library under a heavy table. The bricks and wood came down all around me, but I survived because of that table. It was more horrible for many others in my family, innocent civilians. Why would they want to bomb people like us?"

Stamberg, a usually tough reporter, didn't have an answer for the poor victim. But neither did she do a balancing interview. Possibly because she couldn't find a little girl who had survived the *herrenvolk* roundup of Jewish girls and women in Dresden. No library tables to protect them, they were shorn of their long hair, which went to make seats for German military vehicles, some of which sported leather covers of human skin courtesy of Ilse Koch. The little girls' parents' and grandparents' gold teeth were wrenched from their mouths for the war machine, and surviving children and adults were then sent off to the camps to become ashes in the ovens or soap in the

With the novelist Lee Stringer, publisher Dan Simon, and author Kurt Vonnegut, Jr., alongside the East River in New York City. I was shooting both distinguished writers for a book edited by Simon.

vats. These were powered, one prideful account informs us, by the otherwise wasted heat of the death ovens, piped to the human tureens by vaunted German engineering efficiency.

There are many mysterious theories about why the RAF's Sir Arthur (Bomber) Harris targeted Dresden. My theory, as a lead navigator who had finished his combat tour four months before? Well, the weather had kept the Brits grounded for some forty nights, during which the Nazi V-2s were tearing up the south coast of England and the Low Country harbors. Other explanations obtain, but most of my fellow flight crews agreed that Harris was just pissed off the night the weather cleared, tired of his impotence against Hitler's V-2s. Who would want to wreak vengeance on the Nazis? Sir Arthur. Where did the cloud cover finally break and offer bombsight visibility? Dresden. Could we help the Russians? Sure. Any railroad junction taken out made it tougher for the enemy to supply his frontline troops.

My long-haired granddaughters Natalie, seven, and Celeste, nine.

Dresden happened to be a moderately busy railroad marshaling point, and trains frequently left from there with prisoners for the brimming camps at Auschwitz and Treblinka. Dresden also happened to house a POW camp, where writer Kurt Vonnegut, a captured GI, was imprisoned for a time. Vonnegut's take on our brutality is famously recorded in *Slaughterhouse Five,* book and movie.

Vonnegut is my age and an ikon. Except for *Slaughterhouse Five,* I like most of his feisty books. I recently photographed him in New York for a book jacket but resisted bringing up Dresden. It took an effort.

In his anniversary interview, the wartime mayor of Dresden told the Associated Press, "The bombing was unnecessary and cruel—an act of Allied bestiality. Everyone knew the war was over by then."

Victims' shoes in the Holocaust Museum in Washington, D.C.

Every time a Nazi complains of cruelty and bestiality, I reach for my calendar. As the AP writer did not.

Between our bombing of Dresden of February 13, and VE-day, May 8, 1945, the Germans, despite "knowing the war was over," lofted 1,568 V-2 rocket bombs in aimless terror at the south English and lowland coasts. Seven hundred civilians, many of them children, died in a direct hit on an Antwerp movie house in which, it was said, a pirated Swedish copy of *Fantasia* was playing.

Between September 8, 1944, when the first V-2s were launched, through March 27, 1945, when we overran the German base at Peenemunde, SS Commanders Wernher von Braun (that name ring a bell, NASA fans?) and Hans Kammler had launched a total of 6,268 V-2s, taking 4,278 lives in

Britain, France, Belgium, and Holland. In the same period the Germans at Remagen, Cologne, Aachen, and in the Battle of the Saar took nearly ten thousand more lives, the slaughter accelerating on March 19 when Hitler implemented his scorched-earth policy, commanding his retreating Wermacht to burn everything useful and seed all roads with mines.

I did not bomb Dresden but would not have flinched from doing so. We Americans obey orders too. In the lead plane, I would of course have tried to avoid Vonnegut, as I still do.

Two years ago I visited the Holocaust Museum in Washington, D. C. My young nephew, Dr. Peter Shay, brought an old refugee patient to meet me. We silently watched a screen scrolling dates of Nazi geographic infamy. "Dresden was where they were burning books even before the *kristall-nacht,*" the old man said. "They raped our wives and daughters in front of us. They also tortured us for fun. They hung my uncle by his beard. We would have been happy if you bombed us—just to kill our guards, they were such beasts. By his beard, poor Avrom!" Then he tried to kiss my hand. "Thank you," he gasped. "Thank you." He thought I'd bombed Dresden.

My nephew later said, "I was watching you carefully, Uncle Arthur. The only time I saw your eyes tear up was when they scrolled that date in August 1942 and the screen said, 'The City of Dresden forbids Jews from buying flowers.' "

Peter was right. Wiping my eyes, I mumbled that I wished I had navi-gated the lead plane over Dresden. Revenge? Sure. But human too, I think, to weep all these years later at the Holocaust Museum for people like myself. For my long-haired granddaughters Celeste and Natalie? For Peter, an anesthesiologist who saves lives every day? We would all have been murdered long ago. But first we would have been barred from the won-

Right: Me and, inset, my co-bugler Miltie, who would share my twenty-five-cents-a-week high school trumpet and become the jazz legend Shorty Rogers, at twelve in Lee, Massachusetts, just before migrating to Bronx River Avenue. He double-footedly brought barrel-stave skiing to the Bronx. Rogers photo by David R. Goir; Shay photo by Bert Tunkel.

derful Dresden Zoo, from reading certain books, going to public schools, being in business, having a bank account, or using the public parks.

They manufactured no tanks or planes in Dresden, and in the same year they imprisoned Kurt Vonnegut, 1942, ill-fated Dresden had originated a simple, hateful indignation, as effective as a truncheon, that would half a century later draw tears from me. No flowers for *our* kind in the lovely marketplace thanks to Vonnegut's Nazi jailers, whom Kurt still feels we so unfairly oppressed. So it goes.

The day he died I wrote a letter to the *New York Times*. It began: "The day I almost killed Colonel Jimmy Stewart . . ." My epistle apparently didn't strike their interest. This was disappointing to me, because they had printed letters I wrote after their obits on my friend Shorty Rogers, the great jazz trumpeter, and on my sort of neighbor, William Shawn, editor of the *New Yorker*. Shorty (nee Miltie Roginsky) and I had grown up in nearby houses in the Bronx, and we played the bugle together (Taps, and its echo) at memorial services (around 1936) for increasingly deceasing World War I furriers—that is, members of the Jewish War Veterans' Fur Post. Shorty went on to play with Woody Herman and became a Hollywood record producer with a pool and three serial wives. My published letter brought me letters and memories from other friends of his. Little Miltie had become a jazz legend, but I knew him only as a bugler from Lee, Massachusetts, with perfect emboucher and perfect pitch.

Shawn, I pointed out, was my neighbor in *Who's Who*. One day I dashed off a short story and made the mistake of imposing on the Shawn-Shay concatenation to do an end run around the contributions editor.

Shawn's dry reply suggested that I submit my piece for editing to another neighbor of us both, the writer Lord William Shawcross.

Colonel Jimmy Stewart had been commander of our 703rd Squadron of B-24s before our crew joined it as a replacement for one shot down over Germany. Our base was at a tiny farm town, Tibenham, nine miles south of Norwich. Stewart had been promoted to wing commander at another base, but he still dropped in at our base occasionally.

Each of our cold Nissen huts—especially cold this wet September—housed the officer complements of two or three crews. As lead crews we flew every fourth mission, and so we had lots of spare time. My pilot, Cecil B. Isom of Ennis, Texas, had a great country-boy genius for anything mechanical. The first device he built was a dangerous heating unit to amplify our oil stove. This consisted of a big, slug-shaped oxygen bottle with a long, slender aluminum tube coming from it, ending up on a little plinth of three or four bricks.

He drilled holes in the pipe and filled the big yellow bottle with used aviation lubricating oil that he scrounged from the aircraft maintenance crew. The oil bubbled down and Isom bravely lit it. Blue flames shot up through the holes, and we had a hell of a heating unit. It lasted about a week—confiscated then by a safety-minded paddlefoot (groundling officer).

One morning Isom and I were discussing the V-1 terror rockets the Germans were lofting all over London and the Low Countries. "Easy to make," Isom said. Per his instructions, and because he was *persona non grata* around the mechanics' area, I helped scrounge a four-foot length of three-inch pipe and had a mechanic weld it at forty-five degrees to a metal plate about a foot and a half square. We then raided the armory for a Pancho Villa–sized belt of 50 caliber bullets and a few rocket flares for Very pistols. We found a two-foot-long hollow canister, cut aluminum rocket wings for it, capped the thing with a wooden nose cone, and we were ready.

We began to cut open the bullets and dump the black powder and the flare powder into the launching tube. Isom carefully inserted the top of a

five-foot string into the powder. With seven or eight other fliers enthusing around us, we dragged the device outside, between our hut and the next one, for the launch.

Isom had earned the right to light the fuse and did so with his Zippo. The flame shot powderward, then *whoosh,* our rocket shot off its little gurney and spiralled aloft about a hundred feet and out about the length of a football field. Then, like the miniature buzz bomb it was, it began to drop—to our horror—in the vicinity of several officers going into the mess hall. They scattered. Our rocket hit the corrugated metal roof with a crash, then rolled down practically at the door.

"We coulda all been killed," Stewart said later at our bawling-out debriefing. "Just take the rest of the ammo back and save it for the Germans. And don't write your family about it. Not the picture of the 8th Air Force we wanna send home."

I was in trouble just two other times in the air force.

A young lady I knew in Norwich showed me through a secret room or two in the local museum. "What're those?" I asked, pointing to what looked like bathing trunks made of chain mail.

"Chastity belts," she giggled.

It immediately occurred to me that these metal pants would offer much more protection to our genitals during flak or fighter attacks than the current body armor we stretched out alongside the bombsight and under the navigation desk. I wrote a suggestion to this effect and handed it to our adjutant, who gave me an official form to fill out. It was dutifully sent to 8th Air Force headquarters at High Wycombe, west of London. Three weeks later came an official reprimand for the adjutant, our commanding officer, and especially for me, for trying to play a joke on the command structure and wasting time that could be better used winning the war.

The next time I got in trouble was in Washington, D.C., in 1946. I was stationed at the Pentagon, flying the wounded home from Japan and Australia, and navigating special missions all over the world. Headquarters of the Air Transport Command was eight hundred yards away at Gravelly

Point. It regularly took five or six days for mail to travel those eight hundred yards.

One day the ATC's PR department announced they could now fly a giant Globemaster cargo plane around the world in forty-eight hours nonstop using the new technique of midair refueling. PR was asking us how to capitalize on their stunt, how to utilize this new capacity.

I offered one suggestion on official stationery. Problem: How to cut mail delivery between the Pentagon and Gravelly Point to fewer than five days. Solution: Ship all subject mail to Andrews Field, load it on Globemasters, send it around the world in forty eight hours. . . . I received a reprimand still on my record.

I hadn't thought of the above for fifty-three years until the other evening when I was in the FedEx office near Chicago, trying to send a packet to nearby Elk Grove Village overnight.

"We don't do ground," the lady said. "We send everything through Memphis. It's faster."

In 1945 at 8th Air Force headquarters in a venerable girls' school at High Wycombe, I had seen from a distance two little girls plunking at the grand piano in the officers' club. Guiding the hands of young princesses Elizabeth and Margaret was the tall thin composer who had written "Red Sails in the Sunset." Several security men raised their hands against me when I raised my camera.

In another room I overheard a chubby little Englishman, about ten years my senior and apparently some kind of government official, brilliantly parsing John Gielgud's *Hamlet,* then playing at the Haymarket Theatre in London despite the terrorizing Nazi buzz bombs and rockets. He winked at me, inviting me into the little group. He was Lawrence Durrell, who would ultimately write the classic *Alexandria Quartet.* He was delivering a priceless Shakespearean lecture. During my year or so at Brooklyn College before I enlisted, I had imagined becoming a Shakespearean scholar and so was enthralled by Durrell's discussion of a famous quibble in the Bard's work.

"Sweet Will has come down to us, of course," said Durrell, "in the secretarial handwriting mode. This leaves in question whether *Hamlet* was saying: 'Ah that this too, too *sullied* flesh . . .' or 'Ah, that this too, too *solid* flesh . . .' A great disparity in meaning, don't you know."

I didn't know, but I was a culture-hungry kid, and a few nights later, with a smart sister officer in the RAF, lovely in blue, I sat watching Gielgud to see and hear for myself. The Haymarket was fronted by big Doric columns (still visible as background for Liza the flower girl in the movie version of *My Fair Lady*), and the huge doors were kept open lest a buzz bomb skew them closed and trap the audience inside the theatre.

Hard as we listened, these two American and two English ears, the puzzle remained unsolved, because the masterly Gielgud expertly split down the middle his pronunciation of the line so that "*soleeed* flesh" and "*sulleeed* flesh" resonated as one. What the hell! I wasn't going to be a Shakespearan scholar after all. The war, you know. A drunken GI wandered in one of the open doors during Ophelia's mad scene. He watched her throwing roses from the stage in her anguish, then turned to the rapt audience and said, "That woman is crazy, folks." Having delivered his verdict and got a few titters, he stooped to pick up a rose and walked out into the dangerous night.

After the war I became happily addicted to James Joyce, Durrell, Vladimir Nabokov, and Nelson Algren, but I never went back to college, and my interest in Shakespeare became that of the ordinary playgoer's.

The exact lines in *Ulysses* that hooked me were contained in the approximate pun: "What opera do the railroad yards of Dublin remind you of?" Answer: *The Rose of Castille.* I mulled and mulled and finally got it: the rows of cast steel. Durrell cut into me at a deeper level, and I wrote an obituary of him for a local paper.

"The old love," Durrell wrote in *Mountolive,* "was slowly metamorphosing into admiration, just as his physical longing for her (so bitter at first) turned into a consuming and depersonalized tenderness which fed upon her absence. . . ."

Novelist Lawrence Durrell, dead at 78 (in 1990), knew all about transferring to paper those self-examinations that novelists and letter writers transfer to paper when they have few friends with whom they can commune.

Durrell's *Alexandria Quartet*—four books examining love amongst a group of passionate Alexandrians—appeared between 1957 and 1960. They thundered through postwar literature hurling bolts of illumination into the dark shadows of marital relations among the very rich, the artistic, the inverted, the wicked, the famous, the ordinary.

This man, who was twice married and thought to be bisexual, wrote each of his four masterpieces in fewer than three months, the white heat of creation dovetailing with his notion that a writer's work is his true love. Relations with other contemporaries, he held, were chancy; real friends exist perhaps only among unborn readers-to-be. Or perhaps the unquestioning dead. Heavy stuff, but so efflorescent in its descriptions of the smarmy, musky world of the Near East, and the muskier world of the sexual and financial arrangements that he knew motivated most of human behavior that Durrell fans sprang up all over the literary world. Many of us still read *Justine, Balthazar, Mountolive,* and *Clea* every year or so. Oh you romance novel readers, how I envy you who will put down the dog's dinner salads of Barbara Cortland, Danielle Steele, and Jackie Collins long enough to feast, for the first time, on the real thing.

"Afterwards they locked the tall doors, put away the papers, and in the dead of night lay down before the fire in each other's arms, to make love with the passionate detachment of succubi. Savage and exultant as their kisses were, they were but the lucid illustration of their human case. They had discovered each other's inmost weakness, the true site of love. . . . In these magnificent kisses all his loneliness was expurgated. He had found someone to share his secret."

In Durrell, truths become lies, lies truth. In one book Durrell uses what he called an "interlinear." An all-knowing person on the edge of vastly emotional events comes back to correct the same events as seen and written

down by the keeper of a diary. "No, you have it wrong. What really happened was . . ."

Durrell knew, as did the creators of *Roshomon,* that each of us regards the world from a slightly skewed point of view, skewed to the angle that shows us in our best light—often at the expense of truth, our loved ones, our careers.

Lawrence Durrell's death deprives us of a marvelous voice in the choir of writer-philosophers who created the sexual revolution of the sixties without meaning to, preparing us for the next millennium.

He seemed so laid back, so unprepossessing, visiting 8th Air Force headquarters. I didn't even shoot his picture. I've always regretted it.

While I was stationed in San Francisco, flying the World War II wounded home from hospitals in the Pacific, flying war brides of army and navy brass back from Australia, I was also writing articles and press releases about other special missions for a postwar air force suddenly starved for press attention. A bona fide war hero general pointed to my wings and said, "Hey, lieutenant, I've been reading your flying articles in the *Washington Post*—so you must still remember how to navigate. I need a navigator. I've got to do a record flight to Alaska. Tomorrow at 5 a.m. B-29. It'll be in the record books."

"What record?"

"First ever, longest low-level flight, San Francisco to Anchorage. Thirteen hours."

"How low level? I hate swimming."

"Thirty feet," he said. "Isobaric study." Whatever that meant.

I had never even been in a B-29, but there I was, briefed at 3 a.m., in the B-29 nose at 4 a.m., thirty feet over the Pacific on a north northwest

hcading at 4:40 a.m., frantically working my little plastic E-6B computer—really a circular slide rule with a round face for wind vectors. I remembered my first navigational instructor at San Marcos, Texas, holding up the E-6B.

"This smart little lady," he drawled, "will do everythang for you a good wife'll do except one itty bitty thang—and if you use it wrong it'll do that too. . . ."

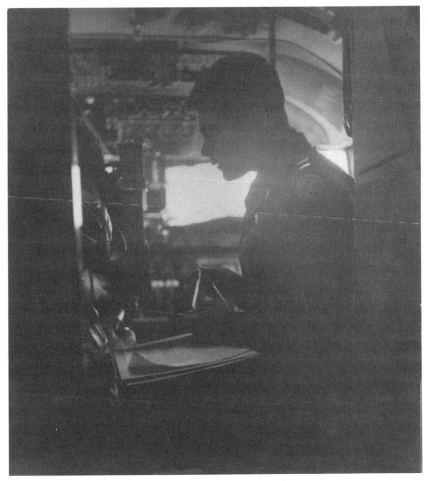

Me navigating.

My E-6B had gotten me through thirty combat missions, another twenty forays into neutral Sweden, and one secret trip in a Canadian Mosquito made of plywood to Murmansk, Russia, where we ferried parts for obsolete P-40s. There, in zero degrees, an athletic lady sergeant with long hair tucked into a parka hat, guarded our plane with a captured German Mauser machine gun, making sure we didn't leave early. Without a word, she dropped gun, jacket, and bra, and nailed two of my crew members who rewarded her with a regulation A-2 leather jacket, two leftover tuna sandwiches, a coke, and a carton of C-rations containing Spam. She kept yelling, "Pieter! Pieter!" which we took to be the only word of organic English some other crew had jokingly lend-leased her during sex. But after we started the engine to get some cabin heat, she used her phrase book to apologize for screaming her husband's name. "I no have man two year," she said. "Now I have two mans"—looking at scared little married me hungrily, as if I were dessert. Fortunately it was time to leave Murmansk to do six dangerous hours over snowbound northern Russia, Finland, and Norway, where our magnetic compasses spun uselessly in polar dismay until we established true south with a blessed sunline from our astrolabe, and followed it in to Metfield in East Anglia. En route we merrily buzzed Robin Hood's Nottingham Forest, Tom Paine's "Common Sense" farm at Thetford, and, for the hell of it, Anne Hathaway's flower-bound cottage, where Will bequeathed Anne his second-best bed because she was a bitch. I gave my aerial docent lecture as we went, occasionally playing Bronx harmonica over the throat-mike PA for my hand-clapping country-boy crew.

Thirty feet is about two stories high, and it was hairy for thirteen hours, but we did it and are truly in the record book. No matter how I fail in life, I will always have the comfort of knowing I moved the science of isobaric weather prediction ahead about a centimeter. I never wanted to see the nose of an airplane, or the water close up after that. With one free day before returning, relaxing at one of the sixty-three bars in downtown Anchorage, a voluble civilian forced his attentions on us.

"I'm the license commissioner of Anchorage," he said proudly. "See that license on the wall—my signature. See those licenses out front—mine."

Nothing availed but that we took the tour of his licensery. He showed us next year's Alaskan license plates—yellow and blue 1947s. Much prettier, I said truthfully, than our California plates.

"How'd you like me to register your car here, your address being Elmendorf Field, right? Ten dollars and forty cents."

So we forked over the dough, got our showy plates, and began counting the hours until we got back to San Francisco to put them on our cars.

In the first week I had Alaskan plates on my 1936 rumble-seat Plymouth, I was stopped by six cops.

"Hey, lieutenant, the Alcan Highway . . . is it drivable yet? The holes fixed?"

"Where should I stay in Juneau?"

The day after my wife went back to her family in New York to wait out her pregnancy with our first child, I got orders to report to Hawaii to edit the Air Transport Command newspaper. Ordinarily this would have been a wonderful job, but I wanted to be closer to New York. Leaning on my wartime friends at the Pentagon, I was advised to head east but make few stops. MPs were patrolling the roads looking for deserters without orders. It would take a few days for my buddies to get new Pentagon orders cut for me.

With eight-buck retreads and much trepidation, I left California—only to run into the usual police lights and sirens of friendly officers wanting information about Alaska. The last straw occurred when I hit Pennsylvania Avenue in Washington, down the street from the White House. A frantic lady driver nearly creased my fender, then came out of her vehicle with camera in hand and directed me to stand near my license plate. She enlisted a confused passerby to shoot the two of us with the Capitol in the background. She pointed left to her license, right to mine. "The Virgin Islands," she said, "and Alaska. The two territories!" Click. Click. The worst ten dollars and forty cents I had ever spent.

The Photographer's Trade

On the very first story I did in Chicago as a reporter, Wallace Kirkland, renowned for his pornographic Christmas cards and reputed to have been Jane Addams's lover when he worked with her at Hull House, was shooting a bathing-suited model in a plastic bag. She and we were sweating it out on Michigan Avenue in front of the Wrigley Building. As the crowd increased, Kirkland, peering down into his Rolleiflex, backed into traffic, causing a traffic jam made worse by hordes of people trying to "get into *Life*."

Suddenly the police grabbed Kirkland despite his shouting "I'm with *Life* magazine. You'll be fired!" He threw me the Rollei. "Shoot them abusing me," he screamed. I did—only to be bawled out later because of the Catch-22 rule: "Only photographers use cameras on *Life*." (As a fledgling reporter holding a second camera, I tasted the bittersweet anonymous glory of having perhaps twenty pages in *Life* under staff photographers' names.)

I tried to bail Kirkland out, proffering the usual ten. The sergeant considered it, then drew his hand back. "If you can just get the sonovabitch to shut up and stop threatening to do an exposé, I'll let him out and deliver you both to the Wrigley Building. But stay on the goddam sidewalk."

It was my first of many dealings with the Chicago police. A few years later, when I'd become a photographer and was covering the Walcott-Marciano fight for *Life,* I brought along a stuffy English cousin of mine as an assistant. Showing off a little, I parked in an alley directly across from the main entrance of the Chicago Stadium. An officer came up, shaking his head at my press card and making the international baksheesh sign—thumb

brushing across the fingers. My ready ten-spot assured us that not only would the car stay well parked but also that it would be professionally guarded from neighborhood thieves always rife in the area. My cousin's jaw dropped with shock at how Chicago worked. Nelson Algren often told how his uncle, a pants maker, when stopped by the police, would come out of his Chevy with tape measure at the ready. Never got a ticket.

Alas, the fight my cousin saw lasted a little less than a minute. "Might they do it again?" he asked. "I was bending down for my program."

Luckily I followed the fighters and referee into the locker room. There the referee reenacted the fight, and *Life* used my pictures of the little guy miming the fight for our cameras. He looked like a cross between Jimmy Durante and Marcel Marceau.

But first a flashback. . . . How did I, a simple Bronx kid who fought the war as a lead navigator in Jimmy Stewart's 8th Air Force Liberator Squadron, get promoted from fledgling chore boy on the *Life* news desk to full correspondent for *Life* and *Time*? The year was 1947.

I was on my first big story, the *Forbes* magazine Waldorf-Astoria dinner for "The 50 Men (yep!) Who Made America Great." Henry Ford was there, sitting next to another Ford. Lincoln of Lincoln Electric sat next to another Lincoln achiever. All up on the stage in alphabetical array, tiers and tiers of Malcolm Forbes's guests. Then GOP presidential candidate Tom Dewey came to the podium, all five and a half feet of him, the little-man-on-the-wedding-cake smile and a hairdo parted in the middle, going back half a century.

Left: Favorite mid-career self-portrait, in New York
subway gum-machine mirror, age thirty-nine.

Suddenly one of the big #22 flashbulbs I had painstakingly socketed around the lip of the balcony, blew up. POW. I was looking at Dewey at the moment, and he suddenly cowered, sinking beneath the podium as if waiting for the next shots to ring out. When mere blather and a few nervous laughs comingled with the blue cigar smoke, Dewey emerged, one feature at a time. Staunchly he beamed at the assembled Forbesians who had that year at least, Made America Great.

My photographer, Al Fenn, photographed pair after pair of the giants on the platform tiers—Kellers, Lincolns, Fords . . . and our spread was complete. By Saturday, *Life*'s go-to-press night, the art department had laid out a spread—the group picture across two pages, and six shots of the similarly last-named saviors, two by two. As the rookie Newsfront section reporter (I'd been on staff eight weeks), I was alone in the vast newsroom on Saturday night, checking spelling and ages of the men in the layout. I blanched. Someone had printed the negatives one name off, and there was a Keller with a Lincoln, a Ford with a Grumman, etc. I reached the chief art director at home in Greenwich. He sounded preoccupied with his beloved martinis. "Do something, kid," he advised blearily, and reminded me he was in Connecticut. I called two or three other editors, but no one was remotely reachable.

I rolled the two-page layout into a cardboard stovepipe and went from our office, high over the Rockefeller ice rink, across the street to a five-story building that housed *Life*'s darkroom and negative files. I talked my way past one guard into the negative room. There were folder after folder of Eisenstaedt negatives—I idly pulled his Times Square strip of the sailor kissing the girl on V-J day. Just to have touched the edge of that negative! On to Fenn, Al. I found our Forbes banquet take and talked my way past another guard into the darkroom. There, with magnifier and lightbox, I re-united our like-named subjects and enlarged them to the exact size of the layout—postcard pictures in a row. I dried them, then pasted the correct ones on top of the erroneous ones and raced them out to LaGuardia Airport, sending them on their way to the printer. When I got back to the office I was

able to reach Bill Gallagher, *Life*'s pressroom guru in Chicago. "They better be the right snaps, kid, and good quality, otherwise it's your ass." He called me at 5 a.m. to say all was well.

Monday morning, editors Ed Thompson and Wilson Hicks came over to congratulate me, express amazement that a typewriter person could use an enlarger, and said they were giving me a raise. And how would I like to be a Washington correspondent for *Life* and *Time*?

Francis Miller and I hit it off on our first big Washington story, *"Life* Crashes a Party." Security hadn't yet come into its own, so we hired a college junior to crash the Hungarian ministry party celebrating "The 100th Anniversary of the Hungarian Ides of March." We photographed our credential-less crasher hobnobbing with the Russian ambassador and others of his ilk. We documented Minister Rustem Vambery holding up a salami, his eyes popping angrily because one of our flashes failed the first two times he lofted it and we begged for a retake. "How do you spell "salami"? I had desperately asked the minister, eliciting the eye pops. I'd also encouraged a gorgeous, buxom ministry employee to lean over the imported paté to serve our crasher. Just beneath her the table had a sign that said "Hungarian delicacies."

Audubonists count the birds in the D.C. area each Christmas. In 1948 Miller and I followed bird panjandrum Roger Tory Peterson and New York Museum of Natural History guru Alexander Wetmore up the Smithsonian Tower steps, where we plowed through two feet of owl droppings to track the aerie scions of an owl family that had moved into the tower during Lincoln's second term, and whose elliptical night hunting runs took them in graceful arcs around the Washington Monument.

It's hard to believe I got into editorial trouble for writing the following caption on birding in the Alexandria marshes (now high-rise country). "Young woman with binoculars, pointing excitedly to a copse, making notes in her bird book, yells to Wetmore: "Professor! Professor! I think I've got three tits!""

"Wetmore—sidles up to her bush with affirming Peterson: "Why so you have, my dear. So you have." "Three tufted titmice, indeed," confirms Roger Tory.

"We're a family magazine," I was told by a shrewish editor.

This episode hastened my transmogrification from reporter to photographer. Captions may mislead, but pictures never lie, right?

A dozen photographers were on hand to shoot General George Catlett Marshall as he announced the great European rebuilding program, the Marshall Plan. I was a Washington reporter for *Time-Life,* working with *Life*'s Francis Miller. His nickname for me was "DeMille," for setting up and arranging pictures that ended up as full pages in *Life.* Everyone was packing up to leave—AP, UPI, INS, *Washington Post, New York Times,* etc.—when Miller said, "Think of something, DeMille."

I heard a father calling his young son in the hallway, and dragged the two of them back to Marshall's door. When Miller and I were the only photo team left, I said to the seated General Marshall: "General, that's the hottest chair in the world right now. How about giving Kevin a spin in it?"

Marshall smiled, said, "Come here, son," and gave the kid a couple of spins—which we flashed.

There was a sudden flurry of action in the corridor—all our competitors alarmed at our flashing lights. They raced into the office, but by then I had sent the kid and his father on their way with a small gratuity. We had made *Life*'s Picture of the Week. This is not, of course, pure journalism. It dangerously begs the question of the Heisenberg effect. In the sixties and seventies *Life*—and *Life* imitators like "60 Minutes," abjured this practice. But gradually the advertising pages of the modern magazine began to imitate

Left: My mentor, Francis Reeves Miller, Life*'s greatest unsung photographer.*

news, and it spilled onto the editorial pages. I was kind of proud of my DeMille nickname, but prouder of having introduced the expression (delivered in the company of other journalists while looking at an artfully contrived photo masquerading as news): "Wasn't it lucky they came along while all that was happening?"

The *Time-Life* writer I'll call Brett was one of the very few born with the gift of laughter and a sense that the world was mad. And, alas, an inordinate need for sex. He was accorded other wonderful baggage at birth: the good looks of a movie star, the body of an Olympian (enhanced by a collegiate career as a runner), and a family with repute and money going back to Benjamin Franklin's time. Brett might easily have doubled for Scott Fitzgerald's rich boy who came to college with a string of polo ponies. And like *Gatsby*'s snobbish narrator, other men and women confided to him stories of wild passions as intemperate as his own. This made Brett a good reporter when he could spare party time to do his job. He was also the guy John Cheever wrote about—who swam across the county swimming pool by swimming pool, and the one who drunkenly set up dining room chairs at parties to show how he had cleared the high hurdles in college, biting his lip to keep from wincing at the pain in his aging shins.

Brett had a Grace Kelly of a wife, culled from the society pages, and four sons he taught to handle guns from the moment they were strong enough to lift them, and to whom he passed on the gene of winning at all costs.

One night *Time-Life*'s Harlem source Earl Brown assured *Life* that Louis Armstrong was dying. Nothing galvanizes news magazines as quickly

Right: Former Louis Armstrong jazz pal crying glycerine tears
in advance of the idol's death.

as the imminent death of a much-loved institution. Brett called me at 11 p.m. to start touring Chicago's jazz joints, looking for musicians who had known Satchmo and were now getting ready to mourn him. He considered chartering a plane for us to continue our quest by covering the probable Bourbon Street funeral in New Orleans with those wonderful guys in loud vests, marching to and from the cemetery, playing slow brass in the morning sunrise. It all played out in the theatre of Brett's vivid imagination. Or to Beale Street in Memphis. Wherever. Whatever it took to get a spread in *Life* better than any other team's. He didn't want to risk a call to New York to determine if another team was in New Orleans already, preferring to charter a night flight from Chicago for a thousand dollars or so and call in from Bourbon Street. And, of course, outshoot the other team, if any. Brett played *Life* and his career like an accordion.

He had me pull over at an all-night drugstore. Glycerine. "If we're gonna shoot grown men cryin' over Louis," he said, "they may as well have tears that show up properly." Happily, Louis survived, and our lachrymose pictures ended up as curiosities.

Shakespeare spoke of "the talent that was death to hide." He meant flaw. Brett's flaw was sex. He took to women like the hunter he was, and they to him. Busy as we were in our search for all-night jazz musicians mourning a not-yet-dead Louis Armstrong, Brett charmed a beautiful black singer into the back of my car while I was shooting, to my journalistic shame, glycerine tears.

My reputation as *Life*'s Sneaky Pete photographer was founded on many illicit sneaks into courts, gangster clubs, and the like, following in the wake of the master, Francis Miller. I am ashamed of but one small con in this

regard. It was 1959, I had the first Mercedes on my block, and I was doing 90 in broad daylight in southern Illinois heading for home from the State Pen at Marion.

Suddenly, two blocks north of a three-block town I was overtaken and stopped by a police car with jukebox lights. Out came the big-bellied officer, as if from a Burt Reynolds movie.

Before he could dress me down, I said, "Officer, before you ticket me, would you just put your right hand out at the camera—good—and smile real big . . . *Life* magazine's doing this story on how southern Illinois has the best and friendliest police forces in the Midwest—"

"No shit, well I'll be damned. Hand close enough?"

"Yeah," I assured him. "We're also doing Iowa but not Indiana."

"They're idiots in Indiana," he said, shaking his head. "I once got stopped there double-clutching a light—me! In my aunt's Chevy from down Terre Haute—and they wouldn't honor my police badge! Thirteen bucks! Can you imagine?"

I was properly sympathetic and did send him a copy of his handshake picture along with a note that said *Life* had the politeness story on hold because there was too much politics taking up space in the magazine for the 1960 campaign.

I once photographed the Birdman of Alcatraz in prison. He whistled the whole session like a bird, didn't say a word.

Covering the vaunted Masters golf tournament at Augusta for *Life* in 1960, it was hard to focus on Arnie Palmer as he moved from hole to hole with his "army" trailing him. I broke out a three-foot ladder I had brought along, climbed to the top of it, and began shooting over the crowd. Polite tug at my pants, and I was being told by the uniformed man in grey: "No ladders allowed." He showed me the rule sheet. "We go by exactly what it says."

I raced downtown and purchased a three-foot six-inch stool. I had the manager hang a tag on it which he labeled with a thick-black marking pen: "STEP STOOL—$7.50."

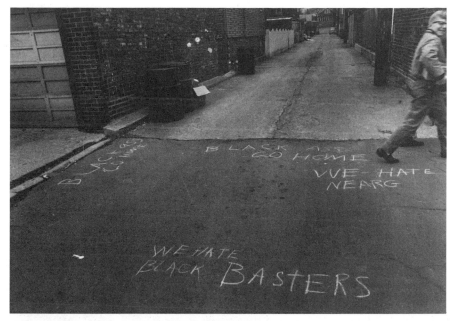

Above: White illiteracy. Left: Black illiteracy.

I positioned my stool behind Arnie's Army at the fifth hole, climbed it, and began shooting. Another pants tug—but this time I stayed aloft, smiled, pointed to the "stool" sign, and showed him my receipt on which "Step Stool" was writ in blue.

He came back with his sergeant, then with their captain, who read the rules yet again, shook his head, and said, "Ain't a ladder nohow. Steppin' stool's okay." Thus began a run on step stools at all of Augusta's hardware stores.

Rock concert morality.

Long before TV took over instant analysis of America's psyche, *Time* and *Life* were out there riding the moral frontiers, mapping the borders of our behavior as they changed. In the early sixties *Life*'s keen-eyed stringers reported that something new was going on: college men and women had begun to *live* together without benefit of clergy! In less than a week *Life* came up with eight couples across the country who were not only living in sin but willing to pose in their pads—understanding that their parents might see them in *Life* and gasp, "Oh my God! Where did we go wrong? Why are we paying the rent?"

I photographed one naughty couple at Wayne State University in Detroit. Next week it was *Time*'s turn to find a few unmarried couples living together. Bingo! My buddy Jon Anderson, a tall, handsome ex-*Time* writer, just joining the *Chicago Tribune,* was happily ensconced in a luxury high rise with none other than tall, beautiful Abra Rockefeller Prentice, a free-lance journalist who was also a friend of mine.

They posed reading chastely in bed by his and her reading lights, and *Time* liked the pictures. Two mornings later I got a frantic call from Abra. *Time had* to kill the picture. "My mother and my aunts would be appalled," Abra said. "Please, please . . ."

The picture was yanked.

Abra and Jon were married, have three children, and are divorced but still friends. At her daughter's wedding, photographed by two of my sons, Abra told them about the aborted *Time* picture and of another time, in 1966, when we worked together covering crime in Southern Illinois. "I let your dad read the copy I was about to file," she recalled, "and in my backgrounder about Southern Illinois I mentioned the rackets and racketeers down there. He saved me great embarrassment by pointing out neither of those words had a "q" in the middle." You can take the girl out of Society, but you can't take Society out of the girl.

Working for *Life* just after the war was like playing for the New York Yankees of that day, or with Michael Jordan on the Chicago Bulls. Nothing seemed impossible, and all day long people rained copious attention on us. Drama editor Tom Prideaux often said that working for *Life* was like being in the middle of a musical comedy.

It was fun and games, and people paid to watch us play week after week. It was this kind of corporate ego that drove us young reporters to sug-

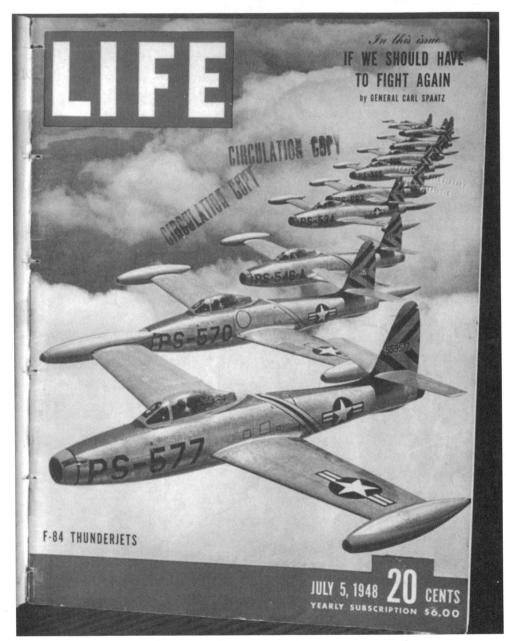

Just plane numbers, not quite as planned.

gest ever wilder ideas and turn ourselves inside out at the whim of editors we respected.

Managing editor Joe Thorndike briefed us at a meeting one day in 1948. "We're raising the price of *Life* from fifteen to twenty cents in two weeks," Joe said. "Can you think of something that could illustrate the change that would work as a cover? Suggestions by Friday."

Lieutenant Robert Drew, a hardworking air force PR man at a jet base in California, had been peppering us with suggestions that would get his jets some print. A tough job, because the public was tired of military hardware after the war. Eager-beaver Drew proposed a story on nonstop flights across the country with in-flight refueling; on an eighteen-year-old hotshot pilot; on a black pilot who had switched to jets after flying prop fighters in Italy; on a visit with air force nurses at his base who were running a clinic for the children of flying personnel. Alas, none of this found a home with *Life*. But we had become phone friends—wartime pilot and wartime navigator, neither of us with more than a year of college, both starting families, both wanting to write, both full of ideas.

I had a notion. "Could you get five jets into ladder information?" I asked.

"Of course," said Drew.

"Could you repaint the tails?"

"Huh?"

"How about five jets with numbers on the tails counting from 15? 15, 16, 17, 18, 19."

"Yeah," he said. "Why?"

"So people would read the numbers 15 through 19—then right below the plane with 19 on its tail would come *Life*'s new newsstand price, 20 cents."

"Consider it done," said Drew. "I'll tell you when to get the photographer out here to make the picture from the chase plane. Hell, I'll fly the chase myself."

Two days later a doleful Lieutenant Drew called. "The general won't let me repaint the numbers," he said. "Too commercial. But it's okay for them to fly a formation for you."

I relayed the information to my boss. He looked disappointed, then said, "Let's try it anyway."

Drew's tight rein on the formation made the Ralph Morse picture a fine pattern, and the cover that launched *Life*'s price rise was a great success, even though the numbers were disparate. (This cover helped *Life* choose Morse to be the eventual prime astronaut photographer.)

I finagled a free trip to New York for Drew, who parlayed it and a subsequent interview into a staff reporter's job like mine.

Like me, Robert Drew eventually left our esteemed Time Inc. alma mater, I to become a photographer, he to become one of the great makers of film documentaries. Drew built a large movie production company, still growing, sometimes with multi-million-dollar budgets, for Time-Warner. Often in the running for Oscars. All from a cover that was beautiful but only 80 percent as good as we knew it could have been, forty years before computers could have easily solved our problem, when we were young and eager enough to try anything to get into *Life*. The musical.

It's fun to work on a story or book with an editor who might have stepped out of Evelyn Waugh's *Scoop*. Such a partner was my former boss on *Life,* its youngest managing editor in fact. Joe Thorndike, a descendant of the last wizard burned at the stake in Massachusetts, left the magazine to become the publisher of *American Heritage*, and here we were in Dearborn, Michigan, working on Ford's fiftieth-anniversary book. Our introduction to

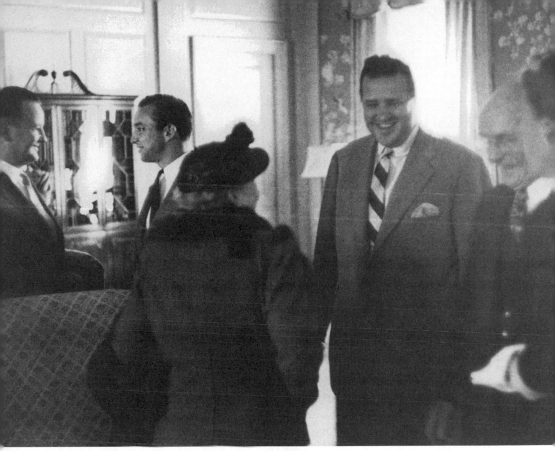

Henry Ford greeting the King and Queen of the Netherlands at Dearborn Inn, 1953. His brothers Benson and Bill are at far left.

Ford's madness in 1953 was being permitted to attend a vast pep rally of Ford dealers from all over the Midwest in the Detroit Shriner's Auditorium. Executives of division after division came on to boast of last year's production, sales, or design performance, and tell how they would exceed it. Finally, the grand panjandrum of spare parts took the stage.

"Once again," he said, "the Ford Motor Company last year sold *more replacement parts for our cars* than GM and Chrysler combinnnnned!"

The place went up for grabs. Stomping, cheering, hosannas, marching in the aisles, liquor bottles raised and passed around. We left in our new Ford, hoping no parts would fall off on the way back to the Dearborn Inn. The

previous day at a press conference, a high Ford production official named Walker Williams had told the gathered automotive press: "No, I don't have one of the new ones yet. I wait a few weeks till they learn how to put them together, then I get one from the line."

Torn between having Ford ads ripped from their papers and listening to the howls of high-priced PR men, the papers were kind.

Thorndike had brought in the famed cover photographer Philippe Halsman to shoot the styling section as well as the Ford family portraits. Philippe was getting the then-princely fee of $350 a day. Bedevilled by guards everywhere we turned, carrying blue passes for this area, yellow for that, Philippe, an anti-establishment refugee from Latvia and Russia, carelessly tossed his passes in with his Rolleiflexes and speedlights. So we were politely stopped every few moments.

At one such stop, where we had to wait for the chief guard to revalidate Philippe, the finally exasperated Halsman slammed down his camera case and said to the guard, "Young man, I am being paid $350 a day by Ford to shoot pictures here. When your chief comes tell him I am in the men's room taking [he looked at his watch] an eighty-dollar shit!"

Thorndike, Halsman, and I were lunching in a Chinese restaurant in Dearborn.

Halsman said, "I always wanted to ask you, Joe. Who would you assign to cover the Second Coming of Christ?"

"Who would *you* assign, Philippe?" Joe parried.

"Why me, of course," said the master. "I would make such a good portrait it would last for the ages."

"And what about the angels flying around and the interplay between them and Jesus?" said Joe. "I'm afraid if I had to assign one photographer, I'd assign Eisenstaedt."

"But Eisie is in Europe with Sophia Loren. I mean here and now!"

"If it happened on Ford property," said Joe, continuing to put Philippe on, "I'd assign Arthur."

"Arr-*tuuur*?" shouted the Latvian. "He's a beginner. I've done fifty *Life* covers. Why not me?"

"Because while you were setting up your tripod and lights, and showing Jesus how to pose," Thorndike said, "Shay would get thirty-six pictures and a release."

For years, every time I saw Philippe Halsman in New York, he would say, "Did you get the release from Jesus?"—still angry that Thorndike would send me to cover the Second Coming instead of him.

Head of the Old World coterie of *Life* photographers at the time was a tall, thin, wire-haired Albanian genius named Gjon Mili. He now did *Life*'s theatre pictures, but early on he had done some of the very first high-speed photography with Harold Edgerton at MIT: the golf swing, the milkdrop and its surrounding coronet of milk drops. Mili had a huge studio, and his Christmas parties were great social events.

At one of these he was talking about Robert Capa's great picture of the Spanish soldier getting killed and falling at the moment of truth, legs and rifle akimbo.

Philippe Halsman poo-poohed the picture with a loud comment: "Capa set it up. It's a fake." This infuriated Robert Capa's surviving brother, Cornell, and many other old-timers.

After Halsman left, Mili reminded the few hangers-on that Halsman had arrived in America in the early forties under a strange cloud. He had stood trial for murdering his father on a ski trip, and been acquitted. We younger journalists were unbelieving. Murder? Naw.

"The case hinged on the fact that Halsman had bought two teeckets to go to the skiing," Mili said. "But only one return teecket. I am glad he was acqueeted if the story is true—he's a marvelous cover shooter. But tonight when Halsman said that Capa's peecture was a fake, I happened to be looking at his face. It had gone cruel, I tell you. Unless it was my imagination. But in that moment I saw something terrible, and I thought it was *possible* he had murdered his father." These exotic foreign geniuses!

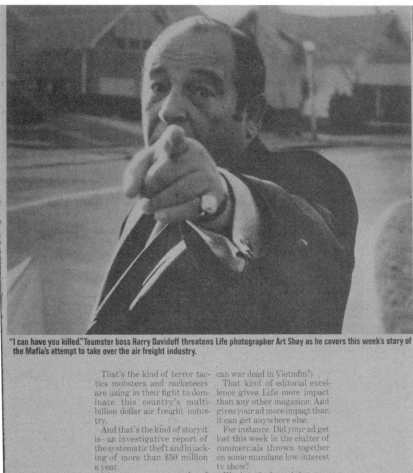

"I can have you killed." Teamster boss Harry Davidoff threatens Life photographer Art Shay as he covers this week's story of the Mafia's attempt to take over the air freight industry.

That's the kind of terror tactics mobsters and racketeers are using in their fight to dominate this country's multi-billion dollar air freight industry.

And that's the kind of story it is—an investigative report of the systematic theft and hijacking of more than $50 million a year.

It's one more example of Life's editorial power. (Who else had the photo of the National Guard about to fire at the Kent State kids? The reminiscences of Nikita Khrushchev? The 242 pictures of one week's American war dead in Vietnam?)

That kind of editorial excellence gives Life more impact than any other magazine. And gives your ad more impact than it can get anywhere else.

For instance. Did your ad get lost this week in the clutter of commercials thrown together on some mundane low-interest tv show?

Was it tucked gently between the pages of some parochial single audience publication?

Or was it right up there in the most respected, most read, most influential magazine in the country, bold as Life?

Was your ad in Life this week?

Life *ad showing my Mafia picture and caption with my name.*

The jury was out on Capa's picture for many years. Recently a Magnum reporter sought out the sister of the soldier. She took him to where his body was buried, and, in tears, read him the military dispatch describing his death by rifle fire, and how the photographer who took the picture almost got killed too. Which forever wiped out any suspicions about the picture. It was Capa, talking of combat photography, who said, "If you can't see the faces of the dying, you are not close enough." Capa himself would die near Dien Bien Phu. He would die much too young but with the unofficial title of the magazine photographer who had slept with more world-class actresses than anyone. Ingrid Bergman was his last great love. Death, alas, was the end of a beautiful friendship.

Generally, *Life*'s advertising and editorial departments existed in different worlds. My job was to track down the only known Jewish *capo,* Harry Davidoff, New York's toughest union chief, the purported leader of the infamous band of thieves who routinely stole Kennedy Airport cargo to order.

Working with yet another beautiful *Life* reporter, we tried the usual legitimate frontal approach. He turned us down and out of his union headquarters near JFK. We then staked him out a block from his home in Great Neck, Long Island, and using my 600 mm lens nailed him going to his car. This annoyed him for some reason, and he came charging at our car. I got out, one small camera in hand, to remonstrate with him. Pow! He grabbed me and my camera and wrestled me to the ground as I futilely signaled to the reporter to get a picture of us. I determinedly kept my hands to myself. Fear of Harry and loathing of getting into legal trouble.

"You sonovabitch," he yelled, letting me up. "I could have you killed!" He pointed his threatening finger at me. I guessed the focus and exposure and shot Harry.

The picture ran in *Life*'s crime story—and then the advertising department came after me. Thus followed a full-page ad in the *New York Times, Wall Street Journal, LA Times,* and *Chicago Tribune*: "Was your ad in *Life* this week?" etc.

When U.S. District Attorney Henry Morgenthau invited me to testify against Davidoff a few months later, and tell of his death threat, I looked at my kids—and chickened out. How could I make a living with broken knees or cement blocks for shoes? Morgenthau was understanding and jailed Davidoff without me. (When Oliver Stone makes the movie, we can always enhance my bravery.)

A Doomsday religious sect in Oak Park, Illinois, not far from Hemingway's home, announced that the world would end the following Tuesday. They would spend the world's final week in prayer in the first-floor apartment of their leader. The three Chicago papers shamefacedly confessed they couldn't get into the apartment for pictures or an interview. They implied that these fundamentalist zealots were kooks. A challenge for the young me trying to switch from typewriter to camera.

Working for *Life* in New York City had toughened me. In the office there I received people who demonstrated wild athletic feats on my desk, boiled eggs while holding them in a heat-resistant glove, moved my three-hundred-pound desk with an eight-pound lawn sprinkler that defied physics, and flashed pornographic pictures of their wives, winkingly implying that the wife would do what it took to get into *Life*. At that hot desk I often felt as if I'd been set down in the second act of a musical comedy without a script. My job: write that script and cajole the editors into assigning a photographer and reporter to the story. There was the guy who staged a pre-death $12,000

funeral so he could peep from the coffin and enjoy his demise from, as it were, rite field. Or the kid who preferred sucking lemons to ice cream cones. Numerous benighted PR people hawking their handsaws, as Shakespeare might say.

I cased the Oak Park flat on the eight-foot ladder I had brought, striking up a conversation with one of the self-doomed flock, an aggressive middle-aged blesser. He was impressed that *Life* had shown up but said, "What good will it do? The planets are all lined up to watch Earth blow. We're doomed." He pointed to the pertinent biblical passage. "If we let you in, how would you publish your story with Earth gone—no printing plant, no readers? Why? Where?" He laughed patronizingly.

"Mars!" I said. "*Life* has made arrangements for a spaceship to Mars. We have a Martian edition of *Life* ready to roll. He was impressed and

Oak Park's Doomsday Cult.

retired to confer with his people, three of whom came to the window to look me over.

I held a Leica body to my ear—this was the fifties!—and said into the lens mount, "I'm talking to them now. Yes. I'll come in for a conference."

"I'm needed at headquarters," I said. "I'll be back in an hour." Down the ladder I went to a church bazaar sale I had passed. I bought a red table-cloth. Returning, I tapped on the window. They let me in, helping me across the sill, impressed with my cape and agility.

"Will you be going to Mars? Red is their color, you know," the now-friendly leader said to me from his kneeling position.

"Only if I get your story," I said. "It means a lot to me—my last story on Earth."

"We'll see it," somebody said. "I imagine we'll be saved the same way."

"We're going to Mars," one of the kids told another. "We'll get red capes too." The leader wasn't amused.

Finally I heard the phrase that brings joy to every photojournalist's heart: "Where do you want to shoot us?" I casually shuffled the group of zealots around the living room, posing them against the one wall I liked as a background, the one with a cuckoo clock. Everyone smiled for eternity—but *Life* (non-Martian edition) ignored my group portrait and instead used a frame of the leader looking out the window from doomed Oak Park to the starry, time-exposed firmament sparkling around his destination, Mars.

The wonderful thing about the old *Life* was its diurnal curiosity about man's (and animals') foibles that would somehow result in a story that would fit a page or a long vertical half-page. Thus the world's tallest doghouse was a natural.

Above left: Smoking dog aided by 600 mm lens, sprouted woman's hands.
Above right: World's tallest doghouse accommodated three Afghan residents.
Below: Canadian birds goose-stepping in Indiana.

An heir to the International Nickel fortune was addicted to Afghan dogs—about ten of them. His hometown, Sudbury, Ontario, refused to let him build an expansive horizontal kennel for them. But his lawyer discovered there was no ordinance forbidding a vertical doghouse, so he went for the record.

Playfully mocking Sudbury's officials at the housewarming, the owner had a couple of minions hold a string of hot dogs across the door. Each of the rooms in the narrow edifice had a double bed, cans of dog rations, and, as a sop to the prevailing bourgeois style in the area, a genuine metal cross over the bed.

As Picasso discovered trying to boss his single pet Afghan into posing for what would eventually be Chicago's homage to him, or to Afghans, Afghans are a stubborn breed. It took six hired hands to make my doggedly stubborn idea of an "opening" full page come true—two holding each Afghan at a window, presumably gazing at Sudbury far below. No humans or animals were injured during the making of this picture. But it was close.

Signs speak for themselves. Which is why I love stumbling upon signs that doubly serve the photographer. My friend Nelson Algren not only took me to visit Viola Larsen's Ashland Avenue animal shelter, but on another day he took his sometime ladyfriend Simone de Beauvoir. "How did she like the place?" I asked. "Turned up her nose," said Nelson. "But she did tell me that Sartre had told her Nietzsche died on a street in Turin, hugging the neck of a horse whose master had abused the beast. He empathized with the poor animal." Probably the first and last time Sartre and Nietzsche were ever discussed on Ashland Avenue.

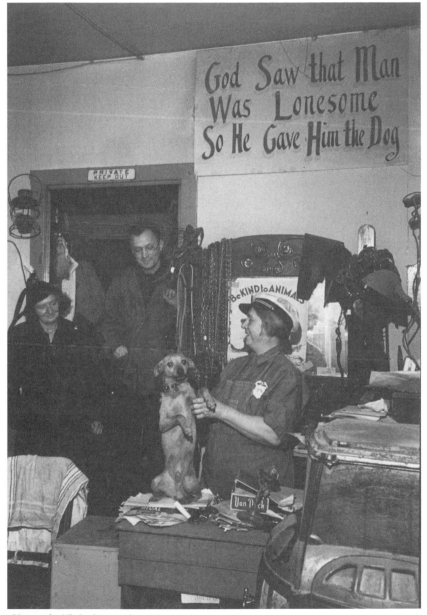

Algren in Viola Larsen's pet sanctuary.

*L*ife and *Time* had much lighter hands than the *Saturday Evening Post*. The photo editor at the *Post* one Christmas instructed me to arrange a picture of a Main Street so that "every woman you can find with a red or green coat" is crossing the street at the same time. They never took chances. No wonder they failed. They husbanded the American Dream so determinedly that they ended up somewhere to the right of their prime illustrator, Norman Rockwell. Their metaphor might have been a field of corn. All that energy locked into myriad kernels of cuteness. In the sixties I was invited to make suggestions at a staff meeting in Philadelphia. "Make your posed pictures look like they really happened," I said, "and stop running cartoons in which all males are idiots." I was guffawed at, all lunch hour. Change was anathema in Philadelphia.

A favorite Philadelphia moment of mine had occurred while I was covering the 1948 Democratic convention as a young reporter. Francis Miller was my photographer, and together (with me illicitly shooting a spare camera under his name) we got six pages of the eight-page story. The other eight photographers shared the other two plus an odd shot here and there. I blew the closing full page. We had gone to the unauthorized (by Ike) campaign headquarters of Dwight Eisenhower, whose people had begun tearing down the posters. The picture needed something sad as a focal point. Inexperienced as I was, I sat down at the central desk and lowered my head onto the table, as if I were a saddened Ike man, finally giving up. Managing Editor Ed Thompson chose this picture for a full-page closing shot, then, good newsman that he was, asked, pencil poised, "Did you get the poor sonovabitch's name, Arty boy?"

"It's me," I said expecting praise.

"You dumb shit," he screamed. "Get outta here." He tore up the picture. I had learned an important lesson in journalism: stay out of the picture. And I earned Thompson's suspicion and enmity the rest of his *Life*.

The transmogrification of a nondescript mongrel into a fierce feline with help from a fun house mirror.

Dog into cat.

Among Nelson Algren's neighbors at his summer cottage in Miller Beach, Indiana, near Gary, was a pig that repeatedly tried to mate with this swan. Thinking this shot a paradigm of my own and possibly other lives—are we not all pigs who aspire to natate with the swans?—I sent one to President Bill Clinton early in his first term. He kept my picture and in return sent me a possibly unique shot of himself alone in the Oval Office. I had wasted an apt paradigm.

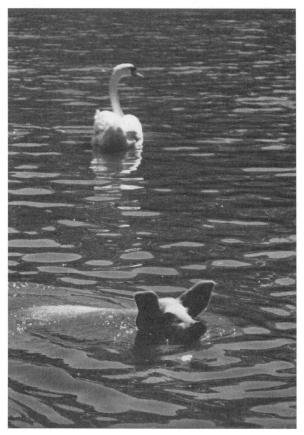

Swan and pig.

Heeding the stricture of the beach sign, this New Jersey dog seemed much relieved to stay within the letter of the law, if not the spirit.

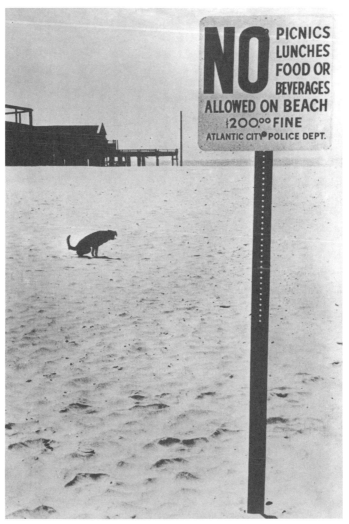

Illiterate New Jersey dog.

love signs and portents.

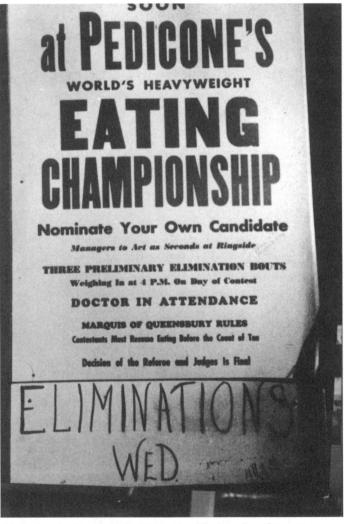

Photography is a private language. My favorite pictures
explain themselves.

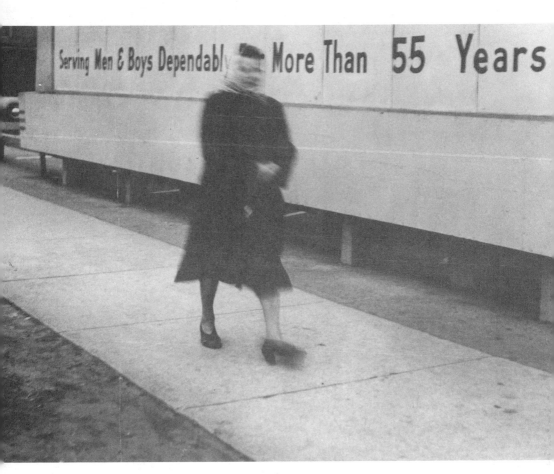

One university art department head—a published photographer, he assured me—suggested that next time I shoot a picture like this I could stop the "movement" in my subject by using a faster shutter speed.

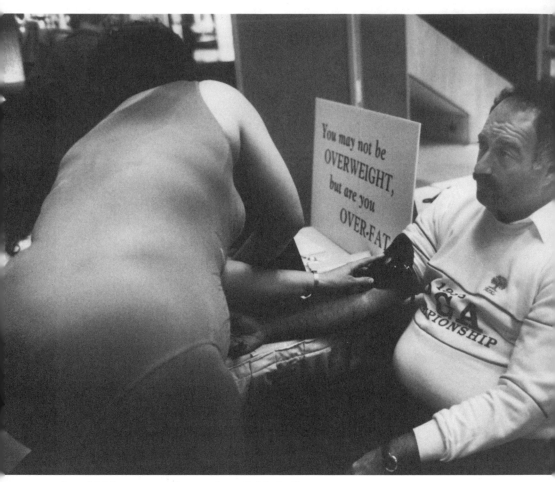

A weight-loss promotion run by weighty ladies.

There appeared in my local Mall one morning a team of hefty women working for a local hospital promoting a weight-loss program. The sign speaks for itself.

Having grown up near the sound of mating elephants trumpeting at the Bronx Zoo, or grunting in the vacant lot behind my house as they struggled through the mud schlepping circus gear for Ringling Brothers, and having raised five kids who were partial to Chicago's Lincoln Park and Brookfield Zoo, I have always kept a camera handy in the presence of beasts.

The ladies in the leopard coats—one synthetic, the other real—crossed each other's paths without an assist from me.

Never mind the lovely coats, the important thing is location, location.

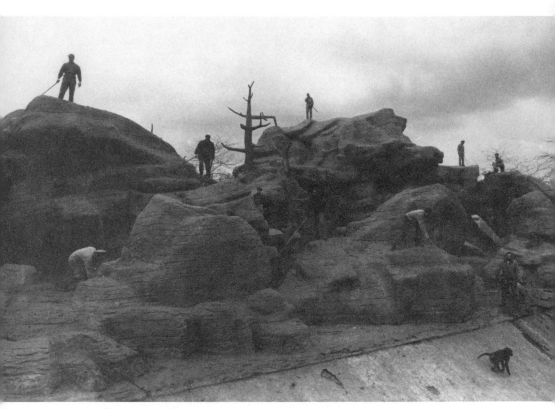

Belying zoology but bearing out Darwin, a monkey descends from ten zookeepers.

T aking my symbols and metaphors where I find them, I especially love this image of my seven-year-old son Steve's head juxtaposed with the jet engine.

With a critic's gun to my head I would say, yeah, I see it as a symbolic representation. From such a head as this comes an engine like that. But if you have to explain it, you shut viewers out of the joy of discovering things for themselves.

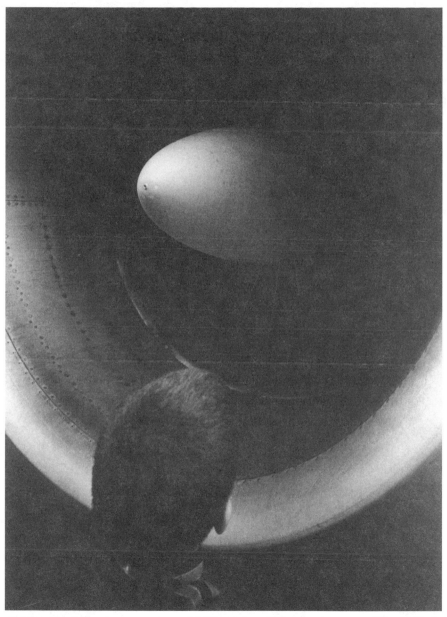

From a head like my seven-year-old Steven's might someday come this similarly shaped nacelle.

If you're lucky, pure joy unfolds in front of your camera and you capture it. Alvin Johnson smiled for me in an Indiana poorhouse in 1949. He also smiles from the walls of many museums and collectors, including the wall of my publisher, Ivan Dee, who has owned an Alvin original for a quarter-century. Several Coca-Cola people have found the picture disturbing for some reason. Sometimes a picture travels from your hand like a joyous boomerang. A Brazilian weaver has made a career of slightly Hispanicizing my "Coke Bottle Man" in elaborate embroidery and making pillowcases with his cheery image. To think that long before the Internet an image made in an Indiana poorhouse in 1949 somehow traveled to Brazil and, however transmogrified, today gives comfort to Brazilians and shares room space with unimaginable events up and down the Rio, with the wild thrumming of Mardi Gras just outside.

Ingenious Chicago tenement gym. Left: "The Pause That Refreshes"—the Coca-Cola company once asked me to stop using their tagline. They objected to the kind of subject I had shown with their product.

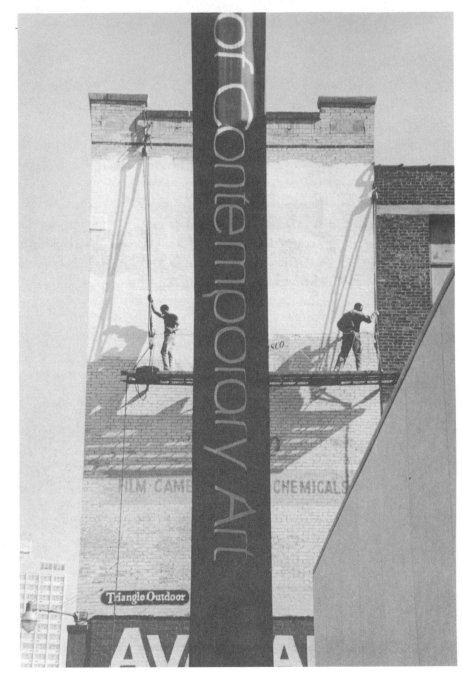

A "formalist" view at the Museum of Contemporary Art.

Someone from Chesterfield once offered to buy this negative, to remove the picture from circulation. I refused. Why should manufacturers care who cadges their products?

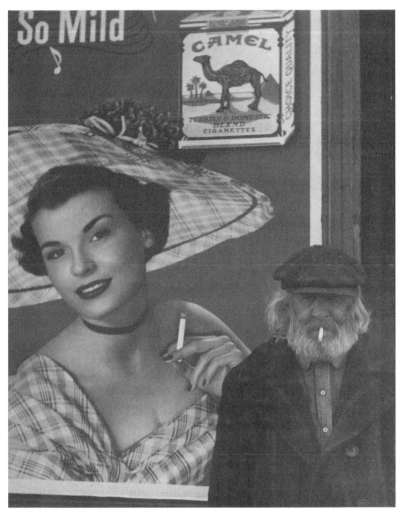

Smokers.

Sometimes a photographer chooses not to shoot a publishable photo. It happened to me but twice. The first time was at the Waldorf-Astoria in New York. My pal Nelson Algren, about whom I'd shot a photo essay, was about to get the very first National Book Award. From Eleanor Roosevelt no less.

I had been a staff reporter on perhaps a hundred stories, but here I was on my first official assignment as a *Life* photographer. The editors of *Life* simply hated the idea of a writer becoming a photographer. They tolerated David Douglas Duncan and David Scherman for their war pictures. They barely tolerated such wiseass kids as John Bryson and me. It would take a few years for us to earn our spurs. So I was being especially circumspect waiting for the Book Award picture.

Suddenly the table in front of me, peopled by seven or eight middle-aged ladies of considerable girth (newspaper people such as Dorothy Dix, the Ann Landers of her day, and Emily Post, the syndicated doyenne of good manners), were having a friendly (possibly martini-driven) tussle over a big plate of hors d'oeuvres. There in the finder of my poised Leica, flash at the ready, I was looking at big, fat Emily Post leaning halfway across the table to spear a fallen morsel with her fork. A picture to make every one of us with bad manners happy. Alas, I froze and did not shoot.

I could see the assignment editor, Ray Mackland, a very stuffy man, who'd been reluctant to hire me as a photographer, throwing up his hands at my contact sheet and saying, "I told you we shouldn't have turned him loose with his camera! He's insulted Emily Post! She's demanded the roll of film and is calling her friend Mrs. Luce to tell Henry not to use the picture of her. Also her lawyers. A *Life* picture like this could ruin her etiquette column." I wasn't about to screw up my first assignment.

The second time I froze at the trigger occurred a few years later. I was on the campaign trail with a former U.S. senator running for higher office. We were on the campaign trip that would cinch the nomination of this circumspect, likable family man.

At 5 a.m. I was walking down the hotel corridor en route to get film from my rented car. The door of the room halfway down the corridor was ajar about six inches. As I walked past I could see my candidate sitting under a lamp—but he wasn't reading, he was fondling a high school or college girl, his hand well under her sweater.

It was long before Senator Gary Hart's bimbo troubles, ages before President Clinton's hobby became known, but I liked the senator and knew I could cause him big trouble. As I walked by the door, I snapped it closed.

Later, on the campaign plane, I told him *I* had closed the door, if he was wondering who had done it. "You must've fallen asleep with it ajar." He looked at me long and hard, put his hand on my shoulder, and said, "Thank you. If I can ever do you a favor, let me know."

He was defeated.

I did covers and other Midwestern coverage for the *New York Times Magazine*. (But when I pitched the *New York Times* for assignments in the 1960s, their picture editor sent me a cheery turndown, saying, "We have looked at your impressive portfolio and think you are overqualified to shoot for us.")

I was illustrating a *Times Magazine* article on Chicago's Mayor Richard J. Daley, who was scheduled to wield a shovel at the groundbreaking for a new park building. Waiting to speak and break ground, *Da* beloved *Mare* sat on the porch of the old fieldhouse, peering benignly down at his gathering flock of admirers and the press. To me the fluted Doric columns between which my telephoto lens framed him added a symbolically mocking Olympian note.

"I don't think you quite got a cover for us," the picture editor reported in a day or so. No, the picture staff didn't think the column picture did it, but they were using one of the cliché shoveling-dirt pictures inside the story. They thanked me for a good try. The first day I went to work as a reporter for *Life,* editor Joe Thorndike (who would found *American Heritage*) held up

Left and above: Mayor Richard J. Daley.

that morning's *New York Times* front page, pointing out a news story: the Fifth Avenue bus had begun skipping streets. "I don't really know what a *Life* picture is," he said, "but Henry Luce and I both know that it isn't a picture of a bus not stopping at 43rd Street."

I thought of my mentor Joe when a couple of weeks after the *Times* rejected my cover tries, *Fortune* magazine asked for recent Daley pictures. I sent them my *Times* take and they turned handsprings, gave me a bonus, and ran in full color the shot of the mock-Olympian Daley.

When *Fortune* appeared, the *Times* picture editor called to complain. The managing editor had bawled her out and asked her to find out why I did better work for *Fortune* than I did for the *Times Magazine*. My impolitic, smart-ass rejoinder cost me the account. Nothing to do with the Daley fiasco, she assured me. "We just want to use photographers who shoot the new kind of pictures."

From the beginning, *Sports Illustrated*'s picture people, like *Life*'s before them, understood the power in photographs. They splashed these Lake St. Clair, Michigan, ice fishers over two pages.

Another time I met a manufacturer on a plane who said, "You want a real picture, give me a call."

He claimed that an area not far from Detroit was the very nexus of North America's crow population. "Comes twilight I can fill the sky with crows."

Thus it was a few twilights later, all booted up, Leica cocked, I stood in knee deep brackish water. No crows.

No problem. My man whipped out a small crow caller that looked like a kiddy machine. It was a record player. As he turned the handle it emitted

One of Sports Illustrated*'s most collected two-page photos: ice fishing.*

caterwauls that he claimed were the sex cries of male crows and the answering howls of the females. "Yeah sure," I thought, until the very minute before all light was gone. In that moment the trees in the far distance disgorged crows until the sky did, as he promised, fill with crows.

A wild full-page picture I'd shot for *Fortune*—how Post Cereals put the blueberries into their cornflakes—impelled Post to hire me to shoot the trading card pictures on back of their cereal boxes. They'd picked the two hundred top major leaguers and were paying them each $240 to pose. My fee was $60 a player. I'd shoot the players during batting practice.

Most of the players were cooperative, even eager. Some righties took lefty stances to confound me; many pitchers grabbed bats so they could be portrayed as sluggers. Biggest problem: getting them to spit out or hide their monumental chaws of tobacco. One player covered Willie Mays's face with a towel the moment I shot.

I amassed so many bad pictures that I sold the *Chicago Tribune Magazine* a feature made up of these lousy pictures, called "Untradable Trading Cards."

Post Cereals used to send me stacks of uncut, mint cereal boxes with my pictures on them, a dozen members of each team on a box.

I gave these artifacts to my sons to give their friends as birthday presents at parties. Good way to save three bucks for a gift, right?

A pricey trading card. Left: Roger Maris clowning during his record season.

Wrong. I have but a few of these uncut treasures left. Collectors trade them for $700. Some of the individual cards—Maris, Mays, Mantle, Musial—go for big numbers too. Pristine sets of each year, which I never bothered to keep, are available, I see by the catalogs, for $25,000. The four hundred or so slides used for the trading cards, which never came back to me from Post as they were supposed to, are each worth $500. "Shall I get 'em for you, Dad?" asked my daughter-the-lawyer years ago. "Now," as Jackie Mason says about real estate investing, "now is too late."

Only one player, Jimmy Piersall, known for his nuttiness, ever gave me a hard time over posing. "I want my $240 up front," he said, putting out his hand. My wallet came up short. He shook his head at $40. A teammate, Elston Howard, laughed him out of it. "Best thing could happen," he said, "would be they print your picture without you signin'. You could hit 'em for $500 at least."

Piersall thought it over. "I'll pose," he said, "but I ain't signin' nothin.' "

A barfly sitting next to my *Holiday* magazine subject, novelist Nelson Algren, sued for $30,000 because the caption, he felt, implied, he was one of Algren's lowlife associates. The case hinged on where I was standing to make my hidden-camera pictures, out on the street looking in, or in the inner vestibule.

"So if the picture was visible to you from the street, Mr. Shay," said the plaintiff's attorney triumphantly, "why did you shoot it from inside?"

"Because it was cold outside," I said. The jury burst out laughing, and the case against *Holiday* was dismissed.

I testified in a *Life* case over a picture a friend of mine had taken. I had gone along on the shoot to help him. The picture showed a three-year-old kid struggling to lift a weight over his little head. He was being developed into a Tarzan by his old man. High dives, running, etc. The *Life* caption prompting the lawsuit averred, "For torment like this, he is later rewarded with an ice cream cone."

The father's plaint: *Life* had accused him of torturing his son.

Plaintiff's lawyer: "Mr. Shay, you witnessed this act. You look fairly strong. Have you ever lifted weights?"

"Yes."

"Would you say the moment of most torment is when the weight is held near your feet, or lifted up over your head?"

"I don't know," I said. "I've never been able to lift one over my head."

Sympathetic jury laughter. Case dismissed.

There used to be—for all I know, still is—a Chicago law that says beer can't be advertised within four hundred feet of a church.

The Pabst Blue Ribbon Company, or its adman, my then-neighbor, somehow couldn't get their fix in early enough. Some smartass in City Hall discovered that the big Pabst sign on a four-story building on the North Side was a mere 324 feet from the beautiful Greek Orthodox church catercorner from it.

My Pabstman neighbor gave me the scoop on how problems like this are resolved in Chicago. He knew *Time* or the *Tribune* wouldn't print the story because Pabst was such a big advertiser. Said he: "We offered the church good money to overlook that fatal 76 feet, hoping it would appease some of the parishioners. It wasn't good enough. Greeks are wine people anyway."

One of the socratic Greeks came up with a sober, Solomonic compromise that would last for years, until the four-story building was devoured by a giant condo. Pabst merely had to retouch one word under the big beer bottle picture—they painted out the word *beer* wherever it appeared on the sign. No beer sign, it. Thus what churchgoers saw was not only a generous four-hundred-dollar-a-month contribution to their kitty but, 324 feet away, a

vast billboard advertising Pabst Blue Ribbon, without a hint that the great big bottle contained you know what. Chicago: city of many wonders, where green is always the color of the day. And sin is kept four hundred feet away, across the street from the church, to be on the safe side.

A UPS driver I know just sold his company stock for $7 million. Federal Express's air force is now bigger than that of ten minor nations combined. There is money in shipping parcels, but it's mostly new money.

Thanks to the vagaries of the Railway Express Agency from the fifties to the seventies, I was able to achieve a decent relationship with my five kids. What normal kid wouldn't rather accompany dad to Midway or O'Hare Field at night than do homework? There was a rickety candy machine in the drafty REA room, and the kids were permitted to rattle it into life. (For truly important film shipments I would shamelessly use my kids as cover as I looked for women wearing red or green coats and tried to force money and packages on them, to be picked up in New York by *Time Inc.* darkroom messengers, with parked motorcycles. They'd wave twenties until the crucial debarking women in those brightly colored coats waved back, trading our film for another payment. I often think of those days when FedEx comes to the door.)

The blame for this state of affairs rested on REA, the idiot offspring of the old Railway Express Agency that used to get your camp trunk to the Catskills by Labor Day if you were lucky. With FedEx still aborning and UPS unconcerned with aviation, my main clients, the *Time Inc.* magazines, were forced to order photographers like me to ship via REA.

Right: Shipping at Midway Airport.

REA was so untrustworthy that each of the magazines—*Time, Life, Fortune, Sports Illustrated*—used a different cargo handler in New York. Like the darkroom, the cargo guys would also send out minions with twenty-dollar bills, searching for our brightly coated bearers. We rarely used male couriers. Males were always more suspicious of being conned than women. We used wild yellow and orange labels on big red envelopes to help our carriers remember their mission and to find a home for parcels thrown away or accidentally left on planes.

I once asked the managing editor of *Life* why they didn't tighten up the company's shipping act. He laughed. "The entire expense of all *Time Inc.* editorial expenditure," he explained, "including salaries and shipping," was only 7 percent of the cost of doing business. A pittance in those cost-unconscious days.

The thing to do of course, was start FedEx, which someone did.

Trying to head off competition, REA invested $6 million in improvements. Designer envelopes, a few hires—but still the same old wind-rattled room at O'Hare, whose big barn doors were held together by thick yellow twine wrapped around two sticks. Cold air in winter blew in through the two-inch crack between those doors. My kids dressed warmly. We all were rooting for REA, but nothing much changed. They still kept losing our hot packages, and the main improvement they made in their O'Hare operation was to change that yellow twine to white venetian blind cord.

A couple of years into the age of TV video, tapes had to be sent from station to station. Chicago to New York and LA were the busiest routes. ABC and CBS eschewed our red coat–green coat operation that used mysterious envelopes of cash to help speed tapes through the system. One night my twelve-year-old, Dick, reported his conversation with two Chicago motorcycle cops.

"They get twenty bucks for running a package out here to O'Hare from the Loop," Dick reported, "while they're on duty. Fourteen minutes from downtown." Easily beating a forty-minute cab run.

Sensing a story, I asked the REA duty officer about the setup. "Networks love the speed, and it gives the boys a little extra dough."

"What if there's an emergency?" I asked.

"There's other cops on the beat for that kind of stuff. This is important. The tapes *must* go through. These cops are helping millions of viewers. The networks have other cops in New York and LA picking them up." A mission, not a job!

Long before Mike Royko became Chicago's chronicler of such indignations, his predecessor was an old touch-football friend, *Chicago Daily News* columnist Jack Mabley. I gave Jack the outrageous scoop on how the citizens of Chicago were paying for their police force to be used as messenger boys for the TV stations. He agreed it was a great story—until the next day.

"Can't do the story, Art," he said. "We also ship *our* film from Channel 32 to LA and New York via cops on bikes. Much faster than REA."

Working on a childrens' book at American Motors in Kenosha, Wisconsin, I heard a true urban legend. A powerful union foreman there had tired of repeatedly telling management that they should build their sluggish four-cylinder Rambler with a slightly bigger engine compartment, to give the car buyer the option of their peppy six-cylinder motor and also to simplify the assembly line.

To make his point, he monitored the construction of his personal Rambler, having his friends along the line stretch the engine compartment and make the other necessary modifications. This screwed up the assembly line so badly, an executive told me, "It would have been cheaper if we had bought this union big shot a Rolls Royce in Milwaukee." At that particular moment this executive engineer was trying to fix a problem just discovered at a dealership: the dimmer light switch on the stick-shift model had been imperfectly designed. When the driver's left foot clutched the gears, it also turned on the brights. For these and other problems that Volkswagen, Honda, and Toyota solved before Rambler could, American Motors soon disappeared.

Fortune, doing a story on great American designs, sent me to Dearborn in the sixties to shoot the vaunted '49 Ford and its proud designer, a nonfamily Ford. The PR department had wheeled a mint vehicle into the Rotunda—with a little three-foot board under the ancient transmission to catch the drippings. Mr. Ford rested a proud arm on the car's roof, and the picture ran not only in *Fortune* but a year later in the *World Book Encyclopedia.* A year after that I got a copy of an embarrassing note. A high school kid in Ohio had pointed out to *World Book* that the car in our picture was not a 1949 model but a 1950. He listed the three or four design differences that Ford had missed when they wheeled out the wrong car from their museum.

O. M. Scott, the premier grass-seed company, hired me to shoot their annual report. I covered their pungent, verdant activities in Marysville, Ohio, then traveled with owner-president Paul Williams to Oregon. There we rented a small plane and began flying up and down the Columbia River, which makes up the border between Oregon and Washington, shooting pictures of Scott's very best seed maturing in the best grass climate in the world.

Our pilot was a young combat veteran with a total disregard for the headwinds that had sprung up one Sunday afternoon. "I think we can make it," he said cheerfully to Williams and me. We weren't so sure. Williams looked left and right, and pointed to an air strip along the river among what looked like some military revetments. "Let's land," he ordered.

I had three motorized cameras around my neck when we bumped to a stop and were met by two jeeploads of armed guards bristling with curiosity about us. I was first off the plane, and one guard said, "You a Russian or

something?" This so infuriated me I went into runway rage. "Yes, comrade," I said. "Vee vant to surrender to America!" I put out my hands for the handcuffs.

"Not funny," said Paul Williams, emerging and explaining our forced landing.

We had landed on the emergency strip of an atomic bomb parts storage facility. Lucky I remembered my air force serial number, I thought.

"So if you're American," said one MP, "why are you surrendering?"

Wonderful way to spend a Sunday—trying to scrounge ten gallons of aviation gasoline at an atomic bomb installation that doesn't accept cash *or* credit cards.

During President Reagan's disastrous *contretemps* with airline controllers, *Forbes* magazine sent me to O'Hare Airport for a "creative" photograph of the overworked guys on the late shift. (You should understand that until *Life* came along, a great many magazine and newspaper pictures showed the subject looking knowingly at a clipboard held by another subject. Or talking into a microphone.)

I was so surprised by the amount of digital activity it took the controllers to bring in one plane that I got permission to tape two tiny battery lights on each hand of two of my subjects. Then I made a time exposure tracking all the moves those talented hands made. At the end of this fifteen-second time exposure in the dark, I would fire one small strobe light to add detail to the scene. I hoped that taxiing planes would be visible out the window as light streaks too.

After I'd shot five pictures like this, the chief operator ripped off his lights and threw them to the floor. He yelled at my other subject, who did the

Inside the control tower at O'Hare.

same. They began to work the mysterious scopes, radars, and phones in the room with frenzy.

Presently I learned what happened. A plane landing in bad weather at New York's La Guardia Field had pancaked into the mudflat parallel to the runway. No injuries, but as I left the tower hastily, my subjects begged me not to use the pictures I'd made.

The reason had occurred to all three of us at once! Suppose a plane had pancaked in or worse at O'Hare while we were taking trick pictures. We could all hear the plaintiffs' lawyer saying: "Would you please explain to the jury why you were bringing this plane in using ordinary hand movements and procedures—with one variation: *you had lights taped to your fingers*?"

As Ralph Kramden would say, "Duh."

Photojournalists are always looking for what the greatest of us all, Henri Cartier-Bresson, calls decisive moments. I think I photographed one while covering the great British director Tyrone Guthrie at the opening of the Guthrie Theater in Minneapolis. The play in rehearsal was *Hamlet,* and the action was: the Players arrival at the castle to put on their little play-within-the-play, designed "to catch the conscience of the king."

As the Players entered they were supposed to plop down their fairly modern luggage, a few suitcases and prop boxes with handles.

To achieve the casual look he wanted in this simple action, Guthrie had the Players enter and throw down their luggage for half an hour, time after time, until what happened ever so casually on opening night matched what it was that Guthrie saw in his head at rehearsal.

Decisive genius, controlled spontaneity in art, if you will, sometimes involves great pains most of us never see or even imagine. It helped make me a more discriminating and decisive photographer to rely more on the selective inner theatre of my imagination than the five-frames-a-second motor driving film through my Nikon, capturing everything in sight.

Politicians and Other Rascals

Daley and Truman.

By 1948 it was clear that Harry Truman was a surprisingly good successor to FDR. He played the piano, lovingly defended his attractive but modestly voiced daughter against music critics, took unscheduled walks, spoke bluntly to the press, had his famous desktop brass apothegm "The Buck Stops Here" disarming visitors, and was as comfy with the electorate as an avuncular Chicago alderman after serving his jail term.

Still, any good Republican would tell you that Truman's baggage included failing at haberdashery (business bankruptcy being Chapter One in GOP anathema) and a kind of unspoken fealty to the Prendergast machine of Kansas City that had first advanced HST for judgeships, then smoothed the political ways of the Democratic party in the Midwest so he'd be able to slide into the White House on his own.

Which brought President Harry in his No. 2 white suit to Kansas City one payback night in 1948, as principal speaker at the dinner party and fund-

raising bash of Bill Boyle Day. Boyle was Kansas City's Mayor Daley and New York's Fiorello and Jimmy Walker rolled into one helluva genial Irish vote-getter. He played the Kemper financial dynasty in KC like an Irish harp.

Photographer George Skadding and I, then a reporter and caption writer, arrived at the Muehlebach Hotel early, to case the facilities. The food would be prepared at the hotel, then wheeled through a tunnel to the festively arrayed hall of the Municipal Auditorium, where the homage took place.

"You think Harry's gonna eat KC steaks?" Skadding joked.

"Let's find out," I said.

We sought out the famous hotel chef, busy preparing the food for the head table. Chefs are as uncamera-shy as cheerleaders, or starlets at a studio promotion.

"The president's going to have a Kansas City steak, of course?" I said.

"Ehvabody think so," the chef said slyly, "But Harry, he have White House lady call me up, unfreeze New York cut special for him. He lovva New York cut."

"Which one is it?" I asked the chef, as Skadding raised his Contax.

Like a prehistoric Belushi slapping down *hombuggahs,* the chef dealt steak after steak from a frozen pile to his chopping table.

"Not zees one. Senator Barkley." Plop. "Not zees one—Meester Boyle steak—" Plop.

"*Zees* one! Eez Harry's steak." He proudly pointed to the New York marbling," and that's the picture *Life* ran.

Several readers complained about *Life*'s arrogance, getting in poison range of the presidential steak. Others said Truman was crazy to abandon his native Kansas City to New York cuts.

I haven't recently tried to photograph a presidential steak, but I suspect the stakes would be higher these days.

A big-league political moment in Oakland, California, involving another national politico, changed my entire life, moving me to Chicago.

I was twenty-six years old in 1948, *Life*'s youngest bureau chief, planted in San Francisco. I was earning $13,000 because I had jumped from the hourly wage class to executive. This cost me some $5,000 a year in overtime. We had moved to San Rafael and rented a two-acre begonia ranch at the foot of Mount Tamalpais in Marin county for $125 a month. I had done more than a hundred stories for *Life* and *Time* in New York and Washington, and in two months at the quiet San Francisco bureau I had done a few more. But I had also earned the enmity of the senior bosses on *Time* and *Fortune* in San Francisco, who had made a country club of the office, answering queries from New York, reading the papers for obvious stories, but also playing gin rummy and quaffing martinis starting at two, when Time Inc., running on Eastern Standard Time, three hours ahead, closed for the day in New York. To them I was a pushy little New York kid rocking their boat by beating the bushes for stories.

It was national election time in 1948. Thomas E. Dewey and California governor Earl Warren were the Republican candidates arrayed against Harry S. Truman. Time Inc. had conceded Harry so small a chance that a week before, *Life* had run a big picture of the diminutive Dewey on a boat, standing on his toes to look over the gunwales. The caption, breaking one of journalism's oldest taboos, said: "The next President of the United States sails down San Francisco Bay." Predicting the future as a fact of hard news, even if it's a sure thing, is a no-no.

A few weeks earlier a roundup questionnaire had asked all bureaus to canvass their cities to get some idea of the power of the Dewey landslide. I dutifully went out along the Embarcadero docks and asked stevedore after stevedore whom he would vote for. My count was 9 to 1 in favor of Truman. Someplace I have a copy of the New York teletype calling mine "a lone voice in the wind."

For Election Day, New York had sent in a fine Chicago freelance photographer who would eventually become a staffer, John Dominis. He was tough, having played for UCLA in the Rose Bowl. We went to the forty-foot garage where Governor Warren would cast his ballot. The place was teeming with press photographers, reporters, and newsreel cameras, some of their film destined for the few TV sets in America.

The single doorway was especially clotted, and the press photographers went into their event mode, a protective formation. The 4x5-inch Speed Graphic was standard in most newspapers then, largely because their ancient darkrooms and darkroom men were ill equipped to handle "those tiny 35 mm films. No way you can enlarge them, boss. Stick with the big stuff."

So one photographer would take the best position for his 4x5 picture. His competitors would all line up around and behind him, passing him a 4x5 film holder and a small #5 flashbulb. After he made his shot, he would shoot the "same" picture four, five, eight times for his buddies. In the voting garage were a dozen 4x5 photographers—and Dominis and his 35 mm Leica, and me. The voting booths, cloth curtained, were thirty feet to our left.

Warren was a little early, and the newspaper photographers set up a howl—getting Warren in position at the vote-counting table—before he'd voted.

The boys got Warren to pick up a blank folded ballot, the election clerk held up the little metal box with a slit for the votes, and to great cheers and laughter, Warren voted, revoted, rerevoted, etc., until every press photographer there had his 4x5 frame of Warren voting for himself.

Meanwhile I pushed my way to the front and made room for Dominis to keep shooting Warren with his small, wieldable Leica as the governor "voted." In the back of my mind was a *Life* spread—"How Many Times Did Warren Vote?" I never gave a thought to the fact I was working for a Republican magazine!

A good picture story needs a closing picture "to get out on." As some of the press photographers raced home to make early deadlines with their

Warren fakes, Dominis and I moved to the far left corner where Warren was actually voting.

My next move sealed my fate. I drew one corner of the white curtain toward me, allowing Dominis to shoot a picture of Warren actually voting for himself. The governor looked up as Dominis shot, then rushed out of the booth toward me.

"The privacy of the ballot!" thundered the ultimate chief justice of the Supreme Court. "You're violating the First Amendment!" Dominis handed the irate Warren the film, and I deservedly took the brunt of the blame and ridicule. Reports of the incident beat me back to my office, where the *Time* bureau chief (who outranked me) smiled villainously and said, "You're fired!"

I took the next flight back to New York to defend myself, but my bosses decided I was not yet mature enough to be a bureau chief and transferred me to Chicago as second in command.

I lasted about a year, doing many Midwestern stories, falling in love with Chicago, then leaving the staff to become a freelance photographer, shooting stories for *Life*. In three years I would become the Midwest photographer of first or second choice for *Time, Life, Fortune, Saturday Evening Post, Collier's, Parade, This Week,* and eventually *Business Week* and *Forbes*.

Life had so instilled in me the idea that photojournalism was a higher art form than pictures for advertising, PR, or annual reports, that I distinctly remember a conversation I had in 1952 with Cornell Capa, then head of the world-renowned Magnum photo agency.

Capa: *(Hungarian accent)* Well, Artoor, I know you've been doing terrific work for *Life* and everyone else. I see you have just brought in a check from the mail.

Me: *(shyly)* My first commercial shoot, $350 bucks a day (versus $75 for *Life*)!

Capa: I see you have two young children. But don't let the money spoil you. Think of your reputation. Why don't you come join Magnum—

we do only editorial worrk. And we'll represent you all over the worrrld. Cartier-Bresson is with us. David Seymour is with us. All editorial work, that's Magnum's reputation. You'll earn more in the long run. Think about it."

I thought about it long and hard, and to my everlasting regret turned Magnum down. In less than a year, proud Magnum was forced to turn commercial and had Cartier-Bresson shooting commercial ads for the City Bank of New York, and his other people were competing with me for annual report business—and making far more money!

All the heads of the Protestant church were in the sunken garden at Northwestern University to honor Ike. They looked stiffer than playing cards in their formal portrait. I was embarrassed for my gigantic *Time* reporter, Sam Welles, who, talking from a stone balcony down to the sunken titular head of an entire denomination, flashed his notebook and said, "Your grace, let me play Juliet to your Romeo . . ." A 250-pound Juliet with an Oxford accent who not only got his story but thanked me for reporting the above to *Time* with my captions. *Time* ran the exchange with my picture of the king-sized "Juliet" on the balcony.

As Ike brushed by me leaving, I put out my hand. "Sir," I said, "your order sent me off on D-day. I was a navigator in Jimmy Stewart's squadron." "I was just as scared as you," he responded. "Glad we both made it back."

I thought it was a pat answer, but later I learned he had risen before dawn on D-day and handwritten a note of apology to the American people in case we failed. He tore it up after reports came in of our first successful beachheads.

Even though Ike and I were brothers in arms, I voted for Adlai Stevenson because he was brilliant and humorous. I thought that he, like

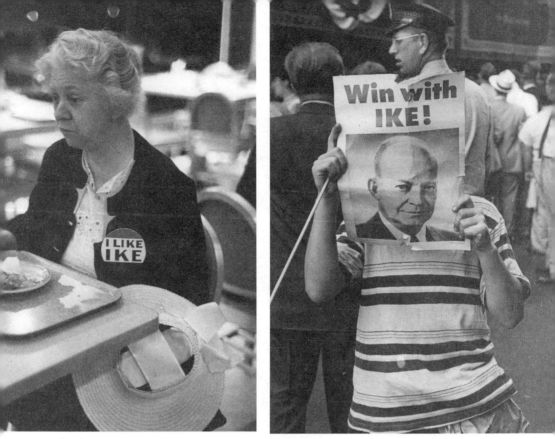

Ike fans.

Nixon and Dewey, had a losing smile that turned off many voters. Ike's smile was invincible. Smart women loved Adlai.

And Adlai loved women. Nelson Algren occasionally slept with the same well-traveled Gold Coast woman whom Adlai saw, the martini-mad daughter of a revered politico. "I don't wanna boast," Nelson said, "but she assured me I had her vote if I ever ran for public office. So we both voted for Adlai. I never liked my old commander-in-chief. Ike took a dim view of my selling canteen cigarettes and stolen C-rations in Marseilles. That's why I turned down the Good Conduct Medal. I didn't want the responsibility and didn't feel it was fair black marketing that stuff while braver GIs were out there risking their lives selling morphine and penicillin they bought from the

Ike getting a degree.

medics. Next time you see Ike, mention it—and try to get me the phone
number of his driver—Kay Somersby? Hell of a driver I hear."

He'd heard right. The first time I'd ever seen Eisenhower was when he
was my commander-in-chief in London in early 1944. In the near absolute
darkness and gentle spring rain dimly reflecting a very few lights in the
blackout near Ciro's Club (to which my wealthy English cousins had taken
me), Eisenhower jacket unbuttoned, he was swaying unsteadily in the arms
of a tall, slightly steadier lady (certainly not Mamie). He kissed her gently,
then he got in the back seat of his khaki Dodge sedan and she got in front.

Too dark for a picture, but it reminds me of another missed wartime
picture: I was a lead navigator in Colonel Jimmy Stewart's former squadron
of Liberators, the 703rd. I lived in a corrugated Nissen hut with the other

three officers of my crew and four of another crew. Stewart's name, if not his presence, drew women to our parties from miles around. Some squatted with us for days at a time.

One 3 a.m. I heard the rustle of our wake-up corporal. His flashlight shone on the cot across from me. He tugged at a toe. "Your crew's flying a mission, sir," he said. "Briefing's at four."

Up popped an eighteen-year-old bosomy blonde. "Oo's flyin', Yank? Not me you can bet your arse. Must be him. Hey cutie, whatever your name is . . ." She shook her bedfellow awake. "You're flyin' a mission," she said. There was time for one noisy round, during which the other seven of us picked up the beat of the trembling cot and clapped on the floor. Then we all applauded, and the blonde stood up on the cot and took a well-deserved bow to wild cheers. No bombardier ever had a better send-off. A lot of 8th Air Force kids died—8,400 of us on missions from England—but it was still better than the infantry.

When Ike died, his body, like Lincoln's long ago, was placed on a black-draped train for the long, dolorous journey back to his native Kansas. *Life* assigned me to get an aerial view of it. Using my old navigation tools, I started with the time of departure, allowed time for stops, then flew to Columbus, Ohio. There I chartered a small plane and flew east along the Baltimore & Ohio tracks until, in a heart-stopping moment, I intercepted the long black train coursing through the farmland land Ike loved so well, and whose admiring people had backed him all the way from the war to the White House.

Senator Robert S. Kerr was a leathery old bird. "It's twenty-six miles from my front gate to my front door," he said proudly. His chauffeur, a pardoned black murderer, was driving us along new macadam. "The government was kind enough to build the road for me," said this congressional pork-barrel master as we skimmed across miles of lush Oklahoma river basin farm land, past lowing congeries of his purebred Black Angus.

His huge house was high on a hill that overlooked miles of Kerr property. I stayed in a palatial guest room and the next morning set out to accom-

pany the senator campaigning throughout the state. By the second day we had become friends, me a kid from the Bronx, the senator, who had actually broken the plains with a hand plow in his youth. We swapped stories. Returning to our base at twilight, flying over his native Oklahoma, he slapped me on the knee and asked about my then four children, my plans for their education, was I saving, and so on.

He whipped out a checkbook, poised a pen over it, looked me in the eye. "It'll cost you about $35,000 each to educate four kids," he said. "That's $140,000."

I got a lump in my throat.

"You know, my boy, I could write you a check for their education and that would be off your back."

"I couldn't accept anything like that," I lied.

"I know that," he said, "but that's not the reason I'm not gonna give you the money." Strangely, I felt relieved.

"Reason is, if I wrote you out a check, I'd deprive you of the pleasure of working your ass off to get those kids through college and make something of themselves. Hard work is what builds character, my boy." He put his checkbook away—a billionaire's cruel game I was sure he played with many people in his time—then made a suggestion that would have been worth far more than any check he made out.

"Buy Kerr-McGee oil stock," he said. "It's 7 or 8 today, but McGee thinks it's going to the moon. He's never wrong." I wish I had.

Years later I told this story to J. Irwin Miller, the president and cofounder of Cummins Diesel and the lay head of the Protestant Council of Churches. Only half a billionaire, I'd guess. We were on his swimming raft in Canada, and I had heard Miller play his Stradivarius at lunch in his Saarinen house. "Senator Kerr was kind of cruel but basically right." Miller said. "You spoil kids, giving them too much, I believe, in confiscatory taxation. When you die you should not be able to perpetuate a fortune. Bad for your kids' character. I've already told my kids. Didn't make them happy, just more

Stevenson and Kefauver, the 1956 Democratic ticket.

ambitious." I wondered what would happen to his Stradivarius, his Saarinen home, the private DC-3 we'd come up in, and the very first Cummins Diesel–powered Chris-Craft ever built, in which Miller gave me a ride around his private lake. Money isn't everything.

The head of the new Federal Crime Commission, Senator Estes Kefauver, knew when he was outgunned.

Running as Adlai Stevenson's vice presidential candidate in 1956, Kefauver hoisted a paradigmatic emblem of his calling, a ham.

The quintessential GOP political windbag, speechifying Senator Everett Dirksen, scaled ever higher rhetorical heights and milked his audience for even more applause by invoking the image of another Republican politician on the wall behind him! Who mocks himself better on the hustings than the blowhard politico invoking Lincoln?

Some years after he'd disappointedly left the hustings for the UN, and left the UN to return to law, Adlai Stevenson donned a mailbag and spoke before TV cameras in favor of a postal workers' union seeking higher pensions.

I first interviewed Stevenson in 1951, when I was fairly new to Chicago. He was then governor of Illinois and a dark-horse Democratic candidate for 1952. My stupid question: "Are you the first politician in your family?"

"No," said Stevenson graciously, "my grandfather was vice president of the United States."

When I came to Washington as a *Time-Life* reporter during the 80th Congress in 1948, a fuddy-duddy senator from a Midwestern state asked me to meet him in his limo outside the Senate Office Building. I was a few minutes early, and the married, grandfatherly senator's "secretary" sat me next to her. "What would it take to get *Life* magazine to do a story on me?" she asked, hooking her ankle around mine. "Am I on the right track?" She gave me her card and told me the best time to call was on the weekend, because the senator was then busy with wife and grandchildren.

After the interview I suggested to my bureau chief that *Life* do a story on congressional girlfriends. He laughed and told me the facts of life in the Beltway: most senators and representatives had girlfriends here and wives at home. Everyone knew about them, so it wasn't a news story.

Like the crooked but lovable captain in *Casablanca,* I was shocked, shocked.

Three o'clock in the morning, an hour before I was to board the plane for Des Moines to cover Nikita Khrushchev's famous Iowa visit in 1959, my

Right: Kefauver, then chairing the Senate's crime investigation, gunned down at Midway Airport.

phone rang. It was the Governor of Iowa, Virgil Lawless. "Art," he said, "I've decided to honor *Life*'s request. Raise your right hand. As governor of the great state of Iowa," he said, "I deputize you to represent me at the John Deere Plant in Des Moines this morning when Khrushchev makes the tour with no press allowed inside. Dress like a factory worker, carry one little camera under your overalls, and go through Gate 4. They'll have your pass. If anyone on the *Des Moines Register* hears about this, we're both in big trouble. Good luck."

"What was that?" my wife said sleepily. "Something wrong with your arm?"

I scurried for my overalls.

Khrushchev scrubbed the factory tour, but his visit became curiouser and curiouser. Next morning my fellow *Life* freelance, John Bryson, and I were not happy with the limo arrangements for the trip from Des Moines to the Roswell Garst farm in Coon Rapids. In the middle of the night we bribed our way into the garage where fourteen Cadillacs were being vetted for the trip. Each had a windshield sign and number. Khrushchev would ride in number 3. We stole a spare blank sign, numbered it 5, and for an extra hundred bucks rented the last Caddie and driver in the area. We put the fake number in our windshield and parked the car down the street from the hotel. When the procession started in the morning, Bryson inched our driver toward the motorcycle officer in charge of starting the procession of limos. "*Life* magazine," Bryson purred. "We gotta get in after number 4"—augmented by a discreetly folded twenty. A double sawbuck was big money in the Midwest.

"Yes, sir!" said the cop, smoothly edging us into line two cars back of Khrushchev. Nobody noticed there were two number 5's in the cortege, and we were able to get in range quickly each time Khrushchev got out of his car to speak to Iowans. The press bus with all our competitors was back, as we say, in Kishnev.

On the road to Coon Rapids, kids had been excused from school to see Khrushchev and his retinue come through their little towns. They were

completely befuddled, because President Eisenhower's government had painted the Russians as murdering Commies out to take over the world—and here we were welcoming them into the very aorta of farmland America. Grungy old farmers in bib overalls that had been new at Pearl Harbor time stood at roadside muttering at the limos they thought bore Russkies. Including our illicit number 5. "Commie bastards!" one cussed at Bryson and me at a stop.

"Hush, Herman," said the farmer's doughty wife (bulging a cornflower-blue housedress). "That's not Christian."

"They don't understand English," Herman defended.

"Yes vee do," I yelled, shaking my fist at these poor dirt farmers. "Vee veel bury you you capitaleest pigs." The couple jumped back three feet.

Later, out on Mr. Garst's spread, walking toward me was Khrushchev in a blocky grey Leningrad suit, leading a party of three hundred, mostly press. I was ensconced in a stand of corn. I desperately wanted a picture of Nikita holding up an ear of American corn. Suddenly a State Department guard grabbed my camera straps and lifted me up.

"Get outta there you sumbitch," he screamed.

"Vras voogie," I said, "coq poodyivyishka." When I was eight or nine my Latvian-Russian father, Herman, tried to teach me Russian. I balked and he taught me chess instead, but insisted I learn one phrase of Russian—"just one, my son. Something."

"I beg your pardon, sir," the monolingual security man apologized, letting me go just in time to make *Life*'s Picture of the Year—Khrushchev and the ear of corn.

When Khrushchev had passed, security grabbed me again, looking at my credentials. "You said you were Russian. *You're no Russian!*" he shouted. *"You're under arrest!"*

"I didn't say I was a Russian," I said calmly. "I said 'Greetings, comrade, how are you?' " Just as my father taught me when I was a kid in the Bronx.

Farther down the road I asked a Coon Rapids deputy what the locals thought of the host farmer Roswell Garst. "Nobody likes the bastard," he said. "Too big a mouth for a rich farmer—and way out of line inviting the Commies to see our corn and steal our 100-bushel-an-acre techniques. He likes to get his name in the paper. I think he hankers toward politics and writing letters to the *Des Moines Register*. At our briefing with the state police, somebody got a laugh saying it'd be awful if someone here takes a shot at Khrushchev and kills Garst by mistake." He winked, letting us know he was a country slicker putting on us city folks.

Shortly thereafter, I covered the classic JFK–Nixon debate in Chicago with four just-come-out motorized Nikons and got 100 useable frames in the three minutes allotted still photographers. This put me on the JFK campaign trail.

Kennedy, like Coolidge and Hoover, hated props on the hustings. He was here in North Dakota, early in the 1960 campaign, to address 100,000 farmers. When several determined tribesmen thrust the headdress on his head, JFK bridled, took it off, and held it uncomfortably.

Another specialized camera, the 140-degree Widelux, had just arrived. En route to the airport in Chicago I bought two of them, learning how to use them on the plane. The crowd picture was the first sequence I shot with it. *Time* ran it across two pages, paying for both cameras and then some. I believe it was the first Widelux shot *Time* ever ran. While covering JFK's first debate with Nixon at the CBS studios in Chicago, Kennedy nodded affably. I had photographed him a few weeks before in Gary, Indiana, and had helped him find a men's room. He leaned down as I loaded film. "Where do you take a piss around heyuh?" he asked.

Kennedy with Indians.

1968! Forever sandwiched in my memory between FDR's famously infamous 1941 and Orwell's fictive 1984. I was shooting the Chicago Democratic Convention for *Time*. First night out I raised my camera to shoot a wild-eyed hippy kid who had a headband that said "Fuck." "Don't

shoot me!" he screamed. "The cops will bust me again." It was Abby Hoffman, and over a YMCA supper he told me the cops had yanked him from Lincoln Park, jailed him, then interrogated him about how he was going to poison the water supply of sacred Lake Michigan. "I told them they were full of shit, I wouldn't even piss in their lake, and three of 'em, including a spade, began beating me. 'You fucking fag!' they kept shouting, working themselves up. 'How many dicks did you suck today?'

" 'Just Dick Daley,' I said. 'He loved it.' They beat me some more, rubbed my forehead clean with gasoline that burned my eyes, and threw me out on the street again."

The first-night frontline was Lincoln Park. Donning my World War II gas mask because of expected tear gas, I photographed the onrushing police shooting canisters of tear gas at kids fleeing west out of the park. I shot a tear gas picture in color, and *Time* used it to open its story. I fled to the Lincoln Hotel, my eyes smarting through the mask, and there, more severely lachrymose because they had no gas masks, were Jean Genet and Allen Ginsberg. Genet was daubing at a head wound where he'd been clobbered by

Left: Delegates to the '68 convention were welcomed by militia bayonets. Time didn't use this photo but ran the one on page 247 in full color. Below: Suffering from Lincoln Park tear gas and police clubbing, three weird icons of our time: William Burroughs, Allen Ginsberg, Jean Genet.

a truncheon, but was smiling. (He would later write a completely fake diary of the night for *Esquire,* which to its shame also faked photo coverage based on Genet's extolling the thick blue-clad thighs of the police as they thundered him down.)

I shot the flummoxed Genet and Ginsberg just behind a sign that said "Welcome to Chicagoland."

Our *kristallnacht* came a couple of nights later in front of the Hilton Hotel on Michigan Avenue. At twilight the demonstrators and police faced each other across a no-man's-land of perhaps fifty feet. Chanting ("The whole world is watching . . .") . . . taunting ("Get back, you faggots!") . . . sidewalks lined with spectators and press . . . TV trucks parked just outside the Haymarket Café on the Hilton's street level (the irony of the name wasted on most of us).

Suddenly, rounding a corner came several mule-drawn cotton wagons—a Jesse Jackson–staged tableau to remind one and all of modern slavery. The police were now faced with a problem—getting the wagons through the

In a haze of tear gas the police look for rioters.

crowd. So they began pushing the crowd back, back, into the wall of shops that made up the Hilton's façade. The breaking of the window glass—one, two, three windows—seemed to drive the riotous police berserk. They began flailling their truncheons at everyone in their path. One sergeant yelled, "You see anyone stealing from the windows, kill him."

"What if it's a woman?" a hippie girl mocked, eluding a truncheon.

I wormed my way out of the melee, focused on the cops dragging kids into the paddy wagons, and made my favorite picture of the disaster: "Welcome Democrats," which summed it up.

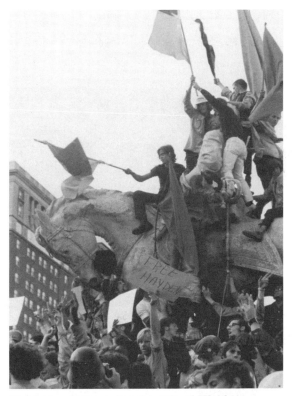

Epicenter of the cultural battle of Michigan Avenue was Grant Park, across from the Hilton Hotel, where demonstrators captured a statue.

The next night Hubert Humphrey was nominated. Close to 11 p.m. I photographed him and his elated entourage pushing through the crowd inside the Hilton to get up to the presidential suite and watch the reruns. He hadn't even waved to the thousands of his supporters camped out in Grant Park across the street. Mayor Daley, on advice of Ted Kennedy and others, after the disaster in Lincoln Park several nights before, had reluctantly given the hippies permission to sleep in the park.

This was the moment, I've always felt, in which Humphrey blew the election. Instead of going up to watch TV, he should have walked across the street into the park—as I'm sure JFK would have done—and listened to the demonstrators, hearing them out on international TV.

Had he done this Humphrey could easily have made up the two or three hundred thousand youth votes that would have beaten Nixon.

Hubert Humphrey watches TV.

I saw a similar lapse in a much different political arena—by Secretary of State Henry Cabot Lodge, escorting Nikita Khrushchev on Roswell Garst's Coon Rapids, Iowa, farm.

With the world's cameras turning, Khrushchev asked Garst, "How many bushels an acre?"

"Eighty," said Garst.

Khrushchev laughed. "In five years we will have one hundred," he said.

Cabot Lodge, instead of saying, "Hey, we wish our friends good luck, but in five years we'll be up to 130 bushels," merely cleared his throat and said, "Isn't that interesting."

Khrushchev blowing hard in Iowa.

No, it ain't accidental. I saw the halolike lamp at the Stockyards Inn in Chicago, and I juxtaposed the execrable senator as you see. When he vaulted down from the platform, he leaned heavily on my shoulder.

"That's the only support you'll ever get from me, senator," I had the pleasure of telling him.

Senator Joe McCarthy gave his venomous name to an opprobrious era that touched me when my scientist brothers Barry (helped design Air Force One's communications) and Stu (modeled the first moon suit) were investigated for loyalty: our immigrant father had belonged to a blacklisted union.

My admiration for Jesse Jackson knows some bounds. The writer of the *Fortune* article on Jesse that I illustrated was troubled that Jesse, intent on reorganizing big-business procedures according to his lights, had evaded answering what he knew about $600,000 or so that had disappeared, unaccounted for, on a Head Start project he worked on around the time he was buying a new house. No receipts, few records. Expenses, an assistant said. "Can't you understand that, whitey?"

Historian Garry Wills (see Foreword) says he disagrees with me on Jesse, having spent some time with him. "I like the guy," he said. "And no one has ever proved anything like that against Jesse Jackson." I respect Garry Wills's opinion and judgment.

In 1968 Jesse survived a tough round with the press in Memphis, when Dr. Martin Luther King was murdered at the Lorraine Motel and Jesse gave an eyewitness account of being next to Dr. King when the shot was fired, his hands getting bloodstained trying to save him. Jesse was nearby, but not exactly as there as he professed to be. He survived the little fib with about half his credibility intact.

My staff reporter and I arrived at Memphis late at night, rented a car, picked up Wills, and started covering the random violence going on, the fights, the smashing of windows and lights, the roiling sadness and boiling anger in the city for the murder of its favorite son. I made a picture of Wills in the combat atmosphere, interviewing a few shotgun-carrying police—which, to my great chagrin, *Life* misplaced to this day.

The day of Dr. King's funeral, the beautiful widow, Coretta King, her small children, and dignitaries like Bayard Rustin and Hosea Williams—the latter *had* been at King's side when he was shot—marched with her at the head of a crowd of five thousand mourners, some fifty abreast. Where was Jesse? we on the press truck wondered as we rode in the sad caravan, our cameras pointed at Mrs. King, her kids, the immediate mourners, and the thousands behind them. State troopers with cocked rifles scanned the roofs.

It was a time of terror with every TV and still camera at the ready, our flatbed riding just ahead of the immediate family funeral party.

Suddenly someone spied the often-tardy Jesse at the far left, fighting his way to front and center. Thus it is that I shot a sequence of ex-footballer Jesse Jackson, bursting through line after line of mourners, until, in ten minutes or so, there he was, striding forward with Mrs. King, certain to be dead center in every camera finder. (I faulted Jesse with this until I spoke to Garry Wills. He made me realize that Jesse was exerting the exact kind of pushiness I had used all my professional life, doing my job. *Mea culpa.*)

Getting hostages freed abroad or going to the aid of indicted rioters in a basketball gym, Jesse's always there where the cameras are, where the lights and issues flash across the screens of our consciousness. Not for his own aggrandizement of course, but for the Cause, whatever it happens to be at the moment. Eventually, even charisma wears thin.

I still think it's wrong-headed of the well-spoken and educated Jackson to use blackspeak Ebonics when trying to rabble-rouse a black audience or raise white money to produce more black college students. "Ain't nobody gonna tell us we ain't gonna go to college," he says to loud scholastic cheering. I still think bad grammar is a lousy weapon in the battle for education. Jesse Jackson, still another American icon.

There is nothing that so concentrates one's attention as imminent death, Dostoevsky wrote after he survived "shooting" by a firing squad of the tsar's cruel police who put their guns down after: Ready! Aim! . . .

Left: Jesse as hippie.

I survived having a Leica shot from my chest in a B-24 over Berlin. But that was the war, where death by gunfire is always in the next room of your mind.

As a journalist I've often asked veteran cops how many times they've had guns pointed at them in anger. Very few. "How many times have you pointed your gun at anyone?" Also very few.

But at 5 a.m. one February in the late fifties, on Peterson Avenue in Chicago, I was stopped by two drunken cops, red-faced, dishevelled, smelling of booze.

"You knowwhashamatter," said one. "You were speedin'."

"Thash right," his partner in crime-detection confirmed.

A decade or so after my run-in with some bad apples, I photographed these hardworking Chicago cops at a briefing for a New York Times Magazine *cover.*

"We get your kind alla time," the first one said. "Oughta get your spee—sppedome—get it checked. You don't know how fash you were goin'."

"I know how fast I was going," I said. "Thirty. And I also know when a cop's been drinking. I'm a reporter for *Time* and *Life* magazines."

"You hear that?" he said to his partner. "Shaid I been drinkin'. Call the wagon. You're goin' down to the station, and if I ain't drunk you'd better have a lotta money. More'n our ten bucks expenses for stoppin' you."

The partner fumbled for his microphone, apparently not eager to call for the wagon.

"They'll give you the test, too," he said. "We'll shee who's drunk." I have about one drink a month, and none during driving time.

"Good," I said. "I'm gonna get my camera from the trunk and get a picture of the test." I reached for the trunk with my key and opened it.

The first cop, jacket awry, patted the .38 he flashed as his jacket opened. When he saw me reach for my Leica and flash, he began to shout.

"You're under arresht."

"I'm a press photographer," I yelled back. "I wanna take pictures of this. That's my right."

"You ain't got no rights," he yelled back. "You're under aresht, I tell you. Put that camera away." (IIis official report would later say I was belligerent, "immune to the law," and had threatened to reach for a metallic object in my trunk.)

I flashed the speedlight once as I put it back in the trunk, and while the cops were momentarily blinded I slipped the Leica into my pants pocket for possible use at the station. I was young and foolish. And outraged. Their motto was on their car. That was the picture I wanted, two drunken cops in front of the ironic logo that said: We Serve and Protect.

Waving his gun vaguely, the first cop said, "Get in the back." He began finally *almost* to write a ticket, having trouble reading my driver's license. "Why do you wanna make a federal case out of a ten-buck stop?" he asked me. "You wanna pay the fine here, or go down and post bond? Or I take your

license and give you a receipt and you take off until your court date or you pay the fine."

"The receipt," I said, imagining whoever was on the desk knew the pair and their scam, or got a cut of it, this being Chicago. "Good move," my friend and attorney Syd Wexler said later as he prepared to defend me in court against the ten-dollar speeding fine and three bucks costs I was about to suffer.

The cops in my case, all sobered up, their ties straight, were sitting in the middle of a table of police officials.

They had all read the column I had written for the *Des Plaines Journal,* headlined "Chicago Police Farce at 5 a.m." I had been a little less specific about the stink of alcohol on my Servers and Protectors. In print I'd wondered if the smell could be antifreeze from their malfunctioning police car, possibly chasing me down at thirty miles an hour.

As the case opened the city's attorney made a little speech: The wonderful men in blue are out there at all hours risking life and limb to Serve and Protect the rest of us. They deserve the thanks of the citizenry, not cheap shots like this article. He waved the offending paper.

My attorney whispered. "It's a fix. Pay the ten and three."

The judge nodded—the men in blue did deserve credit for chasing down miscreants like me. A few police applauded as I nervously waited for Justice to be done.

I must now quote from my follow-up column a few weeks later.

The streamer head said: Case of Shay vs. City of Chicago.

"Narrating my little run-in with two members of the Chicago Police Farce brought me letters from sixteen motorists with similar experiences.

1. I am an army officer attached to Chicago's Missile Defense System. Four of my enlisted men, soberly driving late at night, were pulled over on the Outer Drive.

They were not speeding at all, but one of the cops told them, "What you think don't matter. It's what we think that counts. For five bucks you can keep driving to your barracks."

When the missile men insisted on being taken to the station, the cops backed off, calling them "cheap bastards."

2. Not so lucky or ethical was the woman reporter stopped in her sports car as she sped to catch her plane at Midway.

"Court's in session," one cop announced cheerfully. "The fine is $10, payable immediately."

"I'll be more careful," she said icily, paying her fine.

"Don't matter to us, girly," said his partner. "Speeding is good for our business."

3. "We don't want you to think this is a shakedown, sir," said another boy in blue to a young Chicago executive they'd stopped and seated in back of their squad car. "But we sure could use a steak dinner." Fine $10, payable now.

4. A widow: My late husband had been drinking at an office party. Two cops stopped him and told him they had to pull him in for drunk driving unless he happened to have twenty dollars.

Harold said he didn't, but he'd give them a check made out to Cash. The cops took it.

I'd been a day late depositing Harold's paycheck, and the check bounced.

First I knew of this was a policeman pounds on the door late at night waving the check, looking for Harold. Boy, was he sore.

I showed him my mistake, and the new bank balance, and gave him another check, adding five dollars for his trouble. Then he hung around for a drink from our Christmas punch bowl. Putting his check in his wallet, he told me he hated having to do this, but he couldn't live on his salary. "Merry Christmas," he said.

He came back and sprinkled some of our salt on the stairs. "You don't want any lawsuits," he said.

5. The Chicagoan brother of a local citizen was involved in a Lincoln Avenue early-hours nightmare with the police farce. He had stopped his Cadillac at a red light. A car rammed into him. He got out, the other driver got out. The latter wanted to fight and began to push our Mr. X, who raised

his hands to protect himself. At that precise moment a police car pulled up, two cops alighting.

"You get outta here," one cop said to the driver of the rear car, who left.

"You," the cop said to the victim, "are under arrest for assault. Or to ante up a hundred bucks."

"That's a shakedown."

"Yeah, a shakedown. How much cash you got?"

Mr. X panicked and showed but two tens in his nearly empty wallet. They took it, splitting it right there, ten and ten.

"You don't live far," the other cop said. "Let's go home and get some money."

Fearful, he drove home. His frightened wife handed over the other eighty bucks. They wondered what percentage the third man in their assault scam received.

I was awed that *Life* assigned me to photograph Supreme Court justice Abe Fortas at his home. What tidbit could I relay to my kids (antennae always out for role models) about my moment with a Jewish Supreme Court justice as intelligent in the law as Einstein was in science? As I entered, I admired a striking painting of a Revolutionary soldier hanging just past the door. "A present from—from a rich publisher," said Mr. Justice Fortas. "Part of a famous pair. You'd think the cheap son of a bitch would have given me both."

I forget why Fortas had to leave the Supreme Court shortly thereafter. I never mentioned the shoot to my sons and certainly not to my idealistic daughter Jane, who would in a few years become the first law student in

American history to win a case in the U.S. Supreme Court. She'd warned me: "If you come anywhere near the Supreme Court with a camera that day, they'll get me for patricide."

I had photographed Robert Strange McNamara, the man who would eventually preside over the unraveling Vietnam War, for *Fortune* in 1954, when he was a top Ford executive. Now, a few years later, the White House had summoned him to Washington to be secretary of defense. *Time* sent me to photograph him and his attractive, very social wife, Margaret Craig, in their beautiful Grosse Pointe, Michigan, living room.

"You've worked in the capital," Ms. Craig whispered to me worriedly as I was packing my cameras and Mr. McNamara took a phone call. "I don't know a *soul* there. Do you think we'll be invited to some of those wonderful Washington parties? Here we know everyone and are on all the A lists. There we'll be newcomers."

I assured her that a new secretary of defense, a cabinet member after all, and his lovely wife would automatically make all the best party lists. She was much relieved. Judging from the society pages, Ms. Craig's social life, which had blossomed in Detroit, really bloomed in the capital.

No Biz Like It

Marlon Brando and his dog.

In 1951 *Life* asked me to photograph Marlon Brando and his family in his Libertyville, Illinois, home. We were both around twenty-eight and hit it off right away when I joined him in throwing rocks at the new insulators Commonwealth Edison had placed on nearby poles. "Whaddya wanna end up doing, Art?" he asked.

"I thought I'd be a writer, but I fell in love with the camera," I said.

"Go with what you love, buddy," he said. "I bet you'll get a lot more loving with your camera than with your typewriter."

"Not as much as being an actor," I said. Brando guffawed like Stanley Kowalski.

"Man," he said, "you get laid so many times on Broadway, you forget what it was like to hunt down the live ones. I gotta go to Hollywood next month. I'm scared shitless. Vultures out there. All four sexes."

"You ever wanna do anything but act?" I asked.

"Yeah," he said. "I wanna write novels. I think novels all the time. My old man [he made a funny face and jerked his thumb toward the family homestead] is always putting my dough in cattle. He deals cattle out in Omaha. I'd like to write cowboy novels. Ever read Zane Grey? He was a New York boy like you, buddy."

Another view of Brando and his pal.

We continued to throw, scoring about one out of five shots. We were very pleased with ourselves. I got to direct Brando in some very good pictures. *Life* used one I didn't like—Brando leaning over a porch window, schmoozing with his family. I gave his father and mother a lift into Chicago, though I wasn't going there, and I gathered they were very proud of Marlon but didn't communicate well with him.

"Call your parents once in a while," Brando's mother advised. "Jewish families are especially close, even if they fight about money, aren't they?"

In 1962 a small feature in a Milwaukee paper caught my eye. The great actors Alfred Lunt and Lynn Fontanne were well ensconced in a huge country mansion in Genesee Depot, Wisconsin. I suggested to *Life* that we visit them. *Life* gave me the assignment and sent along a reporter who'd barely heard of the famous couple. The Lunts couldn't be more hospitable to us or to my wife, and let me direct them in many pictures, including mock argu-

Lunt and Fontanne, in their nineties in 1963, studying for TV roles.

ments over cribbage. I moved their chairs so that I could photograph them studying a TV manuscript in separate rooms, as was their custom. The house was French provincial, English country, and so large and beautifully decorated that one expected Henry James or at least Somerset Maugham to appear. Maybe Herbert Marshall. I said so. "Herbert Marshall was a sweetheart," she said. "Had one wooden leg. I kicked it once under the table and hurt my toe."

"It was I who kicked it," Lunt said. "You kicked Alexander Woollcott— and in the very chair Mr. Shay is sitting in."

"Reminds me a bit of Alec, too," Fontanne said.

"We have five children," my wife put in, loyally defending me from Woolcott's eunuchoid reputation.

"Oh dear," said Fontanne. "I meant your husband's humor, not his proclivities."

"Who was Alexander Woollcott?" asked my reporter.

The Lunts promised to attend a play I had running in 1964 but, as they were pushing ninety, regretfully canceled. Best of all, one of their protégés, the actress Julie Harris, playing opposite my friend, actor-director Mike Nussbaum, last year rewarded me with a kiss for the long-ago picture of the Lunts I gave her as a present.

Judy Garland put down the phone into which she'd just said, "Men don't get interesting until they've been divorced twice or queer once, honey. Marry him." Then she started singing to herself in the makeup mirror when I was ushered deeper into her tiny backstage dressing room.

"Be a minute," she said. "Had a daughter's life to straight out." Then she began humming and gradually nursed her voice aloud in a throat-saving

Right: Judy Garland in her dressing room, kicking her leg at the camera and laughing.

whisper, finally including me and her makeup man in her audience, adding passionate tropes to her warm-up doodling. *"Sometimes I'm lonely,* sometimes I'm blu*e-eu* . . . My disposition, depends on *you-ou* . . ."

She paused. Her voice was seamless, but the striations of her face, slowly collapsing under the weight of numerous plastic surgeries I guessed, showed through the makeup like ski trails. "Your voice makes my knees wobble—absolutely thrilling," I gushed. "A little lower than I usually aim for," she said. "It gave me shivers of joy," I told her. *"Frissons"*—a word Nelson Algren taught me the day he learned it from Simone de Beauvoir. I taught it to Judy. "Like a drug-free zone?" she laughed. "I'll remember it. I love to give pleasure—*free zones*?"

"The voice holds up pretty good," she added. "Everything around it is going to hell."

As I loaded film in my Leica and she worked on everything around her voice, her movie clips screened in my head: "Dear Mr. Gable" . . . the five-foot Mickey Rooney and all those flicks with variations of "Wait—there's a bunch of costumes in the barn—why don't we do a show!" . . . the yellow brick road triumph of Oz, in our national conscience forever. . . . and then the old *Look* and *Life* stories flipped by: Judy the schoolkid . . . studying backstage . . . contract signings with various cigarish Louis B. Mayers . . . divorces . . . weird hospitalizations . . . hints of addictions . . . the rickety panoply of life as a fluctuating mote in the public eye.

Garland got herself together in no time, smiled though her skin was breaking, playfully kicked a leg into the air, and asked, "Do you want to direct me in this scene or let it happen?" An echo, I guessed, of many another picture in her life. Good Frances Gumm showwoman that she was, she added, "When I'm finished singing I'll come down front and sign autographs. My gay fans will all be down there waving their little books, and, God bless 'em, they all dress like brokers. Should be good for *Time*."

She knew her picture audiences.

At lectures I give on covering the past half-century I sometimes begin with a picture of Elizabeth Taylor in her prime, casually mentioning that I slept with her only once. I go on, and at the end of my slide carousel I ask for questions. Of course a sea of hands shoots up to ask me for details on sleeping with Liz Taylor.

A few weeks after I photographed Liz at the Pump Room in Chicago during festivities surrounding the introduction of Smell-O-Vision, a company she'd inherited from poor Mike Todd, there I was in the rear seat of a TWA

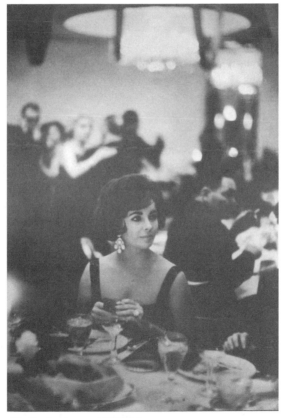

Liz Taylor by candlelight.

Continental leaving LA for Chicago. At the last possible moment a beautiful woman in a perfumed cloud of fur came through the door and pushed across me to the vacant seat next to the window. It was a cute meeting because we recognized each other—I being the *Life* photographer who had dogged her for three days, whose camera bag she had autographed, and whose cheek she had kissed goodbye, and she being Liz Taylor.

"I hope *Life* doesn't run the Smell-O-Vision story," she said. "It's a bomb. We couldn't even get the orange blossom smell to come up on cue at the movie. You know, where they're walking through the orange grove? Lousy scene anyway. One of the editors said, 'I nevair think I cut peecture for smells!" She laughed, patted my hand, and said, "Honey, I'm trying to save my voice. How about we just sleep all the way to Chicago."

That's how I slept with Elizabeth Taylor.

There is a madness in Hollywood the day before the Oscar orgy. The co-doyenne of Hollywood gossip columnists, Hedda Hopper, of wild hat fame, spied a tame lioness across the crowded, press-stippled lobby of our hotel. She affected a feline mien, mewed up to her sister under the skin, then lay down with her, trying her mad hat on the animal.

Hedda's antics reminded me of Chicago's TV zooman, Marlin Perkins. At the Amboselli preserve, in the shadow of Hemingway's Mount Kilimanjaro, Perkins expertly but illicitly let his snake stick with leather noose stray over the roadbed separating the sanctuary area from the hunting grounds, to pull in a puff adder. He bagged it in cheesecloth, knotted the bag, then placed it inside his tent, two feet above his head level.

Right: Hedda Hopper rolling around with a lion.

Our guide, the venerable Willi de Beer, said, "Let heem go, Meester Perkins. He will die in the bag."

"Nonsense," said Perkins. "At the Lincoln Park Zoo in Chicago—"

"Thees is Tanganyika, not Chicago," said De Beer.

In the morning, after presumably falling asleep to the reptile's sinuous writhing, Perkins dumped the now dead adder from the bag into the bush. "Must've been sick," he said.

High in a plantain tree a few days later, Perkins spotted a mother hawk-eagle feeding her young in their nest. She circled warily as we approached. Over De Beer's objections, Perkins sent one of our natives up the tree. He came down with two lovely hawk-eagles with two foot wingspreads.

"Wuzza, wuzza, little fellows," said Perkins for our TV camera. He nudged his sidekick, Jim Hurlbut. "Make a fine addition to the Lincoln Park Zoo, eh Jim?" Jim concurred, and as the mother hawk circled and swooped, Perkins told the camera that the young birds' mother had been eaten by a lion at the water hole, and when you visit Chicago . . ." He cut jerky with his pocketknife and fed pieces of meat to the birds.

Willi De Beer was aghast. "They need zee mother for two more weeks," he said. "They are certainly not ready for meat."

Perkins assured him that at Lincoln Park Zoo he had . . . And placed the birds in the game boxes under the benches of our Peugeot pickup. In the morning both birds were dead.

Dorothy Ruddell, the brilliant and beautiful twenty-three-year-old writer of the show, and I were horrified watching the undaunted Perkins throw the birds into the bush as the mother continued to circle us helplessly. As the gears ground and our benighted movie safari moved forward, Dorothy spoke the best obituary I ever heard: "Imagine having the good luck to be born a hawk-eagle in Tanganyika, and the bad luck to meet a famous zookeeper from Chicago."

I recently heard two young comedians discussing the talent of Milton Berle as a Roastmeister. "But he freezes up if you even joke about his acting."

Which reminded me about shooting Milton Berle in Vegas.

"Where do you want to do it," he asked affably.

"Billiard room," I said. "Behind the eight ball."

"Okay," he said.

When I added, "It might require a little acting," he said, "I'm a great actor. The hell with you. The interview is over."

My writer said, "Never joke with a professional joker."

I hadn't yet learned my lesson when I shot black comedian Dick Gregory at a Chicago nightclub at the height of the human rights revolution. There I was, four feet away from him as he kept the audience laughing. "This guy's from *Time* magazine, he said. "Take a bow." I did. Then he said, "Hey man, tell em to whiten up my face, okay?" Big laugh. Feeling he liked me, I said, "I'll tell 'em to use the negative." Brought the house down. He pushed me away.

"People ask me why I don't play the South. Mostly people there know me for my big joke: I waited nine months to get served at the drug counter

Marlin Perkins, at right, in Africa.

in Birmingham, and when I finally got waited on they didn't have nothin' I wanted to eat. But play the South? No suh, mastuh—I wouldn't even play the south end of this night club!" Cheers, laughs, whistles.

Later, my reporter, the brilliant Miriam Rumwell, and I were alone with Gregory in his phone-booth-sized dressing room. Rumwell was doing a cover story on him and other "movement" comics.

"How'd I do, honey?" he asked her.

"You did like shit," said Rumwell, and raked him up, down, and sideways. "You have a good chance to be *the* comic of the movement, and you're blowing it. Don't you know that when you tell a bunch of rich white businessmen you wouldn't even play the south end of this nightclub that's a nigger joke? 'Yas suh,' you're saying. 'I knows my place.' " Gregory was stunned. "You right, white lady," he said. "You can't have it both ways . . ."

"And when you tell *Time* to make you whiter, that's another kowtowing nigger joke." Miriam turned to me. "And you, Shay, stay away from the mike. When you have a camera, you're not talking for yourself. You're talking for *Time*. It was funny, though."

Dick Gregory and I both learned our lessons. He went on to win accolades as the best comedian of the human rights movement. I learned the danger of *ex cathedra* ad libs.

Cleveland Symphony conductor George Szell and I did not hit it off at the start. It was a *Time* cover story. He sat me down amongst the third violins during rehearsal, my telephoto ready. "I myself am a good photographer," he confessed. "I have Leica. I weel tell you when ees the moment to shoot my peecture. Watch my baton." He tapped the podium. "You are meesing my cue, Artur," he said. "Make zee peecture on zee downbeat, when I look up—my best angle."

He was unimpressed with the news that I had played the harmonica and at fourteen had been the bugle champ of the East Bronx. He repeated his instructions.

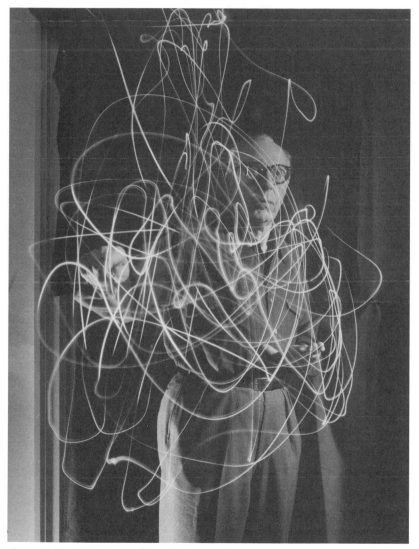

George Szell's baton making light streaks.

I tried following them for a few pictures but failed, possibly because of Szell's instinct to lead everyone in range. I got up at a pause and handed the maestro the Nikon (an immense 80 to 250 mm zoom attached), snatching his baton from him. I waved it around, saying: "When I point to you, take my picture." He gamely raised the heavy rig to his eye, and I shook my head. "You're missing my cue," I said. "Don't shoot on the downstroke but just as I point to you. . . . That's not a little Leica in your hand." He joined the entire orchestra in laughing. They applauded. They had never seen their maestro told off. My fear of failure often made me a smartass with celebrities, a psychologist friend has told me in a free, retrospective analysis.

Szell was a fine amateur cook and performed an entire meal for me, my writer, and a few orchestra friends. After supper I led him to a makeshift studio I had set up. Just a black background with one small strobe light off to the side. I taped a small flashlight to the end of his baton and had him "conduct" a Tchaikovsky march. "Come in when I say 'three,'" I said. "One, two—no, no, no . . ."

He laughed with the rest of us, and I got my picture.

One morning I fell in love with the lead stripwoman of the Royal American Carnival at their stand at the Calgary Stampede. I was there for Hugh Hefner's short-lived magazine *Showbiz Illustrated,* shooting the eighty-car Royal, the world's largest carnival. The third-generation Carl Sedlemeyer family still ran the show. It was young Carl's grandfather who had invented the double ferris wheel in the 1890s. Now, knowing Hefner's focus, he introduced me to Tsu-Li. He whispered, "I told her you were with *Playboy,* so she's half in love with you already. She's English, American Injun, Japanese, and Irish. Father was Chinese, she thinks."

Tsu-Li was twenty-five, of medium height, gorgeously curved, and wearing a brief tight costume with spangles and glitter. Although she didn't need anything to make her sexier, her scent was a heady perfume that an admirer had given her in Minneapolis earlier in the run. "He said he brought it back from some war, but his wife never wore it for him. I did. Drove him wild. Second morning, between shows, I let him call me by her name, Pearl. Stupid name, right? He loved it."

A fleeting, impossible love—stripwoman Tsu-Li.

"Kinda fell in love with him," she said as I photographed her in her train compartment room. "Handsome, and a body builder. Great shape." (I sucked in my gut.) He may come out here—I wish. Says he's gonna leave his wife for me—all my Carny lovers say the same—and take me off the circuit, or join it and work as a flattie. You want me to take it all off, honey?" The *Playboy* syndrome.

"No," I lied. "Just the top."

"You got a boyfriend in the carny?" I asked Tsu-Li gingerly, not wanting a shiv in the back from a visitor misinterpreting the innocent session.

"Don't need one," she said, "as long as I pay my electric bill."

"Huh?"

Tsu-Li whipped out an old-fashioned barber's vibrator and plugged it in, fitting its thongs to her hand. Then she lay down and buzzed her vibrating hand along her fantastic body as I shot away, demonstrating why she didn't need a boyfriend as long as she could pay her electric bill. I knew Hugh Hefner would be proud of me. I had recently photographed his *Time* cover story and pictured him demonstrating a beta-model vibrator to some of his ladies in the exercise room at the mansion.

She then took me to the mess tent for breakfast, where she introduced me to her buddies in the carny band, each of whom looked as if he'd lived two lives to arrive at fifty.

"You play any musical instrument, kid?" one drummer asked.

"Yes," I said proudly. "The trumpet and—" The cornetist handed me his shining Conn and said, "Give us a riff."

I played a few bugle calls, then a bar or two of "The Carnival of Venice." Applause. I loved it.

"You play anything else?" said the brass man.

"Yeah," I said. "The harmonica."

The place goes up for grabs! Wild laughter, whistles, pats on my back, finger shaking at naughty, confused me.

"He plays the *harmonica!*" someone repeated. The piccolo turned to Tsu-Li. "Any good at it?"

Laughing, Tsu-Li got me out of the tent.

"What'd I say wrong?"

"Nothing, sweetie," she giggled. "You know, Carny people have their own language, Mister Playboy. And 'playin' the harmonica' in Carny talk means eatin' it. "They're still laughing. They think I taught you Carny talk. They're just jealous I skipped Choosin' Day." May Day, I learned, is when most Carnies hit the road and the day most unmarried Carny people choose their mates for the season. The choice is irrevocable and serves to eliminate the knife fights among the flatties.

On my final day at the carnival, in front of a full house, the bandleader walked up to me with his portable mike and addressed the audience. "Not only is this photographer the guy who does all those *Playboy* covers," he huffed, "he's one of *the* best harmonica players in the U.S. of A." More undeserved cheers as he and the band blared goodbye to me and I regretfully slunk away from Royal American and the lovely Tsu-Li forever.

I was nervous about being caught with hidden cameras in a Mafia-controlled counting room, so I went to the Sands for a little entertainment and saw the vaunted Rat Pack led by Frank Sinatra. Afterward I called my wife and begged her to come out as soon as she could get a sitter for our kids. I needed her and the hidden purse camera she would carry.

The assignment was to shoot club owners, point men (representatives of share owners of hotels), Mafiosi, and especially Las Vegas honcho Moe Dalitz, and to get a bona fide shot of money being counted.

I had talked my way into a counting room that was rumored to have a "cooperative" gaming commission man present—to see that if you owned three points of a hotel and the guy sitting next to you represented someone who owned six, large cash bills would be swept off the table in direct pro-

The Rat Pack: Joey Bishop, Dean Martin, Sammy Davis, Jr., Frank Sinatra.

portion, so that everyone stole from the government honestly. The process of counting occurred every six hours, when the shoebox-sized money boxes were taken from under the table slits and brought in to be tallied.

This was the moment of truth, so to speak. I had gained entrance as a spurious reporter for the *Saturday Evening Post.* "You can look, but don't touch," I was told. Nobody noticed the wide-angle camera peering through a hole in my dark green jacket, and another in my fedora which was triggered by touching the brim.

The *Post* reported afterward that I had a perfectly sharp shot of the money cascading down to the table from a box. But there was a law saying you weren't allowed to show money photographically. Fear of counterfeiting. So the good square *Post* contracted a pre-computer wizard to retouch each big bill into a blur. Worst full-page picture I ever had published, making my risky gambit a waste of time.

But I really enjoyed the Rat Pack and its antics. I told my wife it was too bad she didn't see this particular show—Frank and Dean used Sammy's

body as a jump rope, Dean tripped on Frankie and spilled his drink all over him, and so on.

A few midnights later I took my wife to see the Pack. Every pratfall, every seeming abuse of the agile Sammy's body, every spilled drink, was accomplished exactly as I had seen it, as well rehearsed and performed as a French farce. Even the stumbling ad libs seemed ad lib! Masterful.

After skulking around, I tried a frontal approach to Moe Dalitz. "Can I take your picture for the *Saturday Evening Post*? They tell me you run this place or own part of it." "Sorry kid, I'm allergic to pictures. Last time I had one taken they put numbers under it. Enjoy the show. Here's a couple of extra tickets."

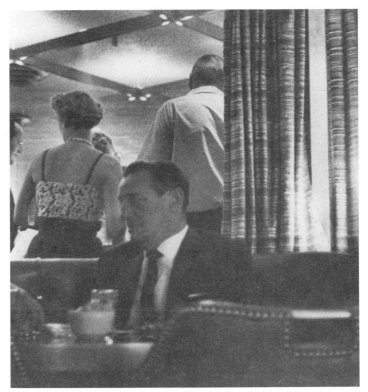

Mobster Moe Dalitz, nailed by Florence's purse camera.

My wife went to the powder room and on her way back saw Dalitz talking in a phone booth. She enterprisingly slid into the next booth like a movie moll, to eavesdrop. She heard Moe tell someone to check out "a maybe" photographer from the *Saturday Evening Post* "who's been following me." So much for the frontal approach.

That night Florence and I sat in the near dark Sands lounge, about two tables from where Dalitz was seated with a friend. I held hands with my wife and aimed her purse at Dalitz, its lens wide open, the shutter set at a full second for the dark. Fortunately Dalitz didn't move much as he listened and occasionally smiled at us. Holding hands with my wife I was able to trigger about five usable frames!

Shooting famed stripper Gypsy Rose Lee at the Memphis Cotton Carnival, I made the mistake of whistling while changing film. Suddenly Gypsy hit me with a fan, knocking a Nikon from my hands, then kicked me out of the dressing room. "You never whistle in a dressing room," she yelled. "Everybody knows it brings bad luck. Now turn around three times and say every bad word you know, then come back in. Cussin' takes the curse off!" I don't know if the cussin' was a cure, but the curse was real. It cost sixty bucks to fix my Nikon.

Gypsy had a son of nine with an artist named Julio de Diego, often mistaken for his friend Salvador Dali. He was a good father, but in his absence one afternoon, the boy, Alexander, ended up sitting next to the very tough and famous Memphis censor, a crusty eighty-year-old, Lester Binford. He had to decide whether Gypsy's strip show was too sexy for Memphians.

Midway through the performance, after a wild move by Gypsy, Alexander looked up at the glowering Binford and tugged his sleeve. "Can

It's tough work, but sometimes you gotta see yourself in the mirror.

your mommy do that?" he asked proudly. Binford laughed till he quaked, then okayed the show for his unshockable city. Afterward Gypsy bawled out Diego for being a lousy baby-sitter.

The circumstance of Liberace's turning from his piano and candelabra at a small concert in 1956 to heft a football was quite ordinary. Since it was to decorate *her* mantle, the wife of a Chicago Bears' official thought it would be a good idea to have a Bears team ball signed by *her* favorite ball handler.

Liberace coming out of an unlikely huddle.

"Would you like to be a quarterback?" one lady asked.

"Oh yes," sighed Liberace, "if he's the one who pokes his hands in the huddle to take the snap."

Then he winked to show he really understood both football and what admiring fans expected of him.

I had photographed Chicago Symphony conductor George Solti, his wife Lady Valerie, and their two small children at home for the *New York Times.* The couple called that night. Would I please not send in the kids' pictures? Understandable fear of kidnapers. Instead I sent those negatives to

Lord Solti and Lady Valerie backstage.

the Soltis. A week later I was hired to photograph Solti and the orchestra for the semiofficial Symphony book. The cover picture I wanted of Solti was one never done before—a head-on view of him conducting with the Orchestra Hall audience as background. Musician's-eye view.

It was Solti who told me he had noticed a tiny cubicle behind the organ pipes, occasionally used by the organ tuner—a space that had a tiny window between the pipes big enough for my telephoto lens. With Solti's okay it was easy to get permission to shoot from there—with one condition: I'd have to be supervised in the cubicle by a Symphony PR person or docent. I couldn't work there alone.

It was something of an athletic feat to get into the tiny room, which had a treehouse-type entrance well behind the last row of the orchestra backstage. There was a flat eight-foot ladder to climb, then draw up after you so no one would trip over the obstruction.

Solti played a delightful Tchaikovsky suite, the management kept the audience lights on an extra minute, and my attractive docent wrote captions. I got the cover. At intermission we let the ladder down and all was well. Later at home, unpacking, I discovered I'd left a prize lens in the aerie.

No problem. I could retrieve it next night, again with an escort. This time my escort was late and the trapdoor was shut and the pull-up ladder gone. I got another ladder from down the hall, climbed up, pushed open the trapdoor—and there surprised a fortyish couple, entwined on the floor, their coats beneath them. Two impassioned members of the orchestra, I learned, who liked to do it dangerously and thrillingly—once in a while, to live music, I assumed. The couple kindly returned my lens and swore me to secrecy. I

Solti conducting.

usually keep my word as a gentleman without having to be sworn, but I assured the relieved couple there was no place in the Symphony book for the incident. Not in that book, anyway.

Mr. T was born Lawrence Tureaud in 1953 and grew up in the jungle of the Robert Taylor Homes in Chicago, one of twelve children abandoned by his father. This so embittered T that when he was rich and famous he pointedly refused to pay his father's burial bill. But he did help kids form sports teams and enjoyed making motivating speeches to them.

He constructed a dynamic body by lifting weights incessantly. When twenty-two, while working as a bouncer at a nightclub, he was tapped to be a thousand-dollar-a-day bodyguard for Muhammad Ali and Michael Jackson. In 1980 Sylvester Stallone cast T as a heavyweight challenger in *Rocky III*.

He was on his way. TV's "A-Team" series found him, and soon there were Mr. T dolls and TV cartoons, and millions of dollars came to him. He affected sixty pounds of heavy metal hanging from his body, including his earlobes. This, plus mismatched gym socks, silver Mercury slippers sometimes wrapped in bandages, and a modified Mohawk haircut, made him a lovable American icon of black power.

From the pulpit of his boyhood church, which he helped support, Mr. T, in full A-Team garb, told one and all, "I don't shout on Sunday and doubt on Monday!" From the same pulpit he warned against vanity—not easy while wearing sixty pounds of gold, ten diamond rings, and six-inch earrings held in place by four holes drilled in each strong lobe.

All of the above was just fun and games for mid-America until Mr. T bought the seven-acre Armour estate in Lake Forest, sometimes known as Tree City, Illinois. The very symbol of landed wealth—the place Scott

Fitzgerald's rich boy, Tom Buchanan, Daisy's husband in *Gatsby,* came from, arriving at Yale with "a string of polo ponies from Lake Forest." Location, location. Money, money.

Suddenly Mr. T was in the news, anathemic news from Tree City: "I cut down 35 trees on my 35th birthday. A present for myself. So what? It's my trees, my land, my money, my exercise."

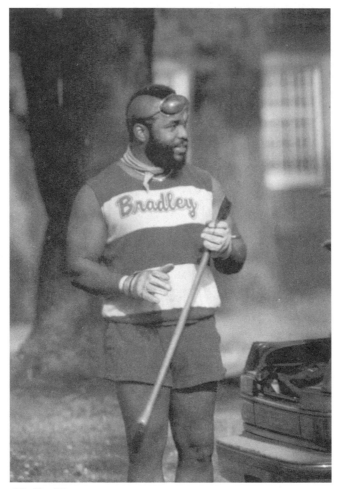

Mr. T with ax.

This land was his land all right, but indignation soon covered it. Claiming he was allergic to trees, T continued hacking down the venerable Armour trees with an ax while his hired arborists used chain saws and the press all over the world, including me, wrote about it.

Alas, hard times and chronic debilitating illness fell on Mr. T. He preaches no more and has dropped out of sight and sound. His $2 million estate has been sold to people who plan to replant the trees with guidance from Tree City arborists. Mr. T's former best friend, who lived on his treeless acres, has sued him, tying up the money from the sale of the estate.

Tourist parents of a certain age still pose in front of the place for snapshots by their kids, who are only dimly aware of Mr. T.

In a recent football movie, *Any Given Sunday,* one footballer instructs another in a phrase he seems to be making up as he goes along: "Football is a game of inches . . . etc. etc."

More than thirty years ago I was shooting Birdie Tebbetts for a *Time* cover story on him and the Cincinnati Reds. (My reporter, Jack Olsen, was a spare-time crime novelist, poker player, and a man so romantic that he fell madly in love with the model who wore the first peek-a-boo bathing suit on a *Sports Illustrated* cover. The story goes—no it's *Sports Illustrated* legend—that he journeyed to Colorado, wooed and won her, and had three children with the lovely lady.)

"How would you describe baseball to somebody who didn't know a damn thing about it?" Jack asked Birdie in the Reds' locker room at Crosley Field.

"Like I told my daughters at bedtime, it has witches and villains," Birdie said. "But mostly baseball is a game of inches. A quarter-inch difference where your bat connects on the ball means a home run or an out. You place your glove an eighth of an inch wrong, you bobble the ball for an error.

People talk 321 feet to the left field wall, so many feet from mound to plate—but baseball is really a game of inches."

Olsen centered his story on Birdie's phrase. Gradually the expression has seeped into the consciousness of many sports.

While Nelson Algren and I were giving Marcel Marceau a tour of Chicago's West Side, the mime was ecstatic about learning how a pool shark swims around the table in fits and starts. On cue, Nelson suggested we show Marcel our wonderful Statesville Prison, where so many of Nelson's loser friends resided.

The warden agreed to our visit a few days later, if Marcel would "do a little show for the boys." So there was Marcel, in tight white Bip suit and a little Chaplinesque topper caparisoned with a rose, doing his classic: Bip trapped in a glass cage, seeking a way out with his hands searching every inch of his walls. Brought down the Big House. Cheers, screams, and, as soon

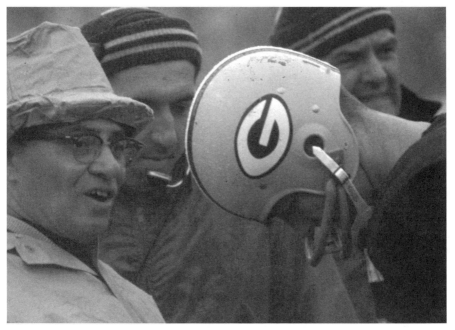

Vince Lombardi with Bart Starr.

as Marcel took his bow and his little toosh tightened against his nylon whites, whistles.

Marcel managed to get offstage, practically in tears. "In Europe whistles mean they hate my work," he said balefully.

"Not in prison," Nelson said. "Half these guys are temporary fags. They just loved the way your ass looked when you bowed."

Marceau's *maitre* as a mime, he said, "was Charlie Chaplin. I met him but one time by chance in a Swiss airport. I had met Charlie's wife, Eugene O'Neill's beautiful daughter Oona. Now she introduced us. There was a *Paris Match* team covering me, but I would not permit pictures. I am sorry now, but I didn't want Chaplin to think I was using him. We amused each other for a few minutes. He did the tramp, I did Bip. He taught me how to twirl the cane. I had tears of joy, and so did he. When we were parting I kissed his hand. He shuffled away, making himself smaller, like his closing cinema scenes. He looked back once, twirled his cane and smiled, and I offered Bip's invisible rose to him, blew a final kiss to thank him for all he had given me. He nodded gently. He understood our silent language, having originated it."

In the early seventies, someone from *Who's Who* called to interview me and ask for my credo. After being listed for several years, I got a call from *Newsday. Who's Who* for the first time had printed everyone's credo in their new edition, and *Newsday* liked mine best of all. Could I tell them whence it came?

Gladly, proudly. My credo (advice I've given to my five kids when they reach age sixteen): "Hang your coat anywhere, but keep your car keys in your pants pocket." It evolved, sort of, from my Russian atheist father's credo: "Pray to God, but keep swimming for the shore."

The robins flew into the worst week of my life, the week I realized that my wonderful oldest son, Harmon, two weeks shy of his twenty-first birthday, was dead. That I would never see him again.

He had been missing for three months in Florida, and the last clues to his disappearance had dissolved. Now on those terrible, beautiful July mornings in 1972, when lesser horrors were going on around Nixon in Washington, I would rise and stand at the bedroom window and look blankly south and east through our moraine locust tree toward Fort Lauderdale, thirteen hundred miles away. Memories came flickering through the leaves: first baseball glove, his Rube Goldberg science projects, watching him race to school cutting across the backyard, his Press Club scholarship.

One morning I became aware of the robins. A fury of activity outside my bedroom window on a branch nine feet away. Two shuttling blurs of orange and grey were building a nest. The female (smaller, less colorful) seemed to be in charge. Together they amalgamated grass, weeds, string, cloth, bark, and mud from bushes. The nest took shape—a cup about five inches across and six inches deep, anchored to a fork in the locust.

Day by day, watching the robins, I became more preoccupied with their progress and began photographing again, something I hadn't done in my months of grief. Driving to the Loop one day, I realized I wasn't brooding over my lost son every moment. Not only had the robins moved my tragedy lower in my mind, they had returned me to photography.

The first flash of new color I saw was a tiny yellow beak, backlit by the rising morning sun. Suddenly the father appeared with a beakful of worms. He deposited them into the tiny mouth and flew away. The mother returned to baby-sit. Hours later another beak appeared—and with it sibling rivalry. The bigger baby wriggled around, crowding the smaller one, which weakly lashed back.

Now the parents began to alternate roles. Mother gathered food, father sat. With each whir of parental wings the babies would rise up hopefully. "Me first!" each one seemed to be saying.

"The pushier baby is getting more worms," I said.

On the twelfth morning of my vigil, I sadly observed that the weaker baby had either flown the nest or been pushed out. Both parents swooped and hovered around the tree, futilely looking for their lost baby.

Now the couple stayed close to the nest, monitoring their survivor who, in a couple of mornings, hopped to the edge of the nest, took a long look at the new world, then hopped back into the secure cup of his nest. When both parents showed up with worms, the little guy took some from each and dutied up his pellet, which the adults removed to keep the nest clean (I learned from a book).

Now both parents were at nest edge going through a Marceau-like charade, pointing out what they expected of their offspring, or so I imagined. Then they flew back into the highest reaches of our locust tree.

All that day my wife and I alternated vigils at my tripoded camera. At twilight I hastily rigged up a speedlight, and at that moment, as if on cue, the little robin spread his wings and leaped from the lip of the nest into the world. He was momentarily halted by a vertical twig, then whirred off in rickety triumph.

Instantly the equally triumphant parents left their perches and zoomed through the tree like two feathery missiles. I envied their feral joy at seeing their kid safely launched in life.

The founder of Land's End, Gary Comer, decided to present the city of Chicago with an expensive millennial gift that would last. He hired the *Sun-Times*'s picture editor, Rich Cahan, to form a team of one hundred photographers to document the life of the city in the year 2000.

As the old millennium dribbled away, this project found me on the icy roof of O'Hare Field's parking garage, examining the skies for the arrival of the very first flight of the new age. The first, of course, of billions to come. All

I wanted was that historic time-exposed streak of light approaching the runway. I must now quote Ellen Warren's January 4, 2000, *Chicago Tribune* story, from the column she writes with Terry Armour:

"Different Kind of Shooter Stopped at O'Hare."

Overlooked in the excitement of the new millennium and the Y2K noncrisis was the touching story of how armed police officers kept O'Hare safe—by holding a photographer at gunpoint.

"Get out of your car. Put your hands on the roof," one of the two gun-pointing cops said to the venerable lensman, Art Shay, on assignment for an ambitious project to document Chicago throughout the year.

Jet tracery at O'Hare.

Shay had gotten permission from the city's Aviation Department to photograph—from the airport garage roof—the millennium's first landing at O'Hare. Nonetheless, two carloads of police, two guns drawn, responded to a report from someone at the nearby O'Hare Hilton, who mistook Shay's tripods with telescopic lenses for weapons.

But, finally, one of the policemen recognized Shay: "You're famous!" he said, "A friend of mine bought some of your pictures on the Internet."

With that, the police holstered their guns. Despite the lengthy mix-up, Shay did get his picture.

American flight 44, from Hawaii, arrived at 4:15 a.m. bearing the glum Ohio University basketball team, just defeated in a Hawaii tournament.

Going back some forty years in my mind, I'd learned by experience not to reach for a metal camera or flash while being held captive by the police. I like to think that, like Dostoevsky surviving the fake firing squad, I've also lived to write you these notes from my own Underground.

First landing of the millennium, O'Hare.

Index

Italic numbers indicate photographs

ABC (American Broadcasting Co.), 116, 218
Accardo, Tony, 33–34
Africa, 123–125, 273
Air Force, 131–159 *passim*
Air Force One, 10, 250
Alaska, 156–159
Algren, Nelson, xi, 24, 25, 46, 54–56, 77–78, 90, 92–94, 165, 190–191, 206, 214, 233, 290
American Heritage, 17, 180, 209
American Motors, 219
American Occupation, 141
Arbus, Diane, xii
Architectural Forum, 139
Armonk, N.Y., 6
Armstrong, Louis, 170
Art Institute of Chicago, 33–34, 57–58, 77, 78, 126
Associated Press, 146–147
Astronauts, 74–75
Atlantic Monthly, xi
Auschwitz, 146
Avedon, Richard, xii

B–24 Liberators, *xv*, 7, 131–133, 142–143
Bailey, Rich, 68–70
Balchen, Bernt, 137–141
Bellow, Saul, 60–61
Berle, Milton, 272–273
Binford, Lester, 282–283
Bishop, Joey. *See* Rat Pack.
Blue Cross, 46, 48
Bollock, Ronnie, 103–105
Boy Scouts, xiv, 6, 11
Brach, Helen, 70
Brando, Marlon, 263–265
Brave New World, 62
Bronx, 6–7, 18–19, 150
Bronx Coliseum, 13–14
Bronx River, 10, 13–14
Bronx River Avenue, 13, 148
Bronx Zoo, 10, 199
Brookfield Zoo, 199
Brooklyn College, 123
Bryson, John, 240
Burroughs, William, *245*
Butler, Paul Jr., 39–40

Butler, Paul Sr., 39

Cahan, Rich, 293
California, 229
Camp Peter Pan, 6
Camp Winston, 7
Capa, Cornell, 231
Capa, Robert, 183
Cartier-Bresson, Henri, 223, 232
Catskills, 7, 16, 19
CBS (Columbia Broadcasting System),
 218
Central Park, 10
Chaplin, Charlie, 291
Chekhov, Anton, 21, 22, 25, 90
Chicago, 15, 42, 43, 50–53, 54–56, 77–
 78, 99, 110–111, 190, 215, 231
Chicago Sun-Times, 293
Chicago Symphony Orchestra, 284–287
Chicago Tribune, 79, 81, 186, 294
Chicago Tribune Magazine, 213
Circus, Circus, 12
Cleveland Clinic, 63–68
Clinton, Bill, 194, 207
Coca-Cola, 203
Cohen, Mickey, 41–43
Collier's, xi
Comer, Gary, 293
Consolidated Foods, 102
Cosell, Howard, 116, 118
Crown, Henry, 99–102
Cuban missile crisis, 60, 63
Cummings, Nathan, 102

Daley, Richard J., 207–209, 248
Dalitz, Moe, *12*, 279, 281–282
Daumier, Honoré, xii–xiv, 56

Davidoff, Harry, *184*, 185
Davis, Sammy Jr. *See* Rat Pack.
De Beauvoir, Simone, 46, 54–56, 190
De Beer, Willie, *124*, 272
Democratic Convention, 1968, xii,
 243–247
Detroit, Mich., 30, 259
Dewey, Thomas E., 165–166, 229
DiMaggio, Joe, 35
Dirksen, Everett, 238
Divorcees Anonymous. *See* Starr, Sam.
Doghouse, world's tallest, 188–190
Dominis, John, 230
Dooley, Tom, 11
Dorfman, Alan, 8
Drabowsky, Moe, 95
Dresden, 144–150. *See also* Shay, Art:
 war years.
Drew, Robert, 179–180
Duchamp, Marcel, 57
Durocher, Leo, xi, 122
Durrell, Lawrence, 153–156

Edgerton, Harold, 183
Einstein, Albert, xi
Eisenhower, Dwight D., 192, 232–234
Eisenstaedt, Alfred, 182
Empire State Building, 100, 102
England, xi; and Hemingway, 89, 136;
 Trafalgar Square, 9; and World
 War II, 137, 142, 144, 147, 152–153
Everglades, 24

Feller, Bob, 35
Fenn, Al, 166
Finley, Charlie, 95–98
Fontanne, Lynn, 265–266

Forbes, Malcolm, 165
Forbes, 165–166
Ford, Benson, *181*
Ford, Henry, *181*
Ford, William, *181*
Ford Motor Co., 181–182, 220
Fortas, Abe, 258
Fortune, 29, 99, 100, 210, 211, 218, 220
From Here to Eternity (Jones), 43

Garland, Judy, 266–268
Genet, Jean, 245–246
George Washington Bridge, 20
Ginsberg, Allen, 245–246
Glenn, John, 74–75
Goldin, Nan, xii
Graflex, xiv
Grand Canyon, 46, *48*
Gregory, Dick, 273–274
Gretsky, Wayne, 10
Gulf War, 39
Guthrie, Tyrone, 223
Gypsies, 15, 17

Halsman, Philippe, xi, xiii, 182–183
Hamburg, 7
Handy, Lowney, 43–45
Harris, Sir Arthur, 146
Havasupai, 46, 48
Heart surgery, 63–68
Hefner, Hugh, xiii, 119–122, 126, 276
Heidelberg University, 9
Hemingway, Ernest, 89–91, 109, 134–136
Henry J, 103–105
Herr, Randy, 103–105
Hicks, G. Napoleon, 74

Hilton, Conrad, 100
Hilton Hotels, 100, 101, 246–247
Hoffa, Jimmy, 29–32
Hoffman, Bill, 125–127
Holiday, 79, 214
Hoover, J. Edgar, 32
Hopper, Hedda, 270–271
Howard, Elston, 214
Humphrey, Hubert, 248
Hussein, King, 39–40
Hussein, Saddam, 39
Huxley, Aldous, 60, 62–63

International dateline, 141
Isom, Cecil B., 151–152

Jackson, Jesse, 251–253
Jackson, Mahalia, 59
Jacobson, Phillip, 114
James, Henry, xii–xiv
James Monroe High School, 13, 131
Johnson, Alvin, 203
Johnston, Dick, 45
Jones, James, 43–47
Joyce, James, 154

Kansas City, 227–228
Kaplan, Paul, 90
Kefauver, Estes, 237, 239
Kennedy, John F. Jr., 242, 243
Kennedy, Robert F., 32
Kenya, 135
Kerr, Robert S., 235–236
Khrushchev, Nikita: in Iowa, 238–242, 249
Kilimanjaro, 136, 270
King, Coretta Scott, 251, 253

King, Martin Luther Jr., 251
Kirkland, Wallace, 163
Kodak, xiv
Kroc, Ray, 82–83

Larsen, Viola: and pet sanctuary, 190–
 191
Las Vegas, 12, 14, 41, 273
Lawless, Virgil, 240
Lee, Gypsy Rose, 282–283
Leibovitz, Annie, xi
Lewisburg Penitentiary, 29
Liberace, 283–284
Life, xi, xiii, 11, 16, 17, 19, 33, 36, 42,
 43, 44, 52, 72, 78, 79, 81, 83, 103,
 111, 114, 139; working for, 163–192,
 206, 209, 214, 218, 221, 228, 229,
 230, 231, 238, 240, 258, 263, 265, 270
Lincoln Park Zoo, 199, 272
Lombardi, Vince, *290*
Long Island Sound, 14
Look, xv, 139, 142
Loren, Sophia, 182
Los Angeles, 41–42
Los Angeles Times, 186
Lunt, Alfred, 265–266

Mabley, Jack, 219
Mackland, Ray, 206
Mafia, 12, 33–34, 43
Manhattan, 92
Mantle, Mickey, 35
Marceau, Marcel, 57–59, 76–78, 290
Maris, Roger, 212, 214
Marshall, George Catlett, 79, 169
Marshall, Herbert, 266
Marshall Plan, 169

Martin, Dean. *See* Rat Pack.
Masai, *135*
Masters and Johnson, 119–120, 122
Mays, Willie, 213, 214
McCarthy, Joe, *250*
McCormick, Robert R., 79–81
McDonald's. *See* Kroc, Ray.
McNamara, Margaret Craig, 259
McNamara, Robert S., 259
Meadowlands Stadium, 32
Memphis Cotton Carnival, 282–283
Menninger, William, 123
Michigan Avenue, 33, 246–247
Midway Airport, 216–217
Mili, Gjon, 183
Military Heritage, 131
Miller, Francis, xiii, 167–169, 172, 192
Miller, J. Irwin, 236–237
Monticello, 16
Morse, Ralph, 180
Mr. T (Lawrence Turead), 287–289
Muller, Jack, 50–53
Museum of Contemporary Art, *204*
Musial, Stan, 214

Nabokov, Vladimir, 154
National Portrait Gallery, xi, 122
Nazis, 137, 141, 145, 147, 150
New York City, 110, 145, 159
New York Review of Books, 60, 77
New York Times, 150, 186, 210
New York Times Magazine, 207, 210,
 254
New Yorker, 150
Newsday, 292
Newton, Helmut, xii
Nixon, Richard, 242

Northwestern University, 36, 39

Norway, 141

Oak Park Doomsday Cult, 186–188

O'Hare Field, 53, 218, 221–222, 293–295

Olsen, Jack, 289–290

Olympics, 1976, 116–118

Operation Thunderclap, 144

Orly Airfield, 7

Our Lady of the Angels fire, 85–87

Perkins, Marlin, 123–125, 270–273

Piersall, Jimmy, 214

Playboy, 276, 278, 279

Police, 50–53, 163–165, 254–258

Post, Emily, 206

Railway Express Agency (REA), 216–219

Rat Pack, 279–281

Reader's Digest, 72, 110

Reagan, Ronald, 221

Reuben, David, 118

Rizzuto, Phil, 16, 35

Rockwell, Norman, 82, 111, 192

Rogers, Shorty (Miltie Roginsky), 148–150

Roosevelt, Franklin D., 227

Rose, Charlie, xii

Rowan, Roy, 43–44

Royal American Carnival, 276–279

Ruddell, Dorothy, 272

Rudiger, Gilbert, 115

Rumwell, Miriam, 273–274

Sackett Lake, 7

San Francisco, 156

Sartre, Jean-Paul, 46, 54, 190

Saturday Evening Post, 59, 70, 72, 95, 98, 109, 192, 280, 281, 282

Shakespeare, 62, 153–154

Shawn, William, 150

Shay, Art, *19, 77, 86, 94, 134, 138, 157, 164*, 296; early years, 3–25; friends and acquaintances, 27–105; politicians and celebrities, 225–259; as professional photographer, 161–223; show business, 261–295; snapshots, 107–127; war years, 129–159

Shay, Barry, 250

Shay, Dick, 100, 218

Shay, Florence, 7, 12, *19*, 46, 94, 282

Shay, Harmon, 23–24, 87–88, 292

Shay, Jane, 60, 62, 63

Shay, Peter, 148

Shay, Steven, 200–201

Shay, Stu, 250

Shimer College, 60

Showbiz Illustrated, 276

Siegel, Bugsy, 41

Simon, Dan, *145*

Simpson, O. J., 116, 118

Sinatra, Frank, 279–280

Skadding, George, 228

Smith, Sandy, 33

Solti, George, 284–286

Some Came Running (Jones), 43–45

Somersby, Kay, 234

Sontag, Susan, xi

Speck, Richard, 83

Spitz, Mark, 116, 118

Sports Illustrated, 7, 11, 33, 39, 41, 45, 98, 210, 218, 289

St. Paul, Minn., 70–72
Stamberg, Susan, 144
Starr, Bart, *290*
Starr, Sam, 110
Statesville Prison, 290
Steichen, Edward, xiii
Stevenson, Adlai, 232–233, *237*, 238
Stewart, James, 150–151, 232, 234
Stompanato, Johnny, 41–42
Stringer, Lee, *145*
Sweden, 137–141
Szell, George, 274–276

Tanganyika, 136, 272
Taylor, Elizabeth, 269–270
Tchaikovsky, Pyotr Ilich, 9
Teamsters, 8, 30, 32
Tebbetts, Birdie, 289–290
Thacker Junior High School, 112–115
Thompson, Ed, 192
Thompson, Eugene, 70–73
Thompson, James, 75
Thorndike, Joe, 180–183, 209
Time, xi, 11, 22, 35, 60, 63, 65, 68,
 73, 79, 82, 119, 123, 135, 167, 169,
 177, 180, 192, 206, 218, 229, 232,
 243, 245
Trafalgar Square, 9
Treblinka, 146

Truman, Harry, 227–228
Tsu-Li, 276–279
Tuleca, Alexandra Ionesco, *61*
Turner, Lana, 42

Ulysses (Joyce), 154
University of Chicago, 60–61
U.S. Holocaust Memorial Museum, 148
U.S. Supreme Court, 75

Vanity Fair, 42, 69–70
Vonnegut, Kurt Jr., *145*–146, 150

Walker, Jimmy, 17
Wall Street Journal, 186
Warren, Earl, 229–231
Washington, D.C., 152, 167–169
Washington Post, 156, 169
Waugh, Evelyn, 180
Welch, Paul, 72
Whitman, Walt, xi
Williams, Paul, 220–221
Wills, Garry, ix–x, 251, 253
Wittgenstein, Ludwig, 62
Woollcott, Alexander, 266
World War I, 9, 12
World War II, 7, 16, 123, 129–159
Wu, Sherman, 36–39

Art Shay grew up in the Bronx and since 1948 has lived and worked in the Chicago area. He has been authoritatively called "the best and most prolific photojournalist Chicago has ever produced." A former *Time-Life* staff reporter, he became a full-time photojournalist in the early fifties. Since then more than 25,000 of his photographs, including 1,000 or so covers, have appeared in a variety of publications, including *Time, Life, Sports Illustrated, Fortune, Forbes, Business Week, The New York Times* and *Chicago Tribune* magazines, and in annual reports for 3-M, Ditto, Baxter Labs, Motorola, McDonald's, National Can, and many others. His work has been widely exhibited, critically acclaimed, and passionately collected. Several of his pictures hang in the National Portrait Gallery. Shay has won some twenty Art Director awards for distinguished photography, including one for *Life*'s Picture of the Year in 1959—Khrushchev waving an Iowa ear of corn. He has written and photographed more than seventy-five children's and sports books, and is himself something of an athlete, having been elected to the Jewish Athletic Hall of Fame for winning the National Golden Masters and two state singles racquetball championships.